TRANSPACIFIC ATTACHMENTS

GLOBAL CHINESE CULTURE

GLOBAL CHINESE CULTURE

David Der-wei Wang, Editor

Michael Berry, *Speaking in Images: Interviews with Contemporary Chinese Filmmakers*

Sylvia Li-chun Lin, *Representing Atrocity in Taiwan: The 2/28 Incident and White Terror in Fiction and Film*

Michael Berry, *A History of Pain: Literary and Cinematic Mappings of Violence in Modern China*

Alexa Huang, *Chinese Shakespeares: A Century of Cultural Exchange*

Shu-mei Shih, Chien-hsin Tsai, and Brian Bernards, editors, *Sinophone Studies: A Critical Reader*

Andrea Bachner, *Beyond Sinology: Chinese Writing and the Scripts of Culture*

Jie Li, *Shanghai Homes: Palimpsests of Private Life*

Michel Hockx, *Internet Literature in China*

TRANSPACIFIC ATTACHMENTS

*Sex Work, Media Networks,
and Affective Histories of Chineseness*

LILY WONG 翁笠

COLUMBIA UNIVERSITY PRESS
New York

Columbia University Press
Publishers Since 1893
New York Chichester, West Sussex
cup.columbia.edu

Columbia University Press wishes to express its appreciation for assistance
given by the Chiang Ching-kuo Foundation for International Scholarly Exchange
and the Council for Cultural Affairs in the publication of this series.

Library of Congress Cataloging-in-Publication Data
Names: Wong, Lily, 1983– author.
Title: Transpacific attachments : sex work, media networks, and affective
histories of Chineseness / Lily Wong.
Description: New York : Columbia University Press, 2017. | Series: Global Chinese
culture | Includes bibliographical references and index.
Identifiers: LCCN 2017022742 | ISBN 9780231183383 (cloth) |
ISBN 9780231183390 (pbk.) | ISBN 9780231544887 (e-book)
Subjects: LCSH: Prostitutes in motion pictures. | Prostitutes in literature. |
Chinese in motion pictures. | Chinese in literature. | National
characteristics, Chinese.
Classification: LCC PN1995.9.P76 W66 2017 | DDC 791.43/6538—dc23
LC record available at https://lccn.loc.gov/2017022742

Cover design: Noah Arlow

此書獻給我的父母: 翁開誠, 劉惠琴

For my parents: Kai-cheng Wong and Whei-ching Liu

CONTENTS

ILLUSTRATIONS

ACKNOWLEDGMENTS

This book would not have been possible without the inspiration, support, and advice of many. I must first thank my parents, Kai-cheng Wong 翁開誠 and Whei-ching Liu 劉惠琴. It is their lifework—as devoted parents, scholars, activists, mentors, and friends—that has inspired the central questions of this project and provided the ethical and emotional drive for me to complete it. Thanks go out to my professors at Taiwan's National Central University, who radically opened up my worldview and provided me the vocabulary for scholarly pursuit during those formative years. Special thanks to Josephine Ho, Naifei Ding, and Bingzhen Xiong, who have stirred in me concerns about culture and social justice that frame this project; An-kuo Tseng, Jerome Li, Wenchi Lin, Daniel Fried, and Steve Bradbury, whose support has been pivotal; and to Amie Parry, who has always gone above and beyond in offering invaluable advice on my scholarship as well as the navigation of academia and life in general.

I am grateful for the guidance of my many mentors at the University of California at Santa Barbara: my advisor, Michael Berry, whose formidable knowledge of Chinese film and literature, persistent encouragement, and unfailing efforts in opening up new opportunities for me throughout the years has no doubt been at the heart of this project; Suk-Young Kim, whose comprehensive, careful, and precise comments have consistently challenged me to take my scholarship to

the next level; Bhaskar Sarkar, whose acute ability to comprehend and tease out my theoretical concerns has been monumental throughout my writing and thinking process. Many thanks to Ronald Egan, Colin Gardner, Josh Kun, ann-elise lewallen, Xiaorong Li, Mireille Miller-Young, John Nathan, erin Khuê Ninh, Katherine Saltzman-Li, and Mayfair Yang, who have graciously commented on various parts of the manuscript at its many stages. Special thanks go out to Bishnupriya Ghosh, whose insights sparked the beginning of this project and continue to inspire its many developments.

My ever-inspiring students, colleagues, and friends at American University have played a pivotal role in helping me transition the project into this book form. Marië Abe, Shalini Ayyagari, and Annie Claus kept me accountable; you pushed me through those days when writing just felt impossible. I thank Fiona Brideoake, Mandy Berry, Erik Dussere, Despina Kakoudaki, Lindsey Green-Simms, Jonathan Loesberg, Jeff Middents, David Pike, Tom Ratekin, Richard Sha, and Kathleen Smith for offering generous feedback on many parts of the manuscript. I am indebted to Heather McDonald for her meticulous edits. Special thanks to Keith Leonard for his kind and patient mentorship, which continues to guide my work on and off the page.

Throughout the years I have benefited immensely from the insights of colleagues in the fields of affect studies, Asian American studies, Asian studies, comparative literature, and Sinophone studies. Alexa Alice Joubin and Michael Gibbs Hill offered invaluable advice on the manuscript and the publication process. Brian Bernards, Howard Chiang, Celina Hung, and Alvin Wong: collaborations and conversations with you on Sinophone studies have been, and continue to be, instrumental in shaping my scholarship. E. K. Tan has been a tireless mentor to many of us in the field; thank you for so kindly nurturing our conceptual worlds. Andy Chih-ming Wang, thank you for showing me that critical transpacific studies is a vital possibility. Your work and your generous feedback on mine have deeply impacted the project's developments. I am especially beholden to Andrea Bachner, whose kind mentorship and intellectual insight have inspired my work's growth at the intersection of comparative literature, critical theory, and Sinophone studies.

Select portions of this book have appeared in different forms, although they have since changed substantially: "Projecting a More Habitable Globe: Hollywood's Yellow Peril and Its Refraction onto 1930s Shanghai National Cinema," in *World Cinema and the Visual Arts*, edited by David Gallagher (London: Anthem Press, 2012), 1–17; and "Sinophone Erotohistories: The Shaw Brothers' Queering of a Transforming 'Chinese Dream' in *Ainu* Fantasies," in *Queer Sinophone Cultures*, edited by Howard Chiang and Ari Larissa Heinrich (New York: Routledge, 2014), 84–105. My thanks to Anthem Press and Routledge for permission to use these materials.

I am grateful for my editors, Jennifer Crewe, Christine Dunbar, and David Der-wei Wang, and the staff at Columbia University Press. Their expert guidance at various stages of the publication process has made this collaboration unbelievably smooth and rewarding. I am also thankful for the three anonymous referees who offered astute suggestions and took the project that extra mile.

Of course, I would not have been able to finish this book without the friendship, care, and indulgence many have extended to me. Danielle Borgia, Hyejean Chung, Niccole Coggins, Mary Garcia, Stephanie Hsia, Douglas Ishii, Rosie Kar, Mimi Khúc, Joomi Kim, Ridah Sabouni, Emily Scheines, and Kristie Soares, your warmth, strength, and energy sustain me through the many life-altering events we have shared. I am thankful for the many long conversations, often over food, with Kyle Dargan, Pei-ling Huang, Keith Leonard, Theresa Runstedtler, David Vine, Linda Voris, and Wes Yin about the world and world making. Your friendship and wit have kept me sane and grounded. Liana Chen, Yi-Jie Chen, LaTisha Hammond, Colleen Ho, Alexa Alice Joubin, Shyama Kuver, Shawn Mack, Ying-chen Peng, Amanda Phillips, Adrian Song Xiang, and Miaochun Wei, you have made DC home.

Deep appreciation goes out to Anne Marcoline, who has long been my most diligent reader, unfailing supporter, and trustworthy partner in academic life. Chrissy Lau and Nhu Le have been like sisters to me: you nurture me when I am most vulnerable, continue to broaden my horizons, and never cease to teach me about courage, justice, love, and life itself. And to my sister, Cher Wong 翁雪雁, words can't express how fortunate I feel to have you in my life. I am in awe of your strength

and creativity, so understated yet so very incredible. You know me best, and I thank you for always reminding me of what is important in life. Roary, we feel so lucky that you adopted us as your humans; you have expanded my heart in ways I would never have imagined. Finally, to my partner, spouse, and accomplice, Yan Zheng 鄭岩, whose unfailing optimism, unwavering strength, and affectionate companionship have no doubt been my life force. Without you, this book would never have taken shape. You are present on every page. You are my inspiration, my rock.

A NOTE ON TRANSLATION

All translations are mine unless otherwise noted. I have adopted the pinyin romanization system per scholarly convention in the United States, except for names or phrases that are commonly known in a different form.

TRANSPACIFIC ATTACHMENTS

INTRODUCTION

Sex Work, Media Networks, and Transpacific Histories of Affect

Xingfu 幸福 *[Happiness]*[1]

你若問我 什麼是幸福叫阮怎樣講
If you asked me what happiness is, what would I say
阮若是千金小姐 好命擱嫌不夠
If I were a rich lady, my good life wouldn't be enough
你若問我 什麼是人生叫阮怎樣回
If you asked me what life is, how would I respond
阮不是在家閨秀 幸福欲叨位找
I am not a proper lady, where am I to find happiness

啊～ 阮是野地的長春花
Ahh~ I'm a wildflower in the field
幸福是風中的蠟燭 咱要用雙手捧
Happiness is a candle in the wind; we need to protect it with both hands

啊～ 阮是野地的長春花
Ahh~ I'm a wildflower in the field
人生是暗夜的燈火 帶咱行向前
Life is the light in a dark night, guiding us forward

雖然是乎人看輕 行著這條路
Even though I have been looked down on all this way

阮嘛是飼家賺食 有什麼通見笑

I've provided food and shelter, what is there to be embarrassed
 about

紅燈路頭街巷 暗暗孤單行

I walk alone amidst the red lights and the shadows

唉喲 換來一家的吃穿

Ahh~ I've provided for my family

我的人生喲～

This is my life Ahh~

On August 23, 2014, more than two hundred mourners assembled at Guisui Park in Taipei City near the former Wenmeng Brothel 文萌樓. At the gathering, the mourners sang "Xingfu" 幸福 [Happiness] to bid farewell to the song's original singer, Li-jun 麗君. Li-jun devoted the final seventeen years of her life to advocate for sex worker rights as the deputy chair of the Collective of Sex Workers and Supporters (COSWAS) 日日春關懷互助協會, after supporting her family through sex work for the majority of her lifetime. She passed away inside the former Wenmeng Brothel. Originally built in 1925 as a low-cost brothel serving working-class clients, Wenmeng Brothel turned into an organizing hub for COSWAS activists at the height of Taiwan's sex worker rights movement in the 1990s.[2] At the time of her death Li-jun was occupying the space of the former brothel; with her body, she temporarily protected the historic structure from the real estate investors who bought the land for commercial development. In solidarity, the mourners held up their middle fingers as a symbol of defiance, Li-jun's signature protest gesture.[3]

Though Li-jun performed the song "Xingfu" on a recorded soundtrack, it was written collectively by Wenmeng Brothel sex workers and the labor rights advocacy band Black Hand Nakasi 黑手那卡西. Composed and performed by sex workers laboring in a "happiness industry," the tune poses how to attain happiness as a question that has no answer. "If you asked me what happiness is, what would I say?" asks the voice of the sex worker. "I am not a proper lady, where am I to

find happiness," the singer laments. Happiness, as expressed in the song, is an ideal unattainable for the singer, despite the fact that she or he has to perform happiness for customers as an occupation.

This disjuncture between the performance of happiness as labor and the unattainability—even unknowability—of happiness expressed in the song frames sex workers as what Sara Ahmed might call "unhappy subjects."[4] Ahmed offers a phenomenological reading of happiness as the feeling of one's identity being smoothly, cohesively, and comfortably housed within established social norms. She suggests that "claims to happiness . . . might be how social norms and ideals become affective, as if relative proximity to those norms and ideals creates happiness."[5] The feeling of happiness operates as a measurement of one's positionality in relation to social models and cultural borders. It marks moral distinctions between subjects who are and are not "worthy" according to their identity's proximity to, or cohesion with, legitimized institutions. The "unhappiness" voiced by the sex worker in the song illustrates the volatile boundaries of sociality; she or he is a subject who is not comfortably housed within sanctioned forms of community.

As a figure who distinctively marks the shifting and intersecting margins of sexual, cultural, and class structures, the sex worker as an "unhappy" subject shows happiness to be a dominating structure of feeling.[6] That is, happiness is an expression of social positionality that holds power. The figure of the sex worker also turns "unhappiness" into a potential site through which less legitimized *feelings about structures* can take shape. The figure marks the contours of comfortably institutionalized social borders; in the worker's very "unhappiness," she or he also creates alternative assemblages around shared discomfort about normalized social structures.

Such an assemblage is spurred near the end of the song "Xingfu" when the lyric's focus shifts from the unattainability of personal happiness to declarations of collective livelihood. The sex worker sings: "Even though I have been looked down on all this way / I've provided food and shelter, what is there to be embarrassed about." Here, the singer shifts the tone from lament to avowal. The music then swells into a chorus of voices that repeats these lines of affirmation:

啊～ 阮是野地的長春花
 Ahh~ I'm a wildflower in the field
人生是暗夜的燈火 帶咱行向前
 Life is the light in a dark night, guiding us forward
雖然是乎人看輕 行著這條路
 Even though I have been looked down on all this way
阮嘛是飼家賺食 有什麼通見笑
 I've provided food and shelter, what is there to be embarrassed
 about
紅燈路頭街巷 暗暗孤單行
 I walk alone amidst the red lights and the shadows
唉喲 換來一家的吃穿
 Ahh~ I've provided for my family
我的人生喲～
 This is my life Ahh~

Echoed by a chorus of disparate voices, the sex worker "I" written into the lyric is performed by an orchestrated "us." While the song begins with the individual sex worker's questioning of happiness, it ends with the chorus's resonating assertion of shared livelihood. This sentiment of a collective right to live conveyed in the lyrics is embodied through the hundreds of mourners singing near the Wenmeng Brothel two decades after the song's creation, amplifying the lingering effects of Li-jun's life's work as sex worker and activist.[7]

The writing and performance of the song "Xingfu" shows how the sex worker figure—in real life and through representation—generates movements. Li-jun's death *moved* the mourners; it motivated them to congregate at Guisui Park and sing in her memory. Li-jun's affective impact was attached to the political efficacy of her activism in Taiwan's sex worker rights movement.[8] It was then intensified by the movement's demands for sexual and labor justice, which resonate with ongoing LGBTQ rights and labor rights movements in and out of Taiwan.[9] The politico-affective engagements galvanized by Li-jun's passing must also be understood alongside the passing of another sex worker-turned-activist, Guan-jie 官姐, just eight years prior.

Organizing beside Li-jun, Guan-jie was also a leading figure in COS-WAS.[10] Together, they rallied 128 licensed sex workers to protest against Mayor Chen Shui-bian's abrupt abrogation of licensed sex work in 1997.[11] Nine years later, Guan-jie jumped off the coast of Jilong and ended her life without leaving so much as a note.[12] Much of the media linked her suicide to the Taiwanese government's heightened policing of licensed sex work, which Guanjie and the COSWAS community fought.[13] Many argued that the state's intensified management was a performance of "global progressivism"; the action seemed to position Taiwan as a leader in anti-trafficking and women's rights in East Asia at the expense of the licensed sex workers' local demands. The Taiwanese government then distinguished itself from mainland China, a nation often critiqued by international organizations for alleged human rights abuses regarding gender and sexual issues.[14] It would appear that Guan-jie's right for livelihood, like that of many other Taiwanese sex workers, was sacrificed in the state's own scramble for legitimacy on the global stage.

The politico-affective engagements driven by Li-jun's and Guan-jie's efforts—as sex workers and sex worker rights activists—raise a number of questions: How might media visibility of these sex workers' tales illuminate the boundaries of citizenship, nationalism, and internationalism that they challenged while living? How have cultural imaginations of affectively charged figures like sex workers, such as Li-jun and Guan-jie, historically produced and problematized ideas of sexual citizenship and global mobility? To what extent can the struggles and agency of sex workers be voiced through cultural productions when they are frequently the objects, not subjects, of representation? These questions compelled me to write an affective history that would recognize the impact sex workers have had on the construction of culture and community (e.g., activist coalitions, the family, the nation, the global community).

The figure of the sex worker, frequently embodying the fringes of society, elicits disdain (by marking the limits of collectivism) as well as desire (by provoking the transgression of these very limits). Within a global context, the "Chinese" sex worker, in particular, has served as

a recurrent trope; this figure uniquely signifies both Asian American sexuality and Asian modernity. Even in the case of the Taiwanese sex workers, we see the specter of "Chineseness"—or the international debates over the global positioning of "China"—affecting the workers' bodies and profession. Taiwan was expelled from the United Nations in 1971 when it was replaced by the People's Republic of China as the sole representative of China. Yet the Taiwanese government's eagerness to still comply with UN regulations (despite objections from local sex workers) reflects the state's struggle for international visibility in light of the "One China Policy."[15] Moreover, the Taiwanese government's increased regulation of sex work also functions as means to control the flow of migrant women from mainland China; it is furthered by perceptions that mainland Chinese migrants pose sexual, moral, and political threats to the Taiwanese state.[16] Thus, shifting international conceptions of "China" and/or "Chineseness" affect these Taiwanese sex workers' livelihood; they operate as particularly "sticky" forms of cultural imagination that carry considerable political salience. By historicizing the divergent ways "Chineseness" attaches to the sex worker figure, I show how representations of sex work activate forms of collective engagement often overlooked under national, ethnic, or linguistic scopes of analysis.

This book identifies shifting formations of "Chinese" attachments, or "Chineseness," through depictions of the sex worker in popular media—from literature to film to new media—that have circulated within the United States, China, and Sinophone communities from the early twentieth century to the present. Utilizing a transpacific and translingual framework, I focus on the mobility and mobilization of the figure, and read Chineseness as an affective product instead of solely an ethnic or cultural signifier. Chineseness, I argue, manifests itself as a morphing affective structure: it embodies social sentiments that reassemble categories of difference and social relations through the circulation of mass media. Detecting these assemblies through the affectively charged figure of the sex worker, Chineseness is deterritorialized from fixed, and often exclusionary, authenticity discourses. As a mobilization of emotion, affect provides the language of movement, desire, and becoming that privileges the *potentiality* of meaning over fixed

interpretive paths of signs and representation. Thus, in tracing an affective history of "Chinese" connections, I emphasize the plasticity of such social formations. An affective reading of Chineseness turns what is often considered a timelessly homogenous cultural signifier into a historically situated—and shifting—theoretical question.

By identifying a transpacific affective history through the sex worker figure, *Transpacific Attachments* offers a threefold rethinking of subject and social formation. First, it explores identity not as ethnic or cultural origins to be uncovered, but as emergent networks structured by the dissemination of desires through media.[17] In particular, the book focuses on the transpacific networks that reconfigure Chineseness beyond that of a diaspora-based paradigm. A transpacific analysis complicates and challenges a diasporic framework, which often utilizes centralizing notions of cultural authenticity and centripetal logics of "homeland" discourse. Second, by using this transpacific perspective, the book serves as a counterpoint to the rich scholarship on cultural and social formation in transatlantic studies; it recognizes the under-studied yet vital role the Asian Pacific has played in the shaping of what we consider to be "the global." Lastly, the book maintains that imaginations of a global community have long been motivated by romantic, erotic, and gendered representations; with that in mind, this book underscores the significant role sex work plays in the structuring of social relations.

Popular representations of the sex worker figure have long served as a discursive surface (a constantly re-inscribed cultural trope), as well as an affective infrastructure (characters who activate affective engagement) to mobilize imaginations of community. The book explores the figure's vital cultural work in producing and problematizing structures of collectivity, such as Chineseness. By approaching the sex worker as an affective laborer, *Transpacific Attachments* proposes a study of affect that examines the ways kinships adhere to objects of affection, surface at historical junctures, and reorient configurations of identity. As a result, the book aims to dislodge identity politics from the centrality of national, ethnic, and linguistic analysis and attach it, instead, to a transpacifically networked history of shifting affective structures.

THE WORK OF AFFECT

Affects/emotions are not simply private states of expression; they are public practices that constitute social relations. I approach affect as a politics of emotional mobilization—the power to move and be moved by others—that allows for a more flexible framework to study subject and social formation. Affect displays the workings of social meanings; it exhibits the ways conceptions operate within identifiable social structures, but also move across, push against, and even, at moments, exceed them.

For some, affect's ability to flow beyond systems of code, text, and signification is what affords it the potential of restructuring social relations.[18] Brian Massumi, for instance, argues that affect is a part of a different order of experience. It is formulated beyond given cultural or linguistic constructions. He claims that affect operates outside of the epistemological: it is the unknowable and unassimilable that remains in motion despite abstraction and interpretation. Massumi draws from Gilles Deleuze and Félix Guattari's reading of affect, which distinguishes it from privatized emotions.[19] In addition, Massumi emphasizes the autonomous fluidity of affect in comparison to emotions, arguing that affect is "irreducibly bodily and autonomic [in] nature."[20] It is a mobilization of bodily intensities that are "prior" to and autonomous from one's recognition of the personal or subjective, in relation to defined social structures. Affect precedes and/or is outside of consciousness. In contrast, emotions are the personal expressions of experience identifiable within sociolinguistically designated subject-object relations.[21] For Massumi, affects are pre-personal, visceral, and beyond signification (extratextual); emotions are personal, social, and situated within fixed interpretive paths of signs and representation (textual).[22] Massumi carves out a clear distinction between autonomous pre-subjective affects and contained subjective emotions; he also privileges the political potential of the former over the latter. In this way, affect is free from socially determined attachments; it retains the possibility of shaping the social from its exteriors. In comparison, emotions are personal expressions securely embedded in what is already socially learned.

Such claims for affect's freedom from social determinism are often contested. Critics maintain that this autonomous view of affect presumes a sense of fluidity, even universality, which too easily floods over uneven orderings of cultural, gendered, and corporeal particulars.[23] Postcolonial and feminist thinkers like Sara Ahmed, Lili Hsieh, and Clare Hemmings emphasize that individuals who are historically racialized, gendered, and sexualized *by* others are often so over-associated with affect that they themselves are the object of affective transfer. Hemmings and Ahmed both cite Audre Lorde to show this discrepancy of affective autonomy.[24] Lorde recalls a moment on the subway, as a child, when her proximity to a white woman instigated visceral responses:

> When I look up the woman is still staring at me, her nose holes and eyes huge. And suddenly I realize that there is nothing crawling up the seat between us; it is me she doesn't want her coat to touch. The fur brushes past my face as she stands with a shudder and holds on to a strap in the speeding train. . . . Something's going on here I do not understand, but I will never forget it. Her eyes. The flared nostrils.[25]

In this moment of encounter, affect is not attached randomly or openly. Lorde is, even if temporarily, overwhelmingly captured and held by the visceral responses directed at her body. In this instance, Lorde's body carries the weight of and is suffused with affect even though she, as a child, has no understanding of its social meaning. Instead of operating outside of dominant social structures, affect sustains and even strengthens it.

I revisit Lorde's encounter not as a way to claim an overpowering social determinism, but to identify the ways that affect moves inside, outside, and even inside-outside of socially constructed power relations. The work of affect here is in its processes. That is, I read affect's autonomy as a particular component—not the defining characteristic—at a specific time in a longer genealogy of affective/emotive workings. Returning to Lorde's example, Hemmings situates Lorde's encounter within a longer affective trajectory that doesn't end at the instant of

racialization. She describes an ongoing affective spiral moving "not as a series of repeated moments—body-affect-emotion—a self-contained phrase repeated in time, but as an ongoing, incrementally altering chain—body-affect-emotion-affect-body—doubling back upon the body and influencing the individual's capacity to act in the world."[26] Hemmings places Lorde's experience of racialization within an affective spiral. The moment's socially infused emotional intensity is what *activates* affective responses in the white woman and Lorde herself. In turn, the encounter *mobilizes* Lorde's desire for further reorderings of social meaning. Hemmings's idea of an ongoing affective spiral is similar to Ahmed's notion that "if some bodies become containers of affect, these containers spill."[27] Hemmings and Ahmed envision a longer and more flexible trajectory of affective and emotive workings. They conceptualize the relationship between affect and emotion as a spiraling feedback loop instead of being a linear teleology. This affect/emotion spiral at times attaches to social structures and, due to the emotional intensity accumulated through that socialized attachment, instigates affective movements that mobilize beyond it.

In examining a longer trajectory of affective and emotive workings that move in and out of social structures, *Transpacific Attachments* pushes against an affect-to-emotion logic. It also contests the common distinction between pre-subjective affects and subjective emotions; I question whether emotions are subjective or even consciously owned by the individual. Ahmed, for instance, argues that "we do not . . . always know how we feel, and that feelings do not belong or even originate with an 'I,' and only then move out towards others."[28] Emotions—similar to affects—are not transparent and cannot be reduced to personalized intentionality, even if they can be socially identifiable. Ahmed dismantles dichotomous distinctions between affect and emotion. She stresses that through the intensification of affect, bodies manifest as social texts: "What moves us, what makes us feel, is also that which holds us in place, or gives us a dwelling place. Hence movement . . . connects bodies to other bodies: attachment takes place through movement, through being moved by the proximity of others."[29] Reading neither affect nor emotions as comfortably fixated in or out of the individual or the social, Ahmed emphasizes the *processes*

through which the individual's attachment to sociality takes shape. She shifts our focus away from *what* affect is (whether it comes before or is distinguishable from emotions), to *how* social categories become affective over time.

Transpacific Attachments builds on Ahmed's analysis and understands affect to be a *mobilization* of emotion—the politics of moving and being moved by others. It bridges arguments for flow and fixity as well as extratextual and representational characteristics of affect. Affect/emotion reflects and shapes social relations; it not only represents social positionalities but also participates actively in the very processes that constitute them. I see the workings of affect to be within a spiraling, or incrementally altering, genealogy of movements and attachments that operates in and out of collectively identifiable social structures.

Chineseness, I argue, is a particularly charged form of sociality that has long been affectively mediated. Previous scholarship has investigated Chineseness largely in terms of ideological or economic projects stemming from either "the West" (Orientalism) or Chinese-speaking communities (identity politics). However, such works are often unable to address the multidirectional dissemination and transformations of Chineseness that move across and beyond national, medial, and linguistic borders. Instead, I historicize Chineseness as a form of socialized attachment that is rallied, maintained, and mediated affectively; in turn, I stress affect's activating potential over time. To approach Chineseness as an affective product allows us to think more broadly across national, ethnic, and linguistic frameworks, without losing sight of the cultural, racialized, and sexualized particulars to which emotional structures attach, manifest, and move.

On Chineseness

As a poignant signifier of collective identity, the definition of Chineseness has been a recurrent and evolving theoretical question coproduced by intersecting imaginaries across the Pacific Ocean. These makings of Chinese character have long been conceived and negotiated in affective terms.

For instance, the U.S. judicial system framed Chineseness as being external to a desirable citizen-subject. The Chinese Exclusion Acts (1875 to 1943) supported an ongoing expression of "yellow peril" that defined Chinese immigrants as biologically threatening and morally backward. Such perilous imaginaries of Chinese character worked to, on the one hand, justify the persecution of Chinese immigrants within U.S. domestic borders and, on the other hand, frame U.S. expansion abroad as a civilizing mission.[30]

Within a larger genealogy of Anglo-American and European thought, Chineseness frequently operates as a "desired other"; it signifies both the potentiality and the limits of Western conceptions of culture and aesthetics. Stephen Yao, Eric Hayot, and Yunte Huang have shown how twentieth-century avant-garde writers like Ezra Pound and Bertolt Brecht used Chineseness as a sign to develop modernist expressive strategies.[31] Additionally, Andrea Bachner argues that the Chinese script was fetishized by poststructuralist theorists, including Julia Kristeva, Jacques Derrida, Michel Foucault, and Jacques Lacan, as running counter to modern/Western forms of communication.[32] Chineseness consistently signifies a curiously desirable alternative to what are considered Western aesthetic models.

In conjunction with such Orientalist understandings, Chineseness was also formulated in Chinese-identified communities as a charged articulation of collective resistance and political sovereignty. Haiyan Lee and Lisa Rofel have focused on love and desire, respectively, to interrogate the constitution of the "Chinese nation-state" and "Chinese citizen-subjects" at different points in history. Lee delineates an emotive mapping of the relationship between the modern subject and the modern political community: "the modern subject is first and foremost a sentimental subject, and . . . the modern nation is first and foremost a community of sympathy."[33] Lee identifies how the meaning of sentimentality changed from the cult of qing during the late Qing dynasty, to an "Enlightenment structure of feeling" during the early Republican era, to what she defines as a "Revolutionary structure of feeling" under the communist state. In so doing, Lee identifies shifts in conceptions of identity and sociality that worked to transform China into a modern nation-state. Focusing on contemporary times, Rofel

states that post-Mao mainland China operates on the site of "desire," or, more specifically, the production of neoliberal "desiring subjects" with aspirations to be imagined as cosmopolitan citizens.[34] For Rofel, desire is a historically, socially, and culturally produced field of practice that traverses the post-Mao landscape. This affective structure simultaneously constructs China into a desiring nation-state and promotes it as desirable to others within a neoliberal market economy.

While Lee's and Rofel's investigations of love and desire remain within the geopolitical scope of mainland China, scholars of diasporic studies and Sinophone studies have aimed to extend investigations of Chinese identities beyond an analysis of the nation-state.[35] As a concept, "Chinese diaspora" gives rise to terminologies such as "sojourners," "Chinese descendants," and "overseas Chinese," which, as many have noted, frequently conjure affective logics of longing and nostalgia for a "Chinese motherland."[36] The evocation of "Chinese diaspora," thus, often hinges on cultural and/or national affective attachments to China as a place of origin or homeland. Such attachments make it easy to slip into China-centricism. They also frequently rally heteronormative analogies of a reproductive Chinese nation and imagine a cohesive cultural genealogy. As such, the concept of Chinese diaspora often glosses over the internal complexity as well as the continual transformations of diasporic communities.

Sinophone studies, in comparison, does not refer to an identifiable nation-state or ethnic group as its origin; it connotes a transcultural imagined community consolidated through the circulation of Sinitic language cultural production. Depending on the definition, Sinophone may exclude or include mainland China as a locus of analysis. David Der-wei Wang and Jing Tsu note: "In the case of exclusion, the priority of analysis lies with developing a critical network of minority discourses. Inclusion entails a reworking of the lineage of modern Chinese literature as a solely mainland phenomenon. Both approaches seek to dismantle the hegemonic focus of a 'national' Chinese literature and perhaps a 'national literature' at all."[37] In either definition, the concept of Sinophone highlights the instability of notions such as "China" and "Chineseness." It resituates Chineseness in relation to a larger multinodal network of Sinitic-language-speaking peoples, away from

inhabiting a monolithic center attached to a singular affective core. As Shu-mei Shih contends, Sinophone can be a site of "both a longing for and a rejection of various constructions of Chineseness; it can be a site of both nationalism of the long-distance kind, anti-China politics, or even nonrelation with China, whether real or imaginary."[38] In other words, the Sinophonic framework allows for a more expansive, even if contested, terrain of affective belonging. It recognizes differently entangled and often conflicting emotional structures that splinter the centrality of China and Chineseness.

However, Asian American studies scholars warn us of the easy conflation of critical difference if theoretical connections are drawn among the Sinophonic, the diasporic, and the Asian American too readily. For instance, Sau-ling Wong theorizes that, in much current Sinophone cultural discourse—in Chinese-dominant geographical communities and among overseas Sinophone writers—"a center is often spoken of as if it were a powerful gravitational field, made up of some unspecified and irresistible (not to be resisted) combination of the Chinese nation-state, the Chinese cultural tradition (including the Chinese language), the Chinese national literature, and the Chinese people."[39] Wong articulates a fear of Sino-centrism underlying diasporic studies' attachment to *and* Sinophone studies' detachment from China; she claims that rejecting a Sino-centric core still may assume the primacy of Chineseness as being an epicenter to dismantle. For Wong, general theorizations of migratory matrices might undo the discursive space carved out by Asian American discourse, developed since the 1960s, that critiques an American—not Chinese—center through a panethnic perspective.

Keeping in mind the tensions between the disparate and often conflicting theorizations of Chineseness outlined above, the "transpacific" becomes a particularly useful paradigm.[40] It loosens the disciplinary binds to which the respective conceptions are fixed. Recognizing the transpacific as a site of critical inquiry, in and of itself, I focus on how overlapping imaginaries of Chineseness are affectively mobilized through the Pacific Ocean's intersecting currents. With this oceanic framework, our attention moves away from the authenticity of national or cultural origins, since currents are produced collectively and through the process of contact. As Yunte Huang maintains, the

transpacific is "both a contact zone between competing geopolitical ambitions and a gap between literature and history that is riddled with distortions, half-truths, longings and affective burdens never fully resolved in the unevenly temporalized space."[41] This transpacific framework emphasizes the relationality among cultural, ideological, and affective spaces where these ideas meet, clash, and transform.

Transpacific Attachments approaches the ongoing reformulation of Chineseness as a particularly charged contact zone within transpacific ideological networks. Through these networks, affect is generated among bodies, and emotional structures take shape. The book investigates not the truth-value of Chineseness originating in any particular location (i.e., the United States, China, or Sinophonic regions), but the affective impact created by these intersecting imaginaries of Chinese character.

TRANSPACIFIC AFFECTIVE LABOR

By using a transpacific scope, I contribute to a body of scholarship focusing on the linkages and movements produced when national, ethnic, and linguistic particulars are put into contact. For example, Eric Hayot examines early twentieth-century Western imaginings of the "Chinese coolie" figure, and the ways in which the West has historically distinguished itself from and through conceptions of the Asiatic racial character.[42] Similarly, Chih-ming Wang studies the "foreign student" figure in Asian American literature as a means to identify desires for transnational belonging exchanged between Asia and America.[43] *Transpacific Attachments* also takes a transpacific scale to locate a biopolitical history of emotions. However, I underscore the uniqueness of the Chinese sex worker figure in the history of transpacific social formation: this figure distinctively illuminates the intersectional politics of racial, sexual, and class structures.

Constituting a pivotal reflection on the link between sexual and cultural marginality, the figure of the Chinese sex worker has been a central point of analysis in the study of labor and sexual citizenship. In the United States, the management of Chinese human trafficking rationalized the persecution of Chinese immigrants and U.S. expansion

abroad at the turn of the twentieth century.[44] Global interest in Chinese sex work grew as attention turned toward "women of color" and "third-world feminism" during and after the Cold War.[45] Discourses on sex work in Sinophone communities, especially Taiwan, have been central to social movements and academic scholarship that probe issues of citizenship, human rights, and globalization. Most notable would be the debates ignited by the sex worker rights movement (in which Li-jun and Guan-jie participated) between state feminists and sexual liberation activists in 1990s Taiwan, centering on issues of sex work and its relation to the state.[46]

Since discourses on the sex worker have long reflected politics of modernity, labor, and state governance, I read the figure as an "affective laborer" of history—a recurrent character who historically allows for various "feelings" in production of sociality to materialize and to be mediated. In my reading, I emphasize two things: first, the *malleability* of the figure's liminality that simultaneously generates and challenges discursive borders between bodies and the various collectivities they compose; second, the *materiality* of this labor as a production of affect exchanged through the acts of movement, friction, and inscription among bodies, histories, and disciplinary fields. By emphasizing the affective labor the Chinese sex worker figure performs, I call attention to the cultural work these figures do in mobilizing imaginaries of shared identities.

The figure of the Chinese sex worker manifests as a recurrent site through which affective flows *attach*—or, borrowing Ahmed's concepts, "stick" and "surface"—to certain social structures; they reveal the operations of power involved in the production of community.[47] As a stock character, the Chinese sex worker has provided the discursive surface on which social narratives are inscribed or represented. This figure also works as an affective infrastructure through which discourses are given the space to mediate, reinvent, and move beyond their given interpretive structures. Therefore, not only do I analyze representations of the Chinese sex worker in particular cultural texts, I examine the varied affective impacts these depictions generate through their reproduction and circulation in transpacific media networks. I investigate the ways renderings of the Chinese sex worker—as a character

who frequently embodies the borders of "collective intimacy"—simultaneously reflect, construct, and challenge Chineseness as a shifting site of communal attachment.

Movements, Attachments, and Becomings

Popular representations of the Chinese sex worker not only reshape Chineseness across worldviews but also push against such views, championed at three historical intervals at which world divisions were reimagined: the two-world system (imperialism/anti-imperialism) developed in the early twentieth century, the three-world system (first, second, third worlds) privileged during the Cold War, and the one-world system (globalization) emphasized at the turn of the twenty-first century. Despite my distinct categorization of these world systems, with an affective lens I focus on their plasticity and lingering effects. This book details encounters where Chineseness-as-affective-product transforms, and is in turn transformed by, divergent cultural-historical forces with which it comes into contact.

The three historical junctures that organize this project operate less as fixated or overdetermining signposts than as transitory bifurcation points that activate affective formations; these incipient structures are elucidated by popular renditions of the Chinese sex worker figure. First, in the early twentieth century, the figure appears as an elastic transnational character that galvanizes expressions of Chinese connectivity *across* nations, an affective structure I term "Pacific Crossing." During the Cold War era, the figure transforms into a defiant icon who *rejects* the nation-state as a centralized concept, expressing what I argue to be a particularly "Sinophonic" structure of feeling. In the neoliberal contemporary period, the figure morphs into a localizing symbol that *reterritorializes* kinships against narratives of global connectivity without signifying a dominating return of the nation or nationalism, performing an emotional structure I explain as "dwelling." The affective structures located at these historical junctures work not as separate, linear, or contradicting formations; they operate as resonating assemblies that fold over, double back, and affect each other. The three affective structures—Pacific Crossing, Sinophonic, and dwelling—are

separated from each other by dynamic thresholds rather than by distinct boundaries.

Tracing across extended time and distance—transpacific historicization—is required to identify the resonating dynamism between affective formations.[48] The book starts with the early twentieth century, when Chineseness was configured as a sign of backwardness. In particular, U.S. legal framing of Chinese women as sex workers resolved the paradoxical tension between U.S. domestic race-based exclusion and international civilizational expansion. The characterization of Chinese women *as* sex workers portrayed Chinese moral degeneracy; it also highlighted the Anglo-American discourse of biological threat that justified the domestic persecution of Chinese immigrants and U.S. civilizing expansion abroad. This imperialist narrative, which placed Chinese sex workers as stand-ins for a "diseased Chinese race," found an unlikely alliance with anti-imperial reformers in China. They positioned prostitution as another sign of Chinese national weakness, which signified the need for nationalistic reform.

Part 1 of this book, "Pacific Crossings in the Early Twentieth Century," looks closely at this transpacific deployment of Chineseness in the construction of both U.S. and Chinese national character. I identify ways in which popular representations of the Chinese sex worker uncover national paradoxes operating within an imperialist and/or anti-imperialist oppositional framework. By analyzing the transpacific mobilization of the Chinese sex worker figure, I show how "Pacific Crossing" emerges: an affective structure that, as a transnational expression of Chinese identity, uses and contests U.S. and Chinese nationalistic sentiments alike.

I identify this affective structure in chapter 1, "Desiring Across the Pacific: Transnational Contact in Early Twentieth-Century Asian/American Literature." The chapter discusses Sui Sin Far's (Edith Eaton's) *Mrs. Spring Fragrance* (1912), the first English-language short-story collection written by a North American writer of Chinese descent, as well as the first anthology of U.S. Chinatown poetry, *Songs of Gold Mountain* 金山歌集 (1911). Reading the two texts together as an early Asian American literary matrix, I show how the Chinese sex worker operates as an intertextual trope that simultaneously delineates and disturbs

polarizing imaginations of national (United States/China) and bio-ethnic (Asian American/Anglo-American/Han ethnicity) conceptions of kinships. I argue that the frequent representations of the figure activate a "Pacific Crossing," a sense of Chinese connection that rallies in order to cross polarized U.S. and Chinese nationalistic ideologies. Following this articulation of transnational belonging across Sui Sin Far and the Chinatown poets' works, I contend that this affective structure is not a rare or idiosyncratic expression but a historically situated and sustained one.

Chapter 2, "Over My Dead Body: Melodramatic Crossings of Anna May Wong and Ruan Lingyu," shows how the affective structure is further mediated through two actresses who perform the figure on the silver screen: Hollywood's first Chinese American actress, Anna May Wong, and Shanghai left-wing cinema's icon, Ruan Lingyu 阮玲玉. Comparing Wong's performance as a murderous Chinese prostitute in Paramount Pictures' *Shanghai Express* (1932) and Ruan's enactment of a "virtuous sex worker" in Lianhua Studio's *Shennü* 神女 [The goddess] (1934), I show how the two icons' "degenerate" images as sex workers create nationalistic fervor across the Pacific Ocean. Additionally, I look closely at this mass-mediated process. The heroines' popularized images also produced emotional excess that both fueled and surpassed nationalistic political use-value. The overwrought sentiments ignited by Ruan's and Wong's contending performances doubled back and rallied beyond U.S. developmentalist and Chinese reformist framings of Chinese womanhood. Such superfluous stirrings, I argue, obscured the sanctity of the "nation" as a centralizing site for collective belonging.

In part 2 of the book, "Sinophonic Liaisons During the Cold War," I display how the rupture of national fervor located in chapter 2 expanded with full force during the Cold War. This was a time when the project of Chinese nation-building itself was split along two territories: the Republic of China (ROC) aligned with NATO and the People's Republic of China (PRC) as a communist state. While part 1 of the book identifies imaginations of Chinese connection across nations through the developing affective structure of Pacific Crossing, part 2 detects ways in which this transnational expression morphs, in part, into a *rejection* of the nation-state as a predominant organizing model. In

other words, I identify the emergence of a Sinophonic affective structure that refuses "China" (either ROC or PRC) as naturalized sites for belonging during the Cold War.

Such decentering of Chineseness, or what I explain as a particularly Sinophonic expression, is explored in chapter 3, "Erotic Liaisons: Sinophonic Queering of the Shaw Brothers' Chinese Dream." The chapter discusses the Hong Kong and Singapore film studio, Shaw Brothers. It analyzes how, on the Shaw screen, the Chinese courtesan/sex worker figure morphs into a defiant icon that challenges Chinese cultural-nationalist and ethno-nationalist orthodoxy. I stress that this loosening of cultural and historical binds allows for the rise of a Sinophonic affective structure; it does not mobilize but in fact "queers" heteronormative analogies of a reproductive Chinese motherland, or a lasting patriarchal state. Sinophone and queerness become oscillating paradigms that mutually intervene and continually co-produce. The chapter investigates this dynamism with an analysis of same-sex desires enacted through the courtesan figure Ainu, across *Ainu* 愛奴 [*Intimate Confessions of a Chinese Courtesan*] (1972) and its remake, *Ainu xinzhuan* 愛奴新傳 [*Lust for Love of a Chinese Courtesan*] (1984). Ainu's performance of desire for her lover, Madam Chun, restages a queer form of intimacy—what I term "Sinophonic liaisons"—that rejects a heteronormative progression of home, family, and nation. Sinophonic liaisons, I argue, manifest as a queer affective structure; the structure conveys expressions of collectivity that are not loyal to China as a nation-state, or to Chineseness as a cohesive cultural ideal.

Chapter 4, "Offense to the Ear: Hearing the Sinophonic in Wang Zhenhe's *Rose, Rose, I Love You*," investigates how the Sinophonic affective structure operates in Taiwan, a region stripped of its nation-state status by its former Cold War NATO allies. While much of Cold War–era Taiwanese literature uses the metaphor of "Taiwan as prostitute" to depict the island's exploited status, the chapter focuses on Wang Zhenhe's 王禎和 use of the trope in his last novel, *Meigui meigui wo ai ni* 玫瑰玫瑰我愛你 [*Rose, Rose, I Love You*] (1984). Wang's prostitute figures talk back to the governing authorities using a broad range of "unauthorized" languages (e.g., unofficial dialects, curse words, and inscrutable grunts), articulating a Sinophonic expression that disorders clear

analogies of both a reproductive Chinese motherland and a nativist Taiwanese state. Wang's evocation of this Sinophonic affective structure is amplified by his choice to close the tale with the song "Rose, Rose, I Love You," which the sex workers are scripted to sing. The transpacific, translingual, and transmedial mutations of the song expand and morph the Sinophonic expressions depicted in Wang's novel. I maintain that Wang's *Rose, Rose, I Love You* and the eponymous song echo beyond sheer rejection of Chinese orthodoxy; together, they call for a more capacious, transnational ear that hears minor (less legitimized chords) of global connectivity at the end of the Cold War.

Part 3 of the book, "Dwelling Desires and the Neoliberal Order," answers Wang Zhenghe's call for a "minor transnational" comprehension of collectivity. The Sinophonic affective structure identified in the Cold War era reassembles into an expression that localizes "Chinese" identity against global economic flows, without conveying a dominant return of nationalism. Chineseness becomes an affective structure that simultaneously breaks apart the centrality of the nation-state and suspends the pace of globally marketized exchange: it is an affective structure that "dwells." Using "dwelling" as a paradigm, I refer to both the structural and affective registers of the term. Structurally, the concept ties in with ideas of home, house, and residence. Affectively, it alludes to excessive attachments to memories. I see dwelling not as a rooted relation between self and one's place of residence, but as a relationship between place and identity that is persistently volatile and reworked. Dwelling contests neoliberal logics of progress and upward mobility often used to depict China as a "rising global power"; Chineseness operates, instead, as a continually reused affective interface on which neoliberal desires attach.

In chapter 5, I locate this "dwelling" affective structure by analyzing mainland China-born, yet transnationally trafficked, immigrant brides depicted in two films: the Taiwanese feature film *Di si zhang hua* 第四張畫 [*The Fourth Portrait*] (2014), and the Asian American documentary *Seeking Asian Female: A Documentary* (2012). I expand the definition of sex work beyond the occupation of prostitution, and focus on the labors these two heroines undertake as they exchange their bodies in order to enter state-sanctioned family institutions in Taiwan and the

United States, respectively. I demonstrate the ways Chineseness is packaged through the heroines' bodies as a reusable site on which they center their identities against the flows of transnational capital, without generating a heteronormative analogy of reproductive nationalism for their host countries. *The Fourth Portrait* and *Seeking Asian Female* are juxtaposed under the affective structure of dwelling, which, in turn, highlights minor forms of subject and community creation. I show how dwelling expressions of Chineseness are reused by the films' new immigrant/sex worker figures. As a suspended affective structure, dwelling allows for a more entangled mapping of sociality and individual agency that stalls, and potentially redirects, the flow of neoliberal capital.

Therefore, dwelling as an affective structure echoes, but is unlike, the transnational affective structure of Pacific Crossing identified in the early twentieth century (part 1). While Pacific Crossing is galvanized through competing nationalisms, dwelling as a structure of feeling is detached from the nation-state and disinterested in discourses of cultural and national authenticity. Dwelling emphasizes how recursive and entwined intimacies challenge the centrality of both a nation-state (similar to the Sinophonic affective structure in part 2) and a globalized marketized exchange in a neoliberal age.

In tracing the affective politics of the sex worker figure in transpacific cultural production, I use affect as a critical lens to detect emergent processes of community formation. *Transpacific Attachments* does not merely denaturalize Chineseness, it underscores the relational pulls among disparate bodies, histories, and places that allow for it to take shape, highlighting its plasticity and sociality. That is, I show Chineseness to be an affective form coproduced among unevenly marked subjects, incrementally altering through the ever-divergent process of movement, attachments, and becomings.

PART I

PACIFIC CROSSINGS IN THE EARLY TWENTIETH CENTURY

1

DESIRING ACROSS THE PACIFIC

Transnational Contact in Early Twentieth-Century

Asian/American Literature

A t the turn of the twentieth century, "Chineseness"—conceptions of Chinese character—obtained particular significance within the global imaginary. The European colonial powers' "scramble for Africa" was drawing to a close at this historical moment, and China was acquiring a mythic status for imperial powers. It was not only the last stretch of territory yet to be directly colonized, but also a high civilization that, if colonized, would signify the colonizing nation's rise in global influence.[1] The emergence of the United States as a world power at this time was arguably choreographed on the Pacific stage, particularly in its neocolonial involvement in China.[2] Differentiating itself from previous forms of European colonialism grounded in occupying territories, U.S. expansion into China operated as nonterritorial economic diplomacy (what came to be called the Open Door policy). This new, more "benevolent" model of imperial expansion sought the benefits of economic dominance without the burden of political governance. The United States' rise as an imperial power at this time heralded a neocolonial paradigm of "corporate reconstruction" that operated through economic expansion without the responsibility of colonies.[3]

U.S. involvement in China was conditioned by not only imperial desires for global influence but also U.S. domestic need for transnational labor during post-emancipation industrialized nation building.[4] The Chinese people were thus positioned as a "desired other": on the one

hand, they provided cheap labor essential to U.S. consolidation of do-
mestic borders; on the other hand, they illuminated a uniquely "be-
nevolent" sense of U.S. national character distinct from the aggression
of European colonial powers.

This positioning of Chinese character as that of a "desired other" in
service for U.S. empire- and nation-building can be clearly seen in the
popular representation of Chinese laborers as "yellow slaves." The la-
borers' vast migration over U.S. borders presented a civilizational
threat to the liberties of Anglo-Saxon Americans and testified to the
global influence of American exceptionalism.[5] As Yu-fang Cho argues,
it is at this historical juncture that " 'whiteness' was becoming the dom-
inant racial norm in the United States as its Anglo-Saxon foundation
coalesced with other 'assimilable' European immigrant ethnicities,
Chinese workers, albeit once indispensable to U.S. capital, would now
become the 'yellow slave': unfree and feminized laborers who under-
mine white workingmen's ownership of their 'free' labor."[6] Chinese labor
was framed as a useful substitute for a waning system of slavery as well
as a threat to white American men's wages. The perception of "yellow
slavery" triangulated previous constructions of black slave labor and
white wage labor, creating a new unassimilable outer limit for U.S.
citizenship that threatened the supposedly emancipated, benevolent
core of American character.[7] When the United States implemented the
Chinese Exclusion Acts from 1882 to 1943, it solidified the legal designa-
tion of Chinese immigrants as "aliens ineligible for citizenship."[8] Doing
so illuminated the paradoxical need for the United States to exploit
Chinese labor during industrialization and, at the same time, retain an
Anglo-Saxon-centered exceptionalism for imperial expansion.[9]

Anti-trafficking laws that targeted Chinese female immigrants dur-
ing this time resolved this paradoxical tension between domestic
race-based exclusion and international civilizational expansion.[10] By
characterizing all Chinese immigrant women as unfree sexual labor,
the United States showed Chinese moral degeneracy, but also high-
lighted the Anglo-American discourse of "biological threat."[11] In such
a legal framework, prostitution was positioned as a uniquely "Chinese"
problem that was tied to age-old feudalism and Confucian patriar-
chy.[12] The legalized policing of Chinese female bodies justified both

anti-Chinese "yellow peril" discourse and U.S. civilizing rescue narratives of imperial expansion into Asia.[13] Cho notes, "perhaps as an even more glaring example of unfree labor than Chinese coolies and a symbol of moral degeneracy, Chinese prostitution epitomized the antithesis to the founding values of the United States—an immoral 'alien' practice that posed an imminent threat to the nation's morals, hygiene, racial purity, and freedom."[14] As a result of yellow peril discourse, Chinese women were barred from entering the United States in the name of anti-trafficking, which prevented Chinese nuclear families from forming and settling in the United States until the mid-twentieth century.[15] Additionally, such legalized exclusion of Chinese women popularized American representations of them as degrading figures that could potentially debase white manhood and, as such, threaten the health of the United States' social body as a modern nation and imperial power.

This imperialist narrative, which placed Chinese sex workers as stand-ins for a "diseased Chinese race," found an unlikely alliance with anti-imperial reformers in China, who positioned prostitution as a sign of Chinese national weakness.[16] To the reformers, Chinese prostitution was living proof of a "backward" feudalistic and patriarchal system that allowed for the degradation of Chinese women. Gail Hershatter notes that to many reformers because China "mistreated 'its women' (a formulation that figured China as male), [it] was in turn treated like a woman by stronger nations: subordinated, humiliated, with pieces of its territory occupied by force, rights to its use bought and sold with impunity."[17] Here, early republican reformers' framing of prostitution as a reflection of Chinese feudal ills illuminates the ways they imagined Chineseness as barring China from modern progress. Leading figure Chen Duxiu 陳獨秀 argues in his now-iconic essay, "Call to Youth":

> Now our country still has not awakened from its long dream and isolates itself by going down the old rut. . . . All our traditional ethics, law, scholarship, rites and customs are survivals of feudalism. When compared with the achievement of the white race, there is a difference of a thousand years in thought, although we live in the same period.[18]

In the face of intensifying foreign aggression, Chen's vision for China's nation building had, at its center, a Social Darwinist logic that placed the "white race" at the forefront of modern development. Chineseness, or in Chen's words, "traditional ethics, law, scholarship, rites and customs," is characterized within this developmentalist framework to be a feudalistic deterrent to modern progress.

Curiously, Chen's naturalizing of "Chinese backwardness" echoes the yellow peril discourse that justified the exclusion of Chinese immigrants on American shores. This convergence of U.S. imperial narratives of yellow peril and Chinese nationalistic discourse of backwardness is akin to what Partha Chatterjee terms the "liberal dilemma" of Eastern nationalisms, which contradictorily "measure[s] the backwardness of their nations in terms of certain global standards set by the advanced nations of Western Europe."[19] To Chatterjee, these forms of non-Western nationalisms become simultaneously imitative and hostile to the models they imitate. Ancestral ways are, in turn, seen as obstacles to modern progress, yet also markers of identity. We can therefore identify a deep paradox in the conceptualization of Chinese character mobilized across the Pacific: Chineseness was evoked to implicate imperial management of power as well as liberatory mobilizations for resistance at this high moment of U.S. and Chinese nation building.

In this chapter I look closely at this transpacific deployment of Chineseness through the figure of the "Chinese sex worker" in the construction of both U.S. and Chinese national character. I trace how the figure works as a symbol that illuminates national paradoxes that operate within an imperialist and/or anti-imperialist oppositional framework; more importantly, I explore the figure as a site of transnational contact that, in its oppositionality, generates modes of transgression that breach the exact cultural-nationalist narratives that the figure mobilizes.

My transnational, particularly transpacific, reading of Chineseness through the Chinese sex worker figure draws from David Palumbo-Liu's theorization of "Asian/American." Palumbo-Liu shows that the idea of "Asian/American" illuminates "a history of persistent reconfigurations and transgressions of the Asian/American 'split,' designated . . . by a

solidus that signals those instances in which a liaison between 'Asian' and 'American,' a *sliding over* between two seemingly separate terms, is constituted."[20] To Palumbo-Liu, the intervening slash in "Asian/ American" stresses the transgressive slippages between what is considered "Asian" and what is considered "American." It emphasizes the potency of that transgression in generating a critical space that is interconnected yet unstable.

Building on Palumbo-Liu's concept of Asian/American, I demonstrate the usefulness of cultural-nationalist narratives of China and Chineseness in generating the intervening slash Palumbo-Liu focuses on. I acknowledge the utility of national delineations of identity without disregarding the transgressive potential of crossing them. The passage of Chinese Exclusion Laws is arguably what made some Chinese migrants identify as not merely unmarked sojourners but as aspiring "Chinese Americans."[21] It is precisely the limits of mobility Chinese laborers experienced once they crossed over U.S. borders—limits either to moving upward socially in the United States or to move horizontally to head home to China—that instigated the need to view cultural-nationalism, both Chineseness and Americanism, as necessary categories of identity that were not just in opposition, but in want of transgression. In other words, the increasing exclusivity of national borders at this historical juncture necessitated a transnational articulation of subjectivity in cultural-nationalist terms.

In focusing on the relationality of exclusion and transgression, my use of "transnational" in this chapter signifies a border crossing between nations as well as the affective impact of intersecting nationalistic imaginations. Such physical and affective transgressions-via-limitations, I argue, create a third space of Chinese collectivity that is often overlooked by readings of Chineseness that either rest strictly within nationalistic scopes or are quick to dismantle nationalism as a mode of analysis. This transnational formation of Chineseness, which intervenes in the very cultural-nationalist narratives it mobilizes, can be detected most clearly through an affective lens. To be precise, using an affective viewpoint, I read articulations of emotion not merely as private states of expression, but as public practices that reconfigure imaginations of social order as well as the individual's relation to such

imaginations. Consequently, by comprehending this third space of Chinese identity formation as an affective structure, I pay attention not to the truth-value of Chineseness originating in any given territory (i.e., America or China), but the expressions of collective identity *across* these territories when intersecting imaginaries of nation building come into contact.

To visualize this transnational expression of Chinese belonging, I focus on literary representations of the Chinese sex worker in works about and by Chinese immigrants who traverse U.S. and Chinese borders. I discuss two works: Sui Sin Far's (Edith Maude Eaton) short story collection *Mrs. Spring Fragrance* (1912), one of the first works of fiction in English by a North American writer of Chinese descent; and the first anthology of U.S. Chinatown poetry, *Songs of Gold Mountain* 金山歌集. Both works have been regarded as precursors of Asian American literature. Yet, they have seldom been studied together, given that they were originally written in different languages (*Mrs. Spring Fragrance* in English and *Songs* in Cantonese) and in a variety of locations (spanning the United States, Canada, Mexico, and Jamaica).

Analyzing the two works together as an early twentieth-century Asian/American literary matrix, I trace how the figure of the Chinese sex worker serves as an intertextual site of affective mobilization. As detailed above, representations of the Chinese sex worker galvanized collective feelings about Chinese character in the United States and in China—whether it was threat or pity in the Anglo-American yellow peril imagination, or humiliation and patriotism in the eyes of Chinese reformists. Under Far and the Chinatown poets' pens, however, the figure expresses a mode of Chinese identity that utilizes yet intervenes in these polarizing sentiments, an affective structure I term "Pacific Crossing": a transnational expression of Chinese identity that mobilizes as it breaches U.S. and Chinese nationalistic sentiments.[22] By tracing this emergent structure of feeling through literary representations of the Chinese sex worker in these writings, I identify undertheorized expressions of Chinese collectivity that cut across, as they reorder, imperialist and anti-imperialist desires for the continental (Asia/Americas), the national (United States/China), and the racial-ethnic (Anglo-American-centered whiteness/Han-centric Chineseness).

MRS. SPRING FRAGRANCE

Sui Sin Far's (Edith Maude Eaton) *Mrs. Spring Fragrance* is referred to as the first English-language fiction anthology written by a North American author of Chinese descent. Far's literary significance is usually presented within the contexts of Asian American literature and early twentieth-century American women's literature.[23] For instance, Annette White-Parks argues for Far's pioneering place within the Chinese North American women writer's tradition, positioning her as the "foremother to the women writers of Chinese ancestry . . . to whom such contemporary writers as Maxine Hong Kingston and Amy Tan look for roots."[24] The language of "foremother" and "roots" highlights the importance of cultural origins and, by extension, a clearly delineated ethnic lineage.[25] Yet one can detect a certain destabilizing of racial and ideological rigidity in Far's life and work.[26]

Her stories came out of her experience traversing U.S., Canadian, Mexican, and Jamaican borders. Her crossing of physical borders involved not only her travels across national territories but also her navigation of racial boundaries.[27] While all of her siblings were of English and Chinese heritage, they were frequently racialized as "white."[28] Far, however, chose to identify with her Chinese heritage. Drawing from Amy Ling's study of Far, White-Parks argues that "Sui Sin Far's choice not to deny her Chinese heritage is a key difference [from her siblings]. . . . Recognition that such choices were available *and* that Sui Sin Far chose as she did must be central to any effort to understand Sui Sin Far's writing."[29] This management of racial identity *despite* physicality is reflected in Far's choice to write under her childhood pet name Sui Sin Far, an act that highlighted her Chinese heritage and distinguished her from the English identity and name (Eaton) that most of her family maintained.[30]

As she writes in her memoir, "Leaves from the Mental Portfolio of an Eurasian," her choice to identify as Chinese was the result of racialized provocation. She recollects how she was mistreated as a child when people learned of her mixed-race heritage: " 'I'd rather be Chinese than anything else in the world,' I screamed. They pull my hair, they tear my clothes, they scratch my face, and all but lame my brother; but the

white blood in our veins fights valiantly for the Chinese half of us."[31] Claiming Chineseness, or to be "Chinese [rather] than anything else in the world," was a result of Far having been physically (pulling of hair, tearing of clothes, and scratching of face) and, perhaps more importantly, emotionally crossed. Here, Chineseness emerges as an affective structure that, in Far's reclaiming of Chinese value against whiteness, can reframe identity beyond the physical and visual. It is a mode of identification that not just permeates her "veins"; it also allows for a bio-ethnically defined imagination of selfhood (having separate white and Chinese blood veins) to cross and override the visual "reality" of her Eurasian appearance.

Further breaching visual limits of the physical, Far declares her Chineseness through dreams. She states, "I dream dreams of being great and noble . . . I glory in the idea of dying at the stake and a great genie arising from the flames and declaring to those who have scorned us: 'Behold, how great and glorious and noble are the Chinese people!' . . . I am small, but my feelings are big—and great is my vanity."[32] Transgressing physical reality, she imagines herself crossing over as a "great genie" that proclaims Chineseness with pride. As she dreams of becoming the glorious martyr of a Chinese cause, the Chineseness she longs to embody is ignited by her experience of being scorned, or emotionally crossed. The Chineseness she stands for is not of biophysical authenticity but affective potentiality: "I am small, but my feelings are big—and great is my vanity." Chineseness, here, transforms from a signifier of cultural and ethnic origin into an affective structure that crosses—through her big feelings and great vanity—biophysical borders.

Far's articulation of a Chinese longing reorders an expression of self and sociality that destabilizes biophysical and ethnic fixity and crosses geopolitical precincts. She writes:

So I roam backward and forward across the continent. When I am East, my heart is West. When I am West, my heart is East. Before long I hope to be in China. As my life began in my father's country it may end in my mother's. . . . "You are you, and I am I," says Confucius. I give my right hand to the Occidentals and my left to the Orientals,

hoping that between them they will not utterly destroy the insignificant "connecting link."[33]

First clearly delineating between her father's country in the West and her mother's country in the East, Far utilizes this polarized imagination of geopolitical difference to express her desire to transgress it. While she states, "When I am East, my heart is West. When I am West, my heart is East," her identity emerges through the oppositional identification of "East" and "West," which polarization generates an affective linkage that crosses between them. It is precisely her creation of an East-West binary that allows her to bridge the affectual space and breach such poles through her roaming heart. Framing the Confucian quote, "You are you and I am I," as core to this "connecting link," Sui Sin Far uses this cultural-nationalistic symbol of Chineseness to articulate Pacific Crossing: a structure of belonging that contravenes the very cultural-nationalism it mobilizes.

Sex Worker as Affective Crosser

Such Pacific Crossing emerges clearly through Far's portrayals of sex workers. As mentioned earlier in the chapter, this figure was a stock character in American and Chinese public discourses of the time. Paola Zamperini, for instance, argues that the particular figure of the courtesan, as a high-class entertainer/sex worker, has a long history of providing Chinese literature with artistic stimulus.[34] Zamperini argues,

> The courtesan, by virtue of her multiple bodily locations, could never become a permanent *neiren* [inner person, or wife]. Rather, she is always a *wairen* [outsider], who, by virtue of her social class, lives outside the domestic realm of wifehood and motherhood but who . . . is not entitled to fully occupy the outside world where men of different social classes interact. So she is located at the margins of *nei* [interior] and *wai* [exterior] but not in a static fashion . . . the courtesan moves in the space in-between, she is in constant *transit: transgenderal, transpatial, transgressive.*[35]

As a character that "moves in the space in-between" and is in "constant transit," the courtesan figure opens up an errant space on the borders of sociality, or, in Zamperini's words, "the margins of *nei* [interior] and *wai* [exterior]." The figure's liminality on the fringes of class and cultural borders demarcates the "domestic" in both the national and familial sense, as well as its transgression.

Within the context of "Asian/American" literature, the figure of the sex worker can be similarly read as an agent that disturbs understandings of domesticity attached to, and across, conceptions of "Asia" and "America." This destabilizing potential is reflected in Sui Sin Far's literary universe. Under Far's pen, the sex workers (referred to as "sing song girls" in the text) are one of the most defining characteristics of the "Asia within America," or American Chinatowns. Pau Lin, the heroine in Far's short story "The Wisdom of the New," observes, "The American Chinatown held a strange fascination. . . . The sing-song voices of girls whom respectable merchants' wives shudder to name, were calling to one another from high balconies up shadowy alleys."[36] Depicted as an integral part of Chinatown, the sing song girls' voices mark vying domestic boundaries, of America, Asian America, or the Confucian family structure. At the same time, the sing song girls cause respectable wives, supposedly secure in their place within Chinese and American national frameworks and within the Confucian family structure, to "shudder to name" due to their ability to stir "strange fascination" from their onlookers and potentially pierce those borders.

Framed as transgressive characters who, borrowing Zamperini's phrasing, "[move] in the space in-between" and are in "constant transit," the sex workers in Far's work embody domestic boundaries and their penetrability, as well.[37] As such, they work as one of the most distinct discursive interfaces through which the affective structure of Pacific Crossing surfaces. A good example can be found in Far's short story "Lin John," a tale about a brother who longs to release his sister from prostitution with the bag of gold he's saved up over three years of laboring in the United States. The narrator notes, "A sense of duty done led him to dream of the To-Come. . . . he might be able to establish a little business and send his sister to their parents in China to live

like an honest woman."[38] Lin John's "China" represents a potential site through which his sister is to ascend in class—from that of a sex worker positioned outside of the Confucian family structure in America to that of an "honest woman" entering into one alongside their parents in China. China is here imagined to be a destination that could prompt the crossing of class confines.

Yet, it is precisely Lin John's positioning of China as a site for social respectability that prods his sister to reject it. She forsakes the possibility of becoming an honest Chinese woman by stealing his money, buying herself a sealskin sacque, and choosing to remain a sex worker in America. She explains: "Now, what do I want to be free for? To be poor? To have no one to buy me good dinners and pretty things—to be gay no more? Lin John meant well, but he knows little. As to me, I wanted a sealskin sacque like the fine American ladies."[39] Pushing back against Lin John's wish for her vertical mobility along a Confucian hierarchy, the sister expresses her need for more horizontally enabled cultural crossings from that of a "Chinese" beauty to that of an "American" lady. She betrays Lin John's fidelity toward China and the Confucian family structure it promises in his imagination. Instead, she utilizes what she deems "American" forms of being—an economy of "good dinners," "pretty things," and "sealskin sacques"—to break the cultural-nationally framed attachments—family loyalty, Confucian hierarchy, or Chinese "origins"—she is expected to bear. The siblings' distinctive cultural framing, which designates China to be a site for Confucian respectability and America a destination for debauchery, set the stage for the sister's performance of identity as a Chinese beauty akin to American ladies, against and across such seemingly polarized cultural and class borders.

This transgression of cultural-nationalist fidelity through the sex worker figure's chosen degeneracy is further complicated in Far's short story "The Sing Song Woman." It is a tale about Ah Oi, a sing song girl who helps her friend Mag-gee escape an arranged marriage to a Chinese man. To Mag-gee, who is half-English and half-Chinese by blood, her worst fear is "going away forever to live in China."[40] She refuses to become a Chinese woman through marriage and proclaims

that she "never could put up with a Chinaman."[41] It is the finality of China being a permanent destination, and the inevitability of Chinese intimacy through marriage, that scares Mag-gee. Within her imagination, Chinamen are incompatible with her character, and, ultimately, China operates as a dreaded land that forecloses her future.

While Mag-gee rejects China and Chineseness, Ah Oi longs for China and sees this marriage with a Chinaman as an opportunity to return to her self-proclaimed motherland. To fulfill their disparate desires, one for and the other against China and Chineseness, they enact a crossing of identities. Ah Oi disguises herself as the bride in Mag-gee's place. However, the girls' "wife-swapping" performance provokes strong emotions from onlookers: "'The Sing Song Woman! The Sing Song Woman!' It was a wild cry of anger and surprise . . . for the unveiled, brilliantly clothed little figure standing in the middle of the room was not the bride who was to have been; but Ah Oi, the actress, the Sing Song Woman."[42] Ah Oi's charade aggravates her onlookers, as she elicits "a wild cry of anger and surprise." Such sentiment is provoked by the contortion of expectation: the seemingly flippant transference of the "bride who was to have been" to the sing song woman that "should not be." Due to the two women's polarized desire for and against China and Chineseness, the plot is put into motion as Ah Oi's act of transgression intercepts Mag-gee's arranged marriage to a Chinese man and destined travel to China.

Ah Oi's longing for China prompts her to disrupt the characters', their onlookers', and the readers' devotion to the "domestic" arranged at the beginning of the tale. This troubling of domestic expectations is further emphasized when the groom himself displaces his affection from Mag-gee to Ah Oi. He senses that "a little tenderness crept into his heart for the girl towards whom so much bitterness was evinced."[43] It is Ah Oi's act of physically and emotionally crossing—physically disguising herself as his bride and emotionally evoking bitterness from her onlookers—that stirs the groom's affection, leading him to claim her as his legitimate wife at the end of the tale. In turn, Ah Oi is allowed to cross over from being an illegal sing song girl on the fringe of national and familial borders to being an "honest woman" en route to

China with her husband. Ah Oi moves from outside to inside the domestic sphere of the Confucian family; she also gives herself the mobility to travel across the Pacific Ocean toward the China she yearns for.

With the examples of "Lin John" and "The Sing Song Woman," Far depicts the sex worker as a unique affective laborer who enables conceptions of identity (e.g., the sister's reconfigured attachment away from the Confucian family to imaginations of American ladies in "Lin John," and Ah Oi's swapped marriage to her husband prompted by her desire to return to China) that destabilize, even dismantle, what seem, in the beginning of her tales, fixed notions of class, cultural, and national borders. Far's sex workers can perform such transgressions precisely because of the affective potential they embody. In their marginal position, the figures define the outside contours of domestic borders and signify the borders' penetrability. This echoes Far's articulation of Chineseness as an affective structure that relies on, as it bends across, dominant narratives of biophysical and national differences. That is to say, Far's depiction of Chineseness, through the desiring and desirable figure of the sex worker, articulates a longing to reconfigure a "we" that relies upon distinct imaginations of cultural-national borders in order to envision their crossing.

Such a transnational structure of belonging extends beyond Far's literary universe. It emerges, also, through depictions of the sex worker in the first U.S. Chinatown poetry anthology: *Songs of Gold Mountain*. While I use Far's *Mrs. Spring Fragrance* as an example to unpack the mobilizing implications of "Pacific Crossing" as a transitory affective structure, I turn to *Songs of Gold Mountain*—a collective poetry compilation of anonymous immigrant writers—to trace this pattern of belonging's impact, more broadly, as a shared narrative trope. Put differently, I trace the ways in which repetitive, or even formulaic, portrayals of Chinese sex workers allow for the immigrant writers to express a third space of identity formation that crosses U.S. and Chinese national borders. Moreover, by tracking the depiction of this cross-Pacific affective structure from fiction to folk rhymes, we see how it provides expansive routes for the expression of Chinese identity that can traverse the borders between literary and social reality.

SONGS OF GOLD MOUNTAIN

Songs of Gold Mountain is a Cantonese poetry anthology that was published in two parts by the San Francisco Chinatown's literary community (1911, 1915) and was circulated among U.S. Chinatowns and China.[44] First published around the same time as Sui Sin Far's *Mrs. Spring Fragrance*, the collection is considered the earliest published poetry that articulated the immigrant experience by and for Chinese immigrants. Peter Kvidera states that "the aesthetic that the . . . Chinatown writers developed allowed them to imagine a Chinese position in the United States that ideally, if not materially, defied legal definitions remaining otherwise beyond their control."[45] In other words, the publication and circulation of these folk rhymes turned the Chinatown writers' legally inscribed absence into a literary presence. The speaker of poem #88 contemplates:

多年羈旅館。遊子志難安。
悠悠我念故田園。兩地情牽腸欲斷。
掛心肝。囊空常抱悶。
徒然夢裡回鄉轉。誰知身尚在金門。

Held stranded many years in a travelers' lodge,
The sojourner harbors a restless mind.
With prolonged anxiety, I remember the fields and gardens
 back at home:
A lingering emotion spans the two continents, and my heart
 is nearly broken.
Mind and soul are full of worry.
An empty purse always depresses me.
Suddenly, in a dream, I'm back in the village;
But alas, my body still remains in the Golden Gate![46]

The speaker articulates a concept of selfhood that decouples his mind and body as they extend across the Pacific Ocean, for he dreams of "the fields and gardens back at home" in China while inhabiting a body that "remains in the Golden Gate" in America.[47] Similar to Sui

Sin Far's transnational expression of her heart "roam[ing] backward and forward" between East and West, the speaker in this poem also conveys a cross-Pacific sense of identity extended by his heart, which "spans the two continents."[48] Like Far, the narrator expresses a sense of immigrant personhood that depends on a polarized imagination of China and the United States. This split correlates to that between one's body and mind, generating an affective linkage that bends across national and physical poles. "China" in this poem serves as a desired destination that, in its unattainability, allows the speaker to articulate a clear critique of the American soil on which he is "stranded." Therefore, between the Chinatown poet and Sui Sin Far, we can detect a shared expression of Chinese identity that hinges on the imagination of distinctive cultural-national difference that it transgresses.

The transnational imagining of China and Chineseness in *Songs of Gold Mountain* is particularly pronounced through narrations of sexual desire. Kvidera notes that "bawdiness constitutes an important part of these poems, and in fact, the anonymous authorship evidently made the poets more daring in addressing such topics as sexual longing for wives left in China as well as desires for prostitutes found abroad."[49] It is precisely through the collective anonymity allowed by this literary platform that "bawdy" narratives of desire surface. Such depictions of sexual desire emerge as pivotal sites through which to reformulate not just individual immigrants' relationship with each other, but "immigrant self's" attachment to a shifting "we," or, in this case, Chineseness.

A case in point would be the many poems that express immigrant men's sexual desire for their wives in China, which Hom collects under the title of "Nuptial Rhapsodies."[50] In these folk rhymes about nuptial bliss, the immigrant writers act out their sexual and marital fantasies through writing. This literary "sublimation" becomes a substitute for the physical unions that cannot be achieved in reality due to the physical distance from their wives left in China, and the legal and racial structures emasculating these immigrant writers. Fantasies of domestic union are inscribed into presence, made possible only through the page. Poem #153 articulates this desire:

人生歡喜事。最好桃夭賦。
青年夫婦結絲羅。一對鴛鴦交頸臥。
眼顧顧。未慣雲雨露。
欲就還推神飛舞。嬌娘才子樂如何。

Of all the joys in life,
The happiest is the nuptial hymn.
A young couple, man and wife, consummate their conjugal tie.
A pair of lovebirds, sleeping together, necks entwined.
Eyes meet—
Neither is accustomed to the dew of clouds and rain.
She is willing, yet shy; his spirit soars and dances.
A handsome man with a charming woman, O, what would that joy be
 like?[51]

For the narrator, the height of happiness is a consummated marriage; joy specifically emerges through a conjugal tie. What is here stressed is a particular conception of intimacy legitimate within a Confucian structure of respectability: the reproductive family. This emphasis on heteronormative nuptial desire echoes what Haiyan Lee terms a "Confucian structure of feeling": intimacy created according to Confucian social order, particularly through the expression of devotion toward the patriarchal family and patrilineal continuity.[52] Many of these compositions securely frame the act of sexual union within the Confucian domestic sphere. They articulate a clear desire for a son to result from such a blissful union, presenting sexual acts as what drives Confucian ethics of patrilineal continuity.[53]

However, despite the poems' expression of what seems to be a Confucian structure of feeling, the poems are articulated within a drastically different social context. Unlike Lee's analysis, which refers directly to a Chinese national structure—where such sentiments are not only pervasive but institutionalized—the Confucian structure of feeling is, in an American context, a site of *impossibility* for these immigrant writers. Or, as seen in the closing lines of poem #153, "O, what would that joy be like?" the narrator laments his yearnings for this unattainable joy. The Confucian structure of feeling expressed here

crosses beyond the Chinese nation-state and transforms into a transgressive form of belonging not allowed within American precincts. Put differently, as the Confucian structure of feeling travels from a Chinese to American context, it morphs from a devotional attachment to social order within the Chinese nation to a defiant desire for personhood (as a desirable, masculine, and reproductive self) denied by the U.S. legal structure.

This transformation of a Confucian structure of feeling—from devotion within the Chinese national structure to transgression on the American shore—is further emphasized in the many poems that communicate not merely the impossibility of nuptial union but also the *permeability* of this Confucian imagination. This is expressed in poem #164:

作客羈北美。行樂勿拋棄。
花旗女子極標緻。及早當嘗白種味。
肯投機。與他同夢寐。
若負青春佳景地。有錢歸國再難期。

We're guests stranded in North America;
Must we also give up the fun in life?
Girls of the Flowery Flag Nation, all superbly beautiful and
　　charming;
By all means, have a taste of the white scent while there's time.
If both sides are willing,
Why not share a dream in bed?
If you betray your youthful vigor and such wonderful delight,
Just remember, you may return to the old country as a wealthy man,
　　but you won't have this chance again![54]

The speaker articulates his concerns of "betraying youth" —of the inability to seize time before it passes. He presents youth's generative vitality as a fleeting luxury in Chinatown, a place filled with immigrant men denied a legitimate future to marry and settle in the States. As the speaker emphasizes the need to cherish time, he describes a desire for a sexual liaison that "crosses" such legitimized ideas of domesticity. It is precisely due to the *impossibility* of fulfilling a Confucian structure of

feeling on American soil that the speaker legitimizes his desire to deviate from it. Longing to "have a taste of the white scent while there's time," the speaker expresses an affective structure that contravenes Confucian social order (i.e., desiring a sexual liaison as opposed to a nuptial union in service of patrilineal reproduction) and disobeys the U.S. legal structure (i.e., desiring sexual encounters with white women in a time when miscegenation was outlawed). He emphasizes not just the unattainability but, perhaps more importantly, the penetrability of the Confucian structure of feeling within the American context. This expression of transgression—crossing both Confucian and American social orders—is articulated clearly in the pervasive depictions of the sex worker throughout the poetry collection.

Prostituting Desires

A significant portion of the poems collected depict desires for sexual liaisons outside of the family structure, and many project such desires onto the figure of the sex worker.[55] Mirroring ways in which the figure signifies in Sui Sin Far's short stories, the sex workers portrayed in *Songs of Gold Mountain* trouble conceptions of domesticity. As a character deemed outside of a respectable family structure and on the margins of legitimized citizenship, the sex worker figure serves as a discursive trope articulated to imagine the penetrable potential of national and familial borders. Many poems express the permeability of the domestic sphere through detailing the sex worker's ability to be redeemed through marriage if a capable client desires her, as depicted in poem #216:[56]

跟個佳子弟。老舉好眼界。
忽然上岸遂心懷。換却臭名稱二奶。
咁架勢。再唔蕩落街。
而今歸學家人禮。免將皮肉作生涯。

Hitching up with a nice young man—
This whore sure has good vision.
Suddenly she quits her profession and her prayers are answered;
Rids herself of the infamous label and becomes his second wife.

It's a big deal for her:
She wanders the streets no more.
Now she retires to learn the manners of a family woman;
She's spared from being flesh and skin for hire.[57]

The speaker suggests that sex work is a transient profession, an occupation from which the heroine can "retire" and be "spared." The heroine is allowed to transition from a position outside the family structure into the domestic sphere, as she "learn[s] the manners of a family woman." What is underscored is the possibility of crossing boundaries of propriety, as domestic legitimacy can be "learned" and obtained through practice and "good vision." The speaker accentuates the prostitute figures' elasticity, which illuminates transgressive potentials of sex work—labor that, if performed well, one can leave behind on one's way up the social ladder and into the domestic sphere.

The sex worker figures' ability to breach domestic borders is further emphasized in poems depicting an absolute rejection of the Confucian family structure.[58] Poem #189 is a good example:

嗜淫心未倦。七十不知天。
縱情肆慾比英年。妓館娼寮志貪戀。
發老癲。恐怕人見面。
潛入花叢飽眼癮。偏求淑女伴同眠。

I never tire of the lust for women;
At seventy, what do I care about destiny.
Loose with passion, wild with desire, just like my younger days,
Brothels and whorehouses are places of my mad indulgence.
Am I a crazy old fool?
But I do care if people see me there.
So, I'd rather hide myself amidst beautiful flowers, look around to
 my heart's content,
And ask every lovely creature to spend the night as my companion.[59]

Locating "brothels and whorehouses" as places of "mad indulgence," the speaker rejoices in sites and subjects deemed degenerate within a Confucian structure of feeling. Not interested in carrying on his

patrilineal legacy, the narrator rejects a linear, reproductive conception of sexual union within a Confucian family structure by detailing his indulgences outside of it. He does not crave a domestic future, nor does he long for a pristine past. He desires, instead, "mad indulgence" in brothels and whorehouses in which he can "hide . . . amidst beautiful flowers." In other words, the speaker does not want to push against borders of domesticity prescribed to him either through Confucian moral order or U.S. legal codes. He desires, instead, to flirt with possibilities exterior to it.

Such disregard for the Confucian family structure is frequently coupled with a similar neglect of U.S. national borders in the folk rhymes. This indifference is often depicted through portrayals of love between sex workers and their migrant clients, as demonstrated in poem #215:

生得丰儀雅。命裡帶桃花。
青春貌美更無瑕。妓婦相見同樂耍。
愛戀他。情如膠漆也。
龜鴇聞知來打罵。私逃密約返中華。

Born with a fine and gentle air,
Predestined in life to be intimate with women.
Young and handsome, he's perfect, without a flaw;
O, what prostitute won't want to have some fun with him?
Passionately loving him,
Emotions bound like lacquer and glue.
The pimp hears about this, and scolds and beats her up.
She runs off and sneaks back to China with her lover.[60]

Here, the speaker describes the inevitability of the lovers' transgression as he portrays the client to be someone who is *predestined in life to be intimate with women* (my emphasis), and presents his attraction to the sex worker as being "bound like lacquer and glue." The speaker evaluates the couple's attachment through unworldly measures of undeniable dynamism so the lovers' connection is elevated to the level of destiny. Moreover, he describes the lovers' travel across the Pacific

Ocean at the end of the poem in a near-fated fashion. It is the sex worker figure's liminality, or the celebrated joining of that marginality with her client's precarious position between nations, that opens up the potential to break domestic order—be it boundaries that demarcate the Confucian family structure, U.S. national borders, or worldly/ordinary expectations.

One can further detect this rupture in how the self-other divide between the client and sex worker is itself framed as penetrable, through the act of sexual exchange and in their shared social position on the fringe of class and cultural structures. The migrant bachelor is denied from marriage within U.S. borders but could potentially marry if he can accumulate enough wealth to return to China. Similarly precarious are the sex workers, whose status is far enough from the family institution so they can make a living out of playing with extramarital desires, yet close enough to be incorporated into the family institution if they perform such desires with talent. The migrant bachelor and the sex worker in these poems mirror each other: they are both caught in a temporary, or even ultimately obscure stage, unable to fully secure a place within domestic institutions. They are figures who open up extraordinary narrative spaces that can reconfigure, even dismantle, what has been deemed "normal" (i.e., U.S. legal structure, Confucian familial structure, expectations of the ordinary) in reality.

This unsettling of normality is demonstrated in the many poems in which the migrant writer takes on the voice of the prostitute figure, literally crossing into and taking on the identity of the sex worker. Such "cross-dressing" of identity is seen, for instance, in poem #210:

嘻嘻謦屎講。時尚轉西裝。
我們娼業要上行。服色更新方有望。
雖曲當。褸衫買到爽。
扮足土生靚妹狀。料然合意各情郎。

Yes, it tickles my funny bone to tell you:
The fashion now is Western.
We in this business of pleasing men must keep up with the trend
Our dresses must be new and in style.

Even if we have to sell and pawn,
We'll buy all the clothes we want.
Doll ourselves up like beautiful American-borns;
Surely the men will find us very pleasant.[61]

By penetrating biophysical borders and adopting the voice of the sex worker, the migrant writer stresses the performative potential of identity formation as means to disrupt vertical—biophysical, culturally motivated, and nationally institutionalized—fidelity. Echoing sentiments expressed through the prostitute figure in Sui Sin Far's short story "Lin John," the sex worker in this poem also stresses her ability to culturally cross from Chinese prostitute to "beautiful American-born." She emphasizes the performative routes—the act of selling and pawning old clothes so she can dress up in "Western" trends—that defy hierarchical authenticity discourses of Chinese origins and enduring pasts. The sex worker speaker champions the economy of trends through which she can consistently breach her given positionality and reinvent her subjectivity. She formulates her identity not in accordance to ethnic or national fidelities, but through a demonstration of their permeability.

What occurs is a contorted, or "crossed," relationality between the migrant writer and the prostitute speaker. The "we" used in the poem applies not merely to the sex workers addressed in the lyric, but also to the writer, and the immigrant readers. This shared performance of "we" recognizes an expression of selfhood that violates rigid ethnic borders and polarizing national structures. Uncontained in the dichotomous lenses of U.S. imperialist yellow peril or Chinese anti-imperialist national reform, the emphasized elasticity of the sex worker in *Songs of Gold Mountain* demonstrates the complexity of a migrant community's own attachment to a textual reflection of themselves. As a figure who, in Zamperini's words, "moves in the space in-between" and is in "constant transit," the sex worker's liminality disturbs as it breaches conceptions of the "domestic," whether they be American, Chinese, or Confucian.[62]

Emerging from these tales is an expression of transnational Chinese belonging that is shared by the many anonymous Chinatown poets in

Songs of Gold Mountain and by Sui Sin Far, as found in *Mrs. Spring Fragrance*. In locating this intertextuality, I argue for the importance of seeing this expression of transnational Chinese identity as not just an idiosyncratic, individuated, or private articulation of transgression; it is a sustained and shared affective structure fragmented and illegible under nation-based imperial/anti-imperial scopes of analysis. It is precisely through such repetitive depictions of the sex worker as transgressive character that mobilizes this third space of cross-Pacific identity formation.

As a literary trope that activates transnational expressions of collectivism, the sex worker figure performs the intervening slash in "Asian/American" that Palumbo-Liu explores. The sex worker's body, which simultaneously delineates and disturbs imaginations of U.S. and Chinese domestic boundaries, puts into contact highly fraught, rigidly fixated identity markers of "Asia" and "America." The sex worker embodies undertheorized expressions of "we" generated across cultural-national borders; that is, she embodies Pacific Crossing.

I have focused on how the transgressive utility of cultural-nationalist imaginations is mobilized through popular representations of the sex worker, and how oppositional cultural-nationalist framings can articulate an affective structure (i.e., Pacific Crossing) that bends across and breaches those framings. Next, I complicate my discussion of Pacific Crossing by reading "crossing" as not only a mode of transgression but also a generator of emotional friction. While I have emphasized the usefulness of cultural-nationalist imaginations in this chapter, in the following chapter I look beyond utility. I identify how the emotional surplus generated by the sex worker figure's mobilization of affect reassembles the prominence of nationalist discourse after World War I.

2

OVER MY DEAD BODY

Melodramatic Crossings of Anna May Wong and Ruan Lingyu

W orld War I marked a turning point for U.S. international and domestic policy. A confluence of wartime hyper-nationalism, maturation of industrial capitalism that decreased the need for transnational labor, and postwar isolationism impelled the legislation of comprehensive immigration restriction through the passing of the Johnson-Reed Immigration Act of 1924.[1] The law established a quota system for admission into the United States that classified the world's population according to nationality and race, ranking them in a hierarchy of assimilability, with northern and western Europeans categorized as the most desirable.[2] While the immigration act was principally intended to restrict immigration for southern and eastern European wartime refugees, it also deemed all Europeans to be a part of a white race, distinct from those considered to be "colored" and, by extension, low on the assimilability ladder.[3] For instance, the law's race-based exclusion expanded beyond the Chinese-specific exclusion acts institutionalized since 1882 to the banning of "Asiatic peoples," who encompassed subjects of all nations spanning from Afghanistan to the Pacific.[4] U.S. political severing with Asia was reflected in its heightened immigration restrictions but also in its advocacy of non-involvement in Asian geopolitical conflicts. This was evident in the establishment of the Stimson Doctrine, with which the United States expressed moral concerns over Japan's imperial expansions into northeast China without committing itself to any direct involvement.[5]

Although the United States legislated policies reduced its official contact with Asia, its economic impact in Asia remained, if not increasingly so, in the realm of culture.[6] At this time of U.S. isolationism, some of the most pronounced forms of transpacific contact between the United States and Asia were commercialized networks of cultural production. The starkest example was the dominance of the Hollywood industry in China at a time when cinema emerged as a championed medium to negotiate cultural discourses on global modernity.[7] Producing more than 80 percent of the films shown in China by the early 1930s, Hollywood offered a reflexive horizon for Chinese middle-class filmgoers to contemplate China's positionality in the world.[8] Shuqin Cui notes that "widespread social disorder and the dominance of foreign films directly exposed Chinese audiences to the hegemony of foreign power. This dual spectacle, national and visual, showed progressive filmmakers the power of cinema, the visual medium, to expose social problems and construct national discourses."[9] In China, cinema served as the proof of foreign encroachment (specifically, Hollywood's dominance of market and representation) and also the means to propagate Chinese nationalism. The cinematic medium worked as what Zhang Zhen calls "a complex translation machine and motor for change," generating a social and aesthetic experience that effectively mediated issues of cultural imperialism, technological modernity, and national sovereignty for a growing number of Chinese audiences.[10] It is perhaps less of a surprise, then, that the Golden Age of Hollywood (late 1920s to 1950s) also marked the transformation of China's early film production from a mainly commercialized entertainment industry into an increasingly politicized enterprise. The consolidation and rise of a Chinese left-wing *minzu dianying* 民族電影 [national cinema] in the early 1930s is often read as in part a reaction against the domination of foreign, particularly American, films.[11]

Political ramifications of cross-Pacific cinematic mediation are clear in the contending depictions of Chinese womanhood presented in American and Chinese film productions. Early Hollywood's frequent portrayals of Chinese women as hypersexual or parasitic prostitutes reflect the "yellow peril" discourse of biological threat and moral underdevelopment discussed in the previous chapter. These portrayals

sustain a developmentalist teleology, in which China and its subjects are imagined to be always morally and temporally lagging behind Euro-America, projecting not only the cultural limits of the U.S. citizen-subject but also the need for "civilizing" expansions of American cultural and economic influence.[12] On the other side of the Pacific, Chinese left-wing film productions also evoked the Chinese prostitute figure as a common trope. Yet, instead of staging her as a morally back-ward character, she is often framed as a "virtuous sex worker," ex-ploited by global (i.e., imperial) capitalism and domestic (i.e., feudal) oppression. She therefore serves to herald the urgency of nationalistic reform. These left-wing representations of the virtuous Chinese sex worker externally resist Hollywood's domination while internally mythologizing Chinese nationalistic advancement.

This transpacific "crossing" of Chinese prostitute images—between Hollywood and Chinese left-wing productions—allows for ideological fault lines and political hierarchies between the United States and China to manifest.[13] As a character designed to embody the exterior of the modern woman and, by extension, the modern citizen in both U.S. and Chinese contexts, the Chinese sex worker operates as a pivotal figure through which U.S. Anglocentric exceptionalism and Chinese reformist sentiments rub up against each other, and cross.

In what follows, I focus on the two film industries' exchange of the Chinese prostitute image and trace the ways the affective structure of Pacific Crossing—an expression of Chinese collectivity that utilizes as it breaches both U.S. and Chinese cultural-nationalism—is activated when these intersecting representations come into contact on- and off-screen. I will show how this transnational expression of Chinese be-longing traced in the previous chapter is sustained into the 1930s, a time of presumed hyper-nationalism and U.S. isolationism. As such, I stress the importance of an affective analysis. Emotional exchanges not only continued but were even intensified through cultural net-works at a time when physical travels across the Pacific Ocean were increasingly restricted.

In addition to showing how Pacific Crossing as an affective structure persists into the postwar era, I identify how it develops past an expres-sion of transgression across national ideologies, and intensifies into a

mode of transnational contact that generates emotional excess that spills beyond political use-value. In order to portray this development of Pacific Crossing, I complicate my reading of "crossing" beyond being a form of transgression, as discussed in chapter 1, and show how it shifts into being a mode of emotional provocation, or "friction," in Anna Lowenhaupt Tsing's sense of the term. With the notion of "friction," Tsing visualizes global connections as uneven links often generated at moments of misunderstanding. To Tsing, global aspirations materialize through friction as it produces "the grip of worldy encounter . . . the sticky materiality of practical encounters."[14] Tsing's concept of friction provides a method to classify creative qualities of global encounter across differences, even if those qualities are uneven and unstable.

Building on Tsing's notion, I argue that it is in these discursive and emotional frictions generated between Hollywood's imperialist and China's anti-imperialist images of the Chinese sex worker that the cultural work of both U.S. and Chinese nation building takes shape, and, yet, simultaneously is destabilized. To identify this negotiation of national mythology, seen through the idea of friction, I look closely at the Pacific Crossings activated by two particular actresses who famously embody the Chinese sex worker on the silver screen: Hollywood's first Chinese American actress, Anna May Wong, and China's 1930s icon, Ruan Lingyu 阮玲玉. Juxtaposing the two icons, I show how mass media's reassembling of their images as prostitutes not only galvanizes nationalistic sentiments but, through the emotional excess mobilized, also unsettle the very nationalism produced.

The first half of the chapter is a comparative analysis of Wong's performance of a murderous Chinese prostitute in Paramount Picture's *Shanghai Express* (1932) and Ruan's embodiment of a "virtuous sex worker" in Lianhua Studio's *Shennü* 神女 [The goddess] (1934). It traces how the heroines' bodies work as a critical interface on which Hollywood's projection of imperialist racialization rubs against and, in turn, animates Chinese left-wing cinema's inscription of anti-imperial resistance. This mobalizing potential can be seen when we juxtapose Wong's and Ruan's performances. It allows us to trace the process through which Hollywood and Shanghai National Cinema's contending

imaginations of "Chinese womanhood" take shape through the heroines' bodies at moments of transpacific encounter.[15]

I highlight the plasticity of Hollywood and Shanghai National Cinema's polarized representations by reading their depictions of the two heroines as opposing ideologies that *find grip*. That is, I read the two film industries' contending expressions as shifting sentiments that do not merely exist in opposition but *emerge as* oppositional through the act of friction.[16] By laying out the course of the heroines' images' encounter, with each other and their audiences, I expand my focus beyond questions of ideological intent to include more erratic issues of contact. Focusing on the affective crossings stirred by Wong's and Ruan's performances, I highlight the process of how ostensibly homogenous imaginations of national collectivity take shape, and how, due to these sentiments' elasticity, they continually reshape.

This malleable potential is what I focus on in the second half of this chapter, where I argue that the heroines' crossing images activate not only nationalistic fervor but also emotional excess that accumulates *and* spills beyond the use-value of both U.S. and Chinese nation building. The heroines' performances—on- and offscreen, in life and after death—create overwrought, or what I will call "melodramatic," sentiments. I will explore how these melodramatic expressions show forms of attachment that complicate their projected national scripts. Such superfluous stirrings, I argue, work to obfuscate the sanctity of the "nation" as a centralizing site for collective belonging.

TRANSPACIFIC FRICTIONS ON THE SILVER SCREEN

Anna May Wong was, by the 1930s, quite visible on the Hollywood screen. She was able to play supporting roles in major films such as *Peter Pan* (1924), *The Thief of Bagdad* (1924), and *Piccadilly* (1929), and even took on lead roles in movies such as *The Toll of the Sea* (1922). Praising her performance in *The Toll of the Sea*, the *New York Times* exclaimed that she "should be seen again and often on the screen."[17] English journalist Brussels P. L. Mannock declared her to be a "glamour sensation" in the London-based magazine *Picturegoer*.[18] *Mon Ciné*, a popular French

magazine at the time, even put Wong on the front cover of their July 1924 issue and included a detailed article reviewing Wong's career.

Despite her cinematic visibility, the roles given to her were limited to particular Orientalist imaginations of Chinese women—she was scripted as either the innocently available lotus blossom or the morally loose dragon lady. From pregnant woman-in-waiting to Mongolian slave, from the daughter of villainous gangsters to a murderous prostitute, her roles often ranged from the easily degraded to the degrading woman of the Orient.[19] In fact, in order to dispense of her Chinese American identity (with her multilingual capacity and her unusual height of five feet six inches), her critics split her persona into that which embodies an "authentically Chinese" interior and an "American" exterior guise. As British journalist E. E. Barrett declared, "underneath her mask of American flapperism, there is a Chinese Anna May Wong."[20] Underscoring the distinction between Wong's performance of American femininity and her "innate Chinese identity," mysterious to a Euro-American audience, a journalist in *Film Favourites* stated that "she is a fascinating Chinese woman [who] becomes Western, but not Western enough to change the color of her skin, and make her completely white. She stands alone, a soft-voiced charmer, who brings into our dreary everyday existence a glamour and a thrill, a glimpse of the world we know nothing about."[21] Determined to "unveil" Wong's supposedly inherent Chineseness so audiences could have more than a "glimpse of the world we know nothing about," American film journalist Rob Wagner advised Wong to "can [her] Hollywood feathers and be Chinese . . . to burn incense in her hotel room, to add to her exotic charm."[22] The Euro-American press interpreted Wong's Chinese American identity as a West-East, exterior-interior dilemma that needed to be resolved by Wong releasing her "innate" Chineseness. However, it was precisely Wong's performance of racial, cultural, and sexual deviance that fueled Euro-American viewers' fascination.[23]

Wong's increasingly Orientalized personas in such films as *Thief of Bagdad* and *Piccadilly* provoked strong critiques from the Chinese American community in the United States as well as Chinese intellectuals across the Pacific Ocean. Echoing the Chinese American community's discomfort with Hollywood's representations, Wong,

herself, consistently protested against the predicament she was put in when asked to take on demeaning roles. Publically denouncing unfair depictions of Chinese people, Wong notes in an interview: "Why should we always scheme, rob, kill? I get so weary of it all—of the scenarist's concept of Chinese character."[24] Despite Wong's vocal dissent, Chinese critics across the Pacific Ocean still condemned her for taking on roles that tarnished China's international image. Shanghai's *Dianying zazhi* 電影雜誌 [Movie magazine], for instance, criticized Wong for "not satisfy[ing] Chinese peoples' hopes."[25] Another Shanghai magazine, *Dianying huabao* 電影畫報 [The screen pictorial], argued that she failed to "respect her identity," and urged her to earn the esteem of her countrymen.[26] Competing with Hollywood's marketing of Wong's Orientalized public persona was a transpacifically produced nationalistic rhetoric, which emerged through ideological frictions over Wong's "degenerate" performances of Chinese womanhood and, by extension, Chinese people and Chinese bodies.[27]

Crossing Images of Shanghai Express

Wong's enactment of a murderous Chinese prostitute in *Shanghai Express* (1932), in particular, exacerbated this Chinese nationalistic sentiment that pushed back against Hollywood's depictions. Set in China during a time of civil unrest, *Shanghai Express* portrays the adventures of a group of first-class passengers traveling on the Shanghai Express— a train from Beijing to Shanghai. In the film, China is painted as an exotic place that by nature proves incompatible with modern development. Before the train even departs from Beijing, the foreign passengers bet on how late the train will be when it eventually arrives at Shanghai station. One passenger asserts, "we are in China now . . . where time and life have no value." Despite being named Shanghai Express, the supposed speed (physical and developmental) of the train is weighed down by the purported backwardness of China and the perceived uselessness of its people, whose value is diffused through overpopulation.

Throughout the film, indistinguishable masses of Chinese-looking bodies are framed as spilling in, out, and around the train as disposable props (see figure 2.1). Laboring Chinese bodies are planted throughout

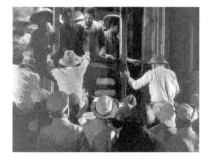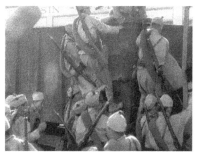

FIGURE 2.1 Masses of "Chinese-looking bodies" staged as if props in *Shanghai Express*

the film, with people constantly cleaning windows and transporting goods in the background or in brief montages between scenes. The prevalence of Chinese labor, however, does not convey an industriousness of Chinese bodies. Almost always, their labor is depicted as inefficient or ill timed. Maids bring hot towels when they are not wanted, goods get loaded and unloaded too slowly, and the newspapers sold on the train are four years too late. At the heart of the narrative is tension caused by a perceived incongruity of time, or development—specifically between the universal modern time the train is engineered to progress along, and the disregard for time of China and its people, which can affect even modern technology (in this case, causing the train to derail from its temporal track). In figure 2.2, we see how the scene shows Chinese people and livestock wandering onto the railroad tracks, literally blocking the train from progressing forward. China and its people are portrayed as inherently incongruent with the pace of modern progress. This depiction of China's underdevelopment reveals the chronopolitics of modernity. Within this lens, Euro-America is at the forefront, and non-Western worlds, such as China, are always lagging behind in a teleological logic of progression.[28]

China is scripted as a place not only temporally out of step with modern progress, but also one where civilization, or more precisely the "civilized white body," is easily led astray. This is shown in the varied depictions of the film's two heroines, Shanghai Lily (a British escort played by Marlene Dietrich) and the Chinese sex worker Hui Fei (played

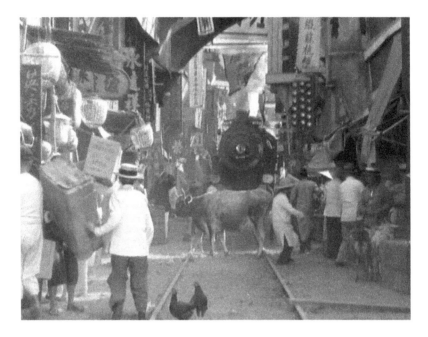

FIGURE 2.2 Chinese people and livestock blocking the train tracks in *Shanghai Express*

by Anna May Wong). Although the two heroines are scripted as travel companions, they embody different developmental temporalities. Shanghai Lily falls from modernity toward the backwardness that China represents in the film, while Hui Fei is the very embodiment of that backwardness. As Shanghai Lily explains her "fallen" situation to her former lover, Dr. Harvey, she states that "five years in China is a long time," as if implying that it was her prolonged stay in China that turned her into a wandering sex worker. Unlike Shanghai Lily's degraded status, Hui Fei's fall from grace is apparently in no need of explanation and, thus, is granted none in the narrative. While the British Shanghai Lily's degeneration can be attributed to a foreign source (China), Hui Fei's fall seems only an external, visual sign of her innate backwardness. Though the film scripts the two women as travel companions and both women of infamous profession, it goes to great lengths to differentiate them along racial lines.

The heroines' differences are shown as soon as they are introduced on screen. At the Beijing station, Hui Fei is carried in on a wooden crate, and with a brief full shot, the camera shows her scurrying onto the train within seconds without giving the audience the time or closeness to see her clearly. Shanghai Lily's entrance, on the other hand, is slowly and surely announced as she arrives in a honking automobile. She strides proudly onto the platform as the camera follows her from long shot to medium shot to close-up. As Anthony Chan observes, "Shanghai Lily is the intense, modernized, and motorized Western woman. She is the female foil to Hui Fei, who represents China in all its backwardness and traditional decadence, made even more primitive by her reliance on a human-powered vehicle."[29] The two heroines' access to modern mobility, respectability, and even cinematic technology are differentiated in this opening scene that highlights the integrity of whiteness and its place as leader of modern development.

The association between modernity and whiteness is clear; moreover, the link between whiteness and desirability is distinctly rendered. To the first-class Euro-American passengers on the train, Shanghai Lily is clearly the more desirable of the two. An American passenger asserts, "I thought they were rather good-looking, at least Shanghai Lily is." While a Presbyterian minister laments the sinful presence of these two women in a first-class compartment, the British Dr. Harvey proclaims: "I don't know about the Chinese woman, but for the other lady . . . she is a friend of mine." This hierarchy of desirability is reasserted when the doctor refuses to recognize Hui Fei when being introduced by Shanghai Lily, stating that he "reserve[s] the privilege to choos[e] [his] friends." In response, Shanghai Lily replies, "she's no friend of mine, I'm only trying to be decent." Here, we again see a scripted distance in the two characters' allowed proximity to modern propriety and even association. A sense of racial hierarchy is established between the two heroines' bodies as they are posed for "first-class" Euro-American passengers in the film, as well as for the "first-class" Euro-American targeted audiences of the film.

The distinction between Shanghai Lily and Hui Fei in terms of respectability and desirability is most pronounced, however, when the tale's villain, Mr. Chen, enters into the narrative. Chen first and

foremost desires Shanghai Lily and takes the time to court her. Yet, because Harvey protects Shanghai Lily, Chen is unsuccessful in his efforts, and Shanghai Lily is untouched. Frustrated, Chen immediately drags Hui Fei into his bedchambers and rapes her. No one comes to her rescue due to her relatively disposable place in the eyes of the train's first-class passengers. Later on, Shanghai Lily is eventually forced to offer herself to Chen in order to save Harvey from being blinded while he is held hostage by Chen. At this moment, Hui Fei mysteriously appears and kills the villain. By killing off the tale's "yellow menace," Hui Fei saves the moral and corporeal integrity of both Shanghai Lily and Harvey. The presence of Hui Fei is represented as only meaningful when preserving white virtue. We therefore witness a series of substitutions: the harm done on and by the "yellow menace" (Chen) is constantly displaced from the white bodies of Shanghai Lily and Harvey, which are of utmost value, onto the other volatile yellow body, Hui Fei. As we are reminded, "we are in China now, where life," particularly Chinese life, "has no value."

The tale closes with the lovers reunited. At the end, Shanghai Lily gives Harvey a new watch as a token of their renewed relationship. Hui Fei disappears from the tale soon after the train arrives at Shanghai station, four hours late (as predicted by the first-class passengers). Here, an analogy can be drawn between Hui Fei and China, as they represent something exterior to a respectable modern imaginary, morally and temporally out of step with their contemporaries. Hui Fei is a murderous sex worker whose body is penetrable and disposable; her embodiment of a "timelessly backward Oriental woman" highlights, and eventually enables, Shanghai Lily's transformation into a respectable modern woman—on time and on site to reunite with her old lover and embark on their bright future. Wong's disreputable role generates a desirable association between whiteness and modern femininity and, in turn, sustains the developmentalist teleology of Euro-American-centric modernity.[30]

Despite being one of the most internationally popular of Anna May Wong's films, *Shanghai Express* provoked significant pushback when it reached a Chinese audience across the Pacific Ocean. Seen as another

example of Hollywood's tendency to humiliate China and to ridicule its subjects, *Shanghai Express* triggered fervent critique from Shanghai's left-wing intellectuals, such as Hong Shen 洪深.[31] The then-screenwriter and professor of drama led a protest of students from Fudan University to interrupt the opening night screening of *Shanghai Express*.[32] *Shanghai Express* was eventually banned, and Paramount Pictures's license in China was suspended as a result.[33]

The film dominated the box office at a moment when Paramount Pictures was attempting to buy out all the Chinese film studios, and *Shanghai Express*'s success worked as a reminder of U.S. economic and cultural hegemony.[34] The film was released during a period of tension between China's Nationalist and Communist parties, and intellectual activists saw the film's depiction of China's revolutionary forces as frail and disposable as offensive to their ongoing revolutionary efforts. Furthermore, the film came out in the midst of the Nationalist Party's "Anti-Spiritual Pollution Movement," a movement to reform the Chinese public into so-called new, modern, and moral global citizens.[35] The portrayal in *Shanghai Express* of the Chinese sex worker and, by extension, China as being hopelessly out of step with global modernity was therefore one of the first things attacked by both intellectual acivists and the Nationalist government.[36]

Wong's enactment of a Chinese prostitute, disposable and degradable within the Hollywood imaginary, was perceived as a disgrace and a call to action. It was at this moment of friction, or emotional crossing, that Wong's performance activated anti-imperial sentiments from her Chinese audiences. *Beiyang huabao* 北洋畫報 [Beiyang pictorial weekly] ran the headline "Paramount Uses Anna May Wong to Embarrass China Again."[37] Shanghai tabloids went on to deride Wong as "the female traitor to China."[38] The violation of Wong's body on the Hollywood screen represented the harm done to imaginations of the collective Chinese body. With this image of shared injury, affect stuck, caused friction, and galvanized collective aspirations. Wong's performance emerged as a pivotal interface on which Hollywood's projection of imperialist racialization rubbed against and, arguably, further fueled Shanghai left-wing cinema's anti-imperial sentiments.

For a left-wing cinematic movement gained full momentum in Shanghai around the same time of *Shanghai Express*'s ban, renarrating Chinese womanhood in reformist films such as *Sange modeng nüxing* 三個摩登女性 [Three modern women] (1933), *Xiandai yi nüxing* 現代一女性 [A modern woman] (1933), *Xin nüxing* 新女性 [New woman] (1935), and *Modeng xinniang* 摩登新娘 [Modern bride] (1935).[39] The trope of the Chinese sex worker, in particular, was reimagined on the Shanghai screen as the character of a helpless victim caught on the fringes of patriarchal traditions and global capitalism. While Hollywood's stereotyping of Chinese women in *Shanghai Express* highlighted the integrity of whiteness and its role as a leader of modern development, the Shanghai film industry refracted the fallen image of the Chinese prostitute into a rising call for nationalistic advancement. This transpacific exchange of representation shows how the Chinese prostitute figure worked not only as a discursive surface on which rival film industries negotiated competing ideologies but also a symbolic medium through which affective intensities were motivated into collective action. We can detect this galvanizing potential when we juxtapose Wong's performance in *Shanghai Express* with Chinese actress Ruan Lingyu's enactment of a virtuous streetwalker in *Shennü* 神女 [The goddess], a left-wing production released just two years after *Shanghai Express*.[40]

The Goddess *of Shanghai National Cinema*

In *Shanghai Express*, Hui Fei, raped and denied any respectable association, was given no access to a legitimized family structure. The Chinese sex worker in Shanghai National Cinema, however, was often unambiguously incorporated within the family structure, but not without a reactionary function. These fallen women were scripted to perform a family in crisis; their precarious place within the family institution was staged to mirror a nation humiliated by foreign invasion and infested by domestic oppression, garnering support for both anti-imperial resistance and domestic reform (national and familial).[41] As such, the majority of Shanghai National Cinema productions were, like *Shennü*, family melodramas.

Here, I read melodrama as both a genre and a historically conditioned narrative mode that involves strong pathos and heightened emotionality.[42] Using the nation's most prominent, persistent metaphor— the family—these sensationalized tales about the private (families in crisis) are staged to move and mobilize public participation from the audience.[43] Elisabeth Anker explains, "By evoking intense visceral responses to wrenching injustices . . . melodramatic discourse solicits affective states of astonishment, sorrow, and pathos through the scenes it shows of persecuted citizens. It suggests that the redemption of virtue obligates state power to exercise heroic retribution on the forces responsible for national injury."[44] To Anker, melodrama is a political discourse that can galvanize nationalistic passions and articulate expressions of national identity. In the case of *Shennü*, the melodramatic framing of the Chinese sex worker elicits nationalistic sentiments generated by anxieties over a nation-state led astray by the power of global capital.

Shennü tells the tale of an unnamed sex worker who walks the streets so she can earn money for her son's education. Titled *Shennü* 神女 in Chinese, the title denotes "streetwalker" if read from one direction and "goddess" if read from another. This Madonna-whore configuration is developed into the heroine's character; she is portrayed as an attentive mother by day and alluring streetwalker by night. When on the streets, the heroine is placed either next to a massive Chinese character for *dang* 當, advertising a pawn shop, or by life-sized mannequins glowing from the store window behind her, as seen in figure 2.3, signaling her status as an objectified commodity traded and consumed alongside flows of capital.[45]

Walking the streets out of desperation, the film's heroine is forced to evade the police, succumb to the bullying of local gangsters, and endure the humiliation of common prejudice. In the eyes of the police she is not a citizen worth protecting, in the minds of gangsters she is to be used as property, and to the public around her she is a disgrace. Yet while viewing her degraded public persona, the audience is allowed a panoramic perspective of the heroine as a virtuous mother within her private quarters. The heroine carries the plight of both capitalist

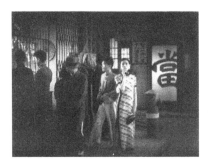

FIGURE 2.3 The heroine juxtaposed with a pawn shop and store window displays in *Shennü*

exploitation and domestic oppression. She embodies a form of humanity that cuts across private and public spheres, beckoning her viewers to expand their empathy beyond conventional domestic borders.

Time is the dominant means through which her two personas are demarcated. In figure 2.4, for instance, the camera cuts from the heroine cleaning up after dinner to a close-up of the wall clock. Next is a medium shot of the heroine rocking her son to sleep to the rhythm of the clock's pendulum until the clock points to the Roman numeral IX. Immediately, she tucks her son to sleep and heads to the streets. The Western-style wall clock rests at the center of the filmic frame, signifying technological and quantified modern time, and functioning as the immaterial force that divides the respective labors of her two personas.

In this sequence, we see how public empathy is stirred through three circumstances: the absence of a just state patriarchy, symbolized by the corrupt police and gangsters running the streets; the oppressive residue of Confucian morals, represented by the prejudice of the public; and the encroachment of global capital, signified through the film's blatant references to commodity culture and the heroine's division of labor through regimented modern time. We are urged to identify with the heroine's Madonna-whore persona, which disturbs clear divisions between the public and private spheres. Her oppressed, fragmented self solicits sympathy for the need to restructure these divisions if her humanity is to be recognized in full.

FIGURE 2.4 The heroine's switch of labors as mother and streetwalker being governed by time in *Shennü*

The urgency to reconfigure public conceptions of the domestic is made apparent when various male figures enter the narrative and, one after another, breach the heroine's private quarters. The gangster is the first to swing open the heroine's door. After a brief encounter on the streets, the gangster seeks her out and barges into her apartment, forcefully enacting a marriage ceremony with leftover food and cheap wine. Left with no choice, the heroine succumbs, letting him exploit her public and private labors. As a self-proclaimed husband, he takes advantage of her domestic work, having her cook and share his bed unwillingly; as her self-appointed pimp, he confiscates the money she earns on the streets and gambles it away aimlessly. The son's schoolmaster is the other patriarchal figure that enters, uninvited, into the heroine and son's domestic life. Stepping into their room, he exposes his concern for her questionable occupation, causing the heroine the embarrassment of having to ask the child to step out of the

apartment while she and the schoolmaster converse. In so doing, the schoolmaster physically breaches the mother and son's comfortable place behind closed doors. Although the schoolmaster leaves feeling sympathetic for the heroine, his exposure of the heroine's profession to the school board nonetheless ends in the boy's expulsion.

With these two patriarchal interventions, questions over this unnamed sex worker's rights as a human being emerge. "Even though I am a degenerate woman, don't I have the right as a mother to raise him as a good boy?" the heroine cries in protest. Moved by the heroine's plea, the schoolmaster argues in front of the school board that "the problem is not with [the heroine], but with our society. She is a human being and has her human rights—so does her son. Particularly her son." In this scene, the schoolmaster takes issue with society and its future, embodied by the son who is set up to fail. The son, particularly the son, is seen as being unjustly deemed subhuman despite his and his mother's arduous endeavors. The schoolmaster declares, "It is all because . . . she [the heroine] wants him to have an education—which she never had. She wants him to have a chance—which she never had. We who consider ourselves educators must make sure he has that chance. We have a moral duty to save him from this toxic environment." The schoolmaster takes up his "moral duty" and calls for a reevaluation of what he sees as unfitting and unjust public understanding of human rights, propriety, and morality in the case of this virtuous sex worker and her son.

The film's conclusion clearly exemplifies this call for social reform. The heroine and her son, she exploited by the gangster and he expelled from school, seen in figure 2.5, are pushed to the edge. Looking out from the windows of their impoverished apartment, they gaze at a public (on and off the screen) that leaves them no space for survival.

Disappointed by the cruelty they encounter, the heroine takes matters into her own hands and sets out to retrieve her money from the gangster, instead killing him by accident. When she is sentenced to twelve years in prison, her labor is consequentially suspended, relieving her from the temporal cycle that divides her private and public labors as mother and sex worker, from dusk till dawn. The regulations of the "modern clock time" that split the heroine's labor are substituted

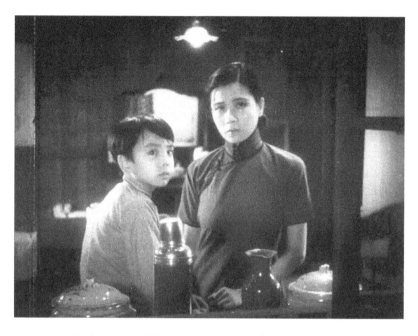

FIGURE 2.5 The heroine and her son looking out of their apartment in *Shennü*

with a "national" time that clocks her moral duty at twelve years. We see a substitution of capitalist regimentation for national regulation, from capital's division of labor to the nation's determination of value.

This substitution is particularly pronounced at the end, when the schoolmaster replaces the heroine as surrogate guardian of her child. The schoolmaster visits the heroine in prison and promises to raise and instruct her son as his own, in turn releasing her from her maternal duties altogether. The heroine, asking never to be mentioned again, willingly erases herself from the son's memory once and for all. The narrator notes, "In the solitary and quiet life in the prison, she finds a new peace in imagining her child's future." Through her symbolic death behind bars, the heroine breaks loose from the temporal shackles of quantified labor and renews her son's future by cutting off his past. She denies her biological affiliation with him to leave room for a more sustainable surrogate. Her degenerative actions as a street-walker, murderer, and unfit mother, in effect, are what generate the

possibility for a renewable future for the son and the Chinese society he embodies.

The disgraced sex worker redeems herself as a selfless goddess by offering her own body as a streetwalker, as forced property to the gangster, as a social problem in need of inspection by the schoolmaster, as a murderer imprisoned behind bars, and finally as a substituted parent erased from her son's memory. She exposes her private body, private quarters, and even private relationship with her son for a reconfigured imagination of a better future and bigger message. Embodying wretched injustices and enduring unending persecution, the unnamed sex worker mobilizes melodramatic pathos from her viewers. Thus, in reaction to Chinese left-wing activists' political and emotional friction against Hollywood's dominance, national fervor is incited by the Shanghai National Cinema's reclamation of the Chinese prostitute figure. The figure heralds an urgency for reform that reflects the Shanghai National Cinema's dual function—it projects an external cultural and economic resistance against Hollywood's international domination while internally mythologizing nationalistic collectivity.[46]

However, inasmuch as reactionary morals are propagated, the hyperbolic performances, emotional intensities, and rhetorical excess performed in this family melodrama also prompt visceral responses beyond urges for nationalistic reform.[47] Bhaskar Sarkar argues that in melodramas, what moves us is not merely the stock moral dilemmas portrayed but "the accentuation of the emotions through excessive stylization. Familiar situations, when presented as grandiose, epic formalism, attain a thrilling intensity that has very little to do with an assumptive moral universe."[48] Ruan Lingyu's hyperbolic enactments of a "virtuous sex worker" on-screen mobilized nationalistic fervor as well as its excess. Ruan's melodramatic performance roused an emotional surplus—a certain overwrought or exaggerated quality—that was galvanized by, but also spilled beyond, left-wing political use-value for national reform.

A good example of these excesses is how, following *Shennü*'s popular release, Ruan quickly became an object of fascination, even a source

of melodramatic enactment, for her spectators. Like the prostitute-mother she played, the actress was pressed to balance her dual identities as ethical-national signifier and commercialized public figure. Ruan was compelled to make her private crises and domestic dilemmas into excessive public spectacles, as if extending her melodramatic on-screen persona into reality. For instance, her complicated relationship with her old lover Zhang Damin 張達民, as well as her later relation-ship with Tang Jishan 唐季珊, were exposed and dramatized for public scrutiny.[49] She was urged to issue continual public statements about her personal life—clarifying her marital status, announcing her domestic companions, and publicizing even the personal lawsuits that ensued. Although Ruan was staged to ignite nationalistic sentiments through her suffering on camera, the dramatic details of her personal life off-camera arrested her fans' attention and mobilized unpredictable waves of affect—most notably, the magnitude of public outcry spurred over Ruan's suicide.[50]

MELODRAMATIC CROSSINGS OF AN/OTHER NEW WOMAN

Ruan committed suicide a year after *Shennü* hit the theaters and just a month after the release of her last film, *Xin nüxing* 新女性 [New woman]. Five kilometers of mourners—one hundred thousand people, or almost a tenth of inner Shanghai's population—followed Ruan's funeral cor-tège through the metropolis on March 11, 1935.[51] Ruan was memorial-ized in a funeral as public spectacle, and her suicide was also seemingly staged as one. The first of her suicide notes was released shortly before her memorial service, addressed "To Society":

> My death now will have people certainly think that I'm escaping punishment. But actually I'm guilty for what? I've never been unfair to Zhang Damin . . . people outside do not understand the situation and think that I've been unfair to him. Ah! What can I do? I've been thinking over and over. The only way to solve the problem is to kill

myself. Ah! My death is not a pity but it's dreadful that gossip is a fearful thing.

I can't clarify that I've been treated unjustly if I don't kill myself. Now I'm dead and he can fulfill his wish at last. Even if you don't kill somebody, somebody dies because of you. Zhang Damin, we'll see how you can escape public opinion.[52]

Even upon ending her life, her private life was made public so as to redeem her already sensationalized image.[53] For "gossip is a fearful thing," and as the case with the tragic heroines she played on screen, death (whether symbolic or real) seemed the only way for a woman like her to "escape public opinion."

However, Ruan did not have the last word. Her dead body quickly accumulated symbolic capital as her enigmatic death functioned as the site for others to gain political and personal profit. Both of her lovers publicly proclaimed to be her rightful husband, despite the endless statements she issued when living to prove her unmarried status.[54] Her ex-lover Zhang Damin made public appearances as Ruan's ex-husband and produced an opera, *Death of a Film Star*, recounting her career.[55] The *Central Chinese Daily News* persistently came out with special issues that speculated about the reason for Ruan's suicide.[56] Left-wing writers used her untimely death as an example of feudal ideology's lingering force; cultural critic Nie Gannu 聂绀弩, for instance, proclaimed that what killed Ruan was not herself, but rather "the residual feudal morality that still infatuates our minds."[57] For critics like Nie, feudal reality left "new women" like Ruan with no place to live freely. As left-wing film producer Li Minwei 黎民偉 lamented: "Women can never elevate their positions in this semi-feudal society, and Ruan Lingyu felt powerless to redeem her and tens of thousands of other suffering women from this injustice.... Protesting with her dead body, she demands justice from us all."[58] Declaring her a heroine beckoning for reform, film director Luo Mingyou 羅明佑 stressed that Ruan "did not die of suicide; she sacrificed herself to society and all women."[59] It is as if her image in life, and even more so in death, was circulated as an affective currency publically available for the production of competing political symbolisms, for personal consumption, and even for public enactments.

Similarly, Katherine Verdery argues, "a dead body is meaningful not in itself but through . . . the way a specific dead person's importance is (variously) construed."[60] That is to say, one's corpse accumulates symbolic value through the multiplicity of interpretations projected onto it. No longer having the ability to speak on her own, Ruan's dead body became this kind of symbolic site, impactful due to the same ambiguity and multivocality stirred over her mysterious death.

Beyond political and commercial value, the effect of Ruan's symbolic economy is, perhaps most importantly, heightened by the affective impact of her dead body. Verdery goes on to explain that "any manipulation of a corpse directly enables one's identification with it through one's own body, thereby tapping into one's reservoirs of feeling . . . these kinds of emotional effects are likely enhanced when death's 'ultimate questions,' fear, awe, and personal identifications are experienced in public settings."[61] The affective impact of dead bodies, which Verdery refers to in relatively universalistic terms, seem especially relevant to Ruan's suicide, in that her death was publicized as if a melodramatic spectacle.

Similar to a melodramatic narrative, the event of Ruan's death was construed through structures of coincidences and untimely resolutions. She was found slowly dying in bed beside her lover, and her botched rescue—being first taken to a faraway hospital then back home before getting any medical attention—was dramatized in media coverage.[62] The belated emergence of Ruan's multiple death notes, along with questions about the notes' authenticity, became a site of public obsession.[63] The media were also quick to latch onto the fact that her death occurred on the eve of International Woman's Day and just hours before her scheduled talk at a women's school. In so doing, they underscored the element of fate, more specifically the fate of the "modern woman."[64] The most publicized coincidence about her death was its resemblance to that of the character Ruan played in her last film, *Xin nüxing* 新女性 [New woman]. The day before *Xin nüxing* was to be presented at a fund-raiser for a woman's educational center in Shanghai, Ruan, like the movie's heroine, Wei Ming, committed suicide by overdosing on sleeping pills.[65]

Ruan's character in *Xin nüxing*, Wei Ming, is based on the life and death of Ai Xia 艾霞—a young woman writer and actress who had committed

suicide just a year earlier in 1934, shortly after starring in her own scripted film, *Xiandai yi nüxing* 現代一女性 [A modern woman]. By enacting Ai Xia's suicide both on the screen (as Wei Ming in *Xin nüxing*) and off it (her own suicide staged in the same manner), Ruan created a genealogy of melodramatic embodiment. That is, by reenacting the death of Wei Ming, which was in and of itself a melodramatic staging of Ai Xia's real suicide, Ruan's death represents the instance of her passing and the performative reappearance of other deaths: Ai Xia, Wei Ming, and the "Modern Woman" and "New Woman" they enacted on the screen. Previous scholarly analysis of the resemblance between Ruan's death in reality and her performed death as Wei Ming on screen (or the "New Woman Incident," as it was later dubbed) focused on the responsibility of urban media—both the left-wing filmmakers and the commercial press—toward the modernization of women and society.[66]

With these conversations in mind, I shift my focus to the layers of melodramatic enactment performed on- and offscreen, and the affective genealogy they create. I argue that this series of events generated a certain "melodramatic temporality" that is coincidentally mistimed and untimely, similar to a melodramatic narrative structured to produce emotional excess. Ben Singer states that melodrama as a narrative mode stresses "outrageous coincidence, implausibility . . . and episodic strings of action that stuff too many events together to be able to be kept in line by a cause-and-effect chain of narrative progression."[67] As an aesthetics of emotional excess, melodrama as a narrative mode overflows with waves of events that spill beyond measured causal progression. Adding a temporal reading to melodrama's excessive narrative actions, Sarkar asserts, the moment when the character is on the point of dying, "the fact that one would like to reverse the course of events to get to an earlier moment in time and act differently, only drives home the irreversibility of time and makes the situation more heart-breaking."[68] For Sarkar, it is the all-too-late in the narrative that moves us and demands our psychological and physical investment of mourning or tears.

In the case of Ruan's death, we can see how the enigmatic event set in motion a different kind of historical narration, or what I've called

"melodramatic temporality." I use this concept to refer to an affective chronotope that, with the excess of emotions generated through melodramatic narrative structures, spurs beyond the dominant political value of linear progression. It instead produces, as in the case of Ruan's death, a suspended loop of mourning. I argue that through Ruan's untimely enactments of death on- and offscreen, her dead body itself created an affective genealogy that built off of and intervened in the national genealogy of time and space scripted by the left-wing intellectuals (seen in *Shennü*), as well as the Euro-American-centric developmentalist genealogy (seen in *Shanghai Express*) that the intellectuals pushed against.[69]

It is in this emotional rupture, mobilized through Ruan's body, that I locate the emergence of the affective structure of Pacific Crossing—an expression of collectivity that utilizes emotional friction caused by contending cultural nationalisms in order to breach it. Ruan enacted virtuously patriotic women who, in their performed degeneracy on-screen, allowed for Chinese left-wing cinema's pushback against Hollywood's dominance to find a foothold. Yet, it was in Ruan's very enactment of her on-screen personas' untimely deaths, with her own offscreen suicide, that galvanized sentiments overflowing the prescribed national fervor. In other words, not only was the affective structure of Pacific Crossing sustained into this moment of Chinese hyper-nationalism and U.S. isolationism; it intensified into a mode of emotional excess (melodramatic temporality) that simultaneously rallied and suspended the urgency of nationalism altogether.

Retrieving her body from the symbolic economy of being Shanghai National Cinema's "virtuous sex worker," Ruan's melodramatically construed suicide created an interlude delaying the developmentalist logics of left-wing and Hollywood cinemas, haunting them with untimely deaths and mournful legacies. This circular deferral can be seen prolonged through the five kilometers of people who attended Ruan's funeral and the many mourning in private. The parading of her corpse served as a certain materiality that, with the slow pace of the funeral procession, refuses full incorporation into the velocity of nationalist or developmentalist progression. It instead suspends time and space, and emerges as a ghostly temporality that, borrowing Sarkar's take on the

temporality of trauma, is "marked by deferral, gaps, and uncertainties, providing no guarantee of the eventual assimilation of the experience within a coherent history, or of therapeutic closure."[70] The melodramatic genealogy that Ruan's body mobilized, in other words, defied nationalistic foreclosure.

The most extreme performances—and extensions—of this melodramatic chronotope were perhaps the suicides committed by fans within days of Ruan's death.[71] One death note reads, "If Ruan Lingyu is dead, what else is there to live for?"[72] Here we see Ruan's untimely death evoke the awe, uncertainty, and fear associated with the meaning of life and death, and more specifically about what it means to be, and to stop being, human. In discussing melodrama's mobilizing potential, Bishnupriya Ghosh states:

> one can hardly ignore the manifest corporeality of melodram[a] . . .—a corporeality that energizes the viewing subject's incorporation into the iconic image. In melodrama, the mirrored image of affect as emotion increases the gravitational force that moves body into the media stream. Yet on the other side of flow lies binding, the reattachment of the subject to the star image as a firmly framed object, a prosthetic that territorializes the subject who enters it.[73]

The melodramatic narrative activates the viewing subject's corporeal connection to the iconic image. In the case of Ruan's fans, they proclaimed themselves actors, not mere spectators, of the social drama Ruan set in motion. Denying any therapeutic closure, these fans arrested their personhood in a moment, through an act inextricably tied to the affective genealogy that Ruan's corpse, just like their own, embodies. Ruan's death impacted an "other" kind of boundary—that of life and death—arresting attachments that were out of sync with the competing temporalities of national and modern progression. Sentiments generated by Ruan's and Wong's contending performances of "fallen Chinese women," through the melodramatic temporality rallied over Ruan's death, were derailed from both the U.S. developmentalist and Chinese reformist framings of Chinese womanhood. They highlighted forms of attachment that were simultaneously ignited by and

exceeded the sanctity of the "nation" as a centralizing site for collective belonging.

Cross-Pacific Reassembly of Anna May Wong

Two months after Ruan's memorial, noted May Fourth writer Lu Xun 魯迅 published a commentary on the phenomenon surrounding Ruan's death titled "Gossip Is a Fearful Thing"—a line drawn from Ruan's first suicide note. Starting with his laments over the actress's ephemeral legacies, Lu goes on for pages describing his sympathies for Ruan's helpless state.[74] At the end of his article, however, we see a shift in tone, from lament to reprimand. He states that the actress's very act of suicide was, in fact, insignificant. He argues: "Naturally, there are many who are brave enough to commit suicide but choose not to. They disdain the act because they believe they can make grand contributions to society. . . . I hope everyone has a notebook and documents all their grand contributions so to one day share with their great grandchildren."[75] Denying any sign of agency in Ruan's act of suicide, Lu proclaims life—in particular a progressive life contributing to the advancement of society—to be the privileged site of significance. Citing the patriarchal logic of reproductive historical progress, he emphasizes the importance of longevity and domestic continuity: to share ones' contributions with their great-grandchildren. Here, Lu retrieves Ruan's symbolic capital and serves it, once again, as a cautionary tale that illuminates the grand narrative of national advancement. He returns her to embody the site of lack—in particular the role of the "virtuous sex worker." We see again the left-wing project of national reform that is "inexorably bound to the transfiguration (and death) of the modern girl on the one hand, and the 'awakening' of the male writer or artist figure on the other."[76] As he warns his readers away from following Ruan's path to death, Lu's lament-turned-reprimand of Ruan's insignificance resuscitates "that which could have been" and, perhaps more importantly, rejuvenates "that which still needs to become" in terms of national advancement.

This moment of political recuperation was precisely the moment when Anna May Wong arrived at Shanghai's ports. Having announced

her decision to travel to China, just months after the rush of the "New Woman Incident," the Chinese media initially held an apprehensive attitude toward the arrival of an/other "new woman." Familiar charges of national disgrace and wariness over the sustainability of modern or new femininity filled the newspaper pages.[77] Even Wong's brother was eventually compelled to publish a public statement pleading that the Chinese press and people accept her. Phrasing Wong's reasons for visiting in cultural-nationalistic terms, he emphasized her "desire to learn Chinese . . . and her warm feelings of patriotism."[78] In her own public statements, Wong mentions that on-screen she, like Ruan, was an actress who "died a thousand deaths." Offscreen, she asserted, she had long desired to visit China and to study "my motherland's scenes and customs, my fellow Chinese, and all other things concerning China."[79] Aligning herself with the tragic heroine and the nationalistic symbol she "could have been," Wong's persistent statements of Chinese allegiance and claims for newfound patriotism recharged her symbolic value for China's urban public. Shanghai National Cinema's "virtuous sex worker," a symbolic figure that died along with Ruan, was seemingly resuscitated through Wong's controversial emergence into China's social scene.

As media attacks eventually subsided, Wong's open friendship with China's "national treasure," Mei Lanfang 梅蘭芳, and Hu Die 胡蝶, the "first lady" of the Shanghai film industry at this time, made the headlines.[80] Urged to meet with officials—including the head of the Foreign Intelligence Department, the principal of the National Opera School, and the chief of the Central Film Industry Office—at the capital of the Nationalist Party, she was berated for taking on roles that denigrated China's image.[81] In the face of such criticisms, Wong proclaimed her joy of "being at home in China."[82] She assured her hosts that she would be spending months in Beijing, studying Chinese, and gathering scripts of historical dramas, so they could be performed in London, Paris, and New York, and that through such studies, she would "be able to interpret our country in a better light."[83] Wong claimed her role as being associated with a Chinese heritage and packaged herself as a cultural ambassador who was willing to promote China's national image for a global, if cosmopolitan, public.

A reconfiguration of political agency in Wong's performance of Chineseness can be located in the wake of Ruan's death. We see Wong appropriating the cultural essentialist rhetoric of the West-East, exterior-interior dualism prescribed to her by the Euro-American press; she stresses her association with Chineseness as a means to serve not the "first-class" Euro-American audiences' exotic imaginaries, but the Chinese officials' and intellectuals' desire to promote national visibility on a global stage. While Wong's performance of a Chinese sex worker on the Hollywood screen highlighted the developmentalist teleology of Euro-American-centric modernity—in which China and its people were always to be stuck in "the waiting room for modernity"—in the wake of Ruan's death, Wong, on Chinese soil, resuscitated the cultural-nationalist discourses of Chinese national progression and longevity. That is, friction caused by Wong's Orientalized performance of Chinese womanhood at one end of the Pacific (Hollywood) was at this moment smoothed out by her devotional enactment of Chinese patriotism on the other.

Wong's re-inscription of Chinese national discourse might seem like a foreclosure of the melodramatic ruptures of U.S. and Chinese cultural nationalism that Ruan's death set in motion. However, I read Wong's cultural-nationalistic performance reflecting not an undoing of Ruan's melodramatic disruption, but an extending ripple effect across the Pacific Ocean. After Wong returned to the United States from her brief visit to China, she volunteered in wartime drives and China relief events.[84]

Her declared affinity to the Chinese national cause as a U.S. citizen, however, provided her a platform to assert a particularly *Chinese American* positionality on- and offscreen. In the 1939 Paramount film *King of Chinatown*, for instance, Wong played an American doctor, Mary Ling, whose Chinese heritage and U.S. citizenship are not framed as dichotomous.[85] It was, in fact, her sympathies for China as an American that motivated her to bring medical resources to China at the end of the tale. While such shifts in representation reflect the change in U.S.-Chinese relations to political allies during World War II, we see the affective structure of Pacific Crossing doubling back, mobilized by the historical moment's wartime hyper-nationalism. It was

precisely Wong's performance of Chinese allegiance on American soil that assisted her crossing of Orientalist imaginations of Asian persons within a U.S. context, which in turn affirmed a particularly Chinese American identity. In chapter 3 I trace the transformation of such Pacific Crossings a decade later, when the project of Chinese nation-building was split across the Taiwan Strait, over the "two China" problem.

PART II

SINOPHONIC LIAISONS DURING THE COLD WAR

3

EROTIC LIAISONS

Sinophonic Queering of the Shaw Brothers' Chinese Dream

European colonial empires weakened after World Wars I and II. In turn, the United States and the Soviet Union fought to reorder global resources through opposing politico-economic theories of capitalism and communism.[1] Rather than dismantling the Western imperial dominance that had been set up during European colonialism, the Cold War reordered world divisions, expanding and reconstituting imperial structures along three politico-economic partitions: (1) the First World (the United States and NATO allies); (2) the Second World (communist nations affiliated with the USSR); and (3) the Third World (nonaligned countries).[2] Territories that had been previously occupied or disrupted by colonial powers were disproportionately affected by the Cold War. Andrew Hammond explains that "the Soviet sponsoring of left-wing regimes and the US rollback of communism resulted in over a hundred wars through the Third World and a body count of over 20 million."[3] The Cold War may have seemed "cold" and innocuous in the United States and Western Europe; however, it was "hot" and bloody in the previously disenfranchised parts of the world it aimed to restructure.

The Chinese national project was, for instance, violently ruptured at this time. After the Chinese revolution of 1949, the concept of "China" was divided between two territories across the Taiwan Strait: the Republic of China (ROC, Taiwan), as a NATO ally, and the People's Republic of China (PRC, mainland China), as a communist state. This

geopolitical split displaced massive Chinese populations through their exile across the Taiwan Strait, the South Seas, and the Pacific Ocean. As a result, "Chineseness" became a highly contentious collective identity claimed by both the Chinese-identified people within mainland China and those exiled from it. The geopolitical fault lines associated with Chineseness shifted from the struggle between Western imperialists and non-Western anti-imperialists at the turn of the twentieth century—as discussed in part 1—to the struggle between communist-affiliated mainland China and the anti-communist Chinese diaspora, split by Cold War politico-economic triangulation.[4]

The Shaw Brothers Studios, a film company based in Hong Kong and Singapore, negotiated the fraught issue of Chinese identity on the silver screen.[5] Originally founded in Shanghai in 1925 by four Shaw Brothers—Runje Shaw 邵仁傑, Runde Shaw 邵仁棣, Runme Shaw 邵仁枚, and Run Run Shaw 邵逸夫[6]—the studio lost its Chinese market in 1949 after the Communist takeover of mainland China.[7] Yet, the Shaw Brothers were able to quickly reestablish a transnational entertainment network that spanned and served mostly Chinese exiles in Hong Kong, Taiwan, Southeast Asia, and U.S. Chinatowns.[8] On top of producing and distributing their own films, the Shaw Brothers set up theme parks, dance halls, hotels, shopping arcades, and a circuit of theaters throughout East and Southeast Asia.[9] They also established a wide-ranging distribution network that imported films from Hong Kong, India, Europe, and the United States.[10] By the 1960s, the Shaw Brothers Studio, now based in Hong Kong and Singapore, had transformed itself from a small local film company into a global enterprise, second in production only to Hollywood.[11] Lily Kong explains that by 1966 Shaw Brothers Studios reached its peak output of forty or more movies a year, many of which were globally distributed.[12] In the 1970s at least 1.5 million people saw a Shaw-produced movie every week, either in a cinema in the Shaw chain or in one of the six hundred theaters with which the Shaws had distribution deals.[13] Shaw Brothers was thus one of the most successful Sinitic-language film empires of its time.

Scholars, including Poshek Fu, Sek Kei, and Siu Leung Li, argue that Shaw Brothers' success came largely from its construction of a "Chinese dream"—a fantasized space and time that projected images of a

changeless China with characters who ideally embodied their commod-
itized reinvention of Chinese tradition.[14] Through elaborate restaging
of Chinese folktales, historical legends, and period martial art dramas,
the Shaw Brothers created a China that was at once idealized and
ahistorical.[15] The company thrived on expressing a reassembled "Chi-
nese" tradition and promoting a sense of unity among its viewers
through a standardized use of the Mandarin language.[16] In doing so,
the Shaw Brothers marketed a sense of Chinese historical continuity
and political collectivity that defied the geopolitical realities of Cold
War divisions.

Many interpret the Shaw Brothers' marketing of a Chinese dream
as their catering to their consumers' diasporic sentiments; however, the
audience they targeted was largely, but not exclusively, composed of
diasporic exiles that held nostalgic attachments to China.[17] Li notes:

> more than simply products of a nostalgic nationalism in exile, . . . [the
> Shaw Brothers' productions] can be more fruitfully read as complex
> representations addressing issues of the imaginary homeland of re-
> constructing "China-home" outside China, reconstructing grand
> historical narratives for contemporary use, the diasporic desire for
> a place in the global context, and self-feminization in representing
> the "I" in an uneven world dominated by the Orientalist gaze.[18]

In other words, the Shaw Brothers' Chinese dream can be more
complexly read as a fantasy framed in cultural-nationalist or ethno-
nationalist terms. This Chinese dream is not necessarily, or merely, a
reflection of a loss of past connections with China; it is a strategic rein-
vention of "China" as cultural sign to gain visibility in a global con-
text. We can see this in their lushly made costume epics, including
Yang Guifei [*Empress Yang*] 楊貴妃 (1962) and *Liang Shanbo yu Zhu Yingtai*
梁山伯與祝英台 [*The Love Eterne*] (1963), which they entered into interna-
tional film festivals to compete with the thriving Japanese film industry
in hopes of representing the "true orient."[19] To Run Run Shaw, the way
to globalize their industry was to emphasize its cultural difference
or, as he phrased it, "*Zhongguo weidao*" 中國味道 [Chinese flavor], be-
cause it was precisely what attracted the global audience.[20] The Shaw

Brothers' cinematic Chinese dream served both the international viewership's Cold War Orientalism and the Chinese diaspora's desires for cultural visibility and continuity despite political rupture.[21] The power of the Shaw Brothers' creation of a Chinese dream resided in its value as a semiotic commodity that could circulate and be reimagined across cultural and linguistic boundaries.[22] We can thus detect a multidimensional reinvention of "China" on the Shaw screen; it repackaged Chineseness in a way that dramatized cultural differences so as to compete in a global market that was largely Euro-American centric. It also capitalized on a reconfiguring Sinophone community that was increasingly, if not already, detached from mainland China.[23]

This particular interpretation of the Shaw Brothers' Chinese dream as a strategic—both commercial and ideological—reinvention is why, in this chapter, I classify the Shaw Brothers' cinema as a Sinophonic, rather than a diasporic, production. Analyzing Shaw Brothers' productions within a Sinophonic frame allows us to think *across* questions of cultural origins and national longing that "Chinese diaspora" as a category often raises. As Shu-mei Shih argues, "It is important to question . . . the unifying category of the Chinese diaspora, at once complicit with China's nationalist rhetoric of the 'overseas Chinese' who are supposed to long to return to China as their homeland, and the Western racialized construction of Chineseness as perpetually foreign."[24] Unlike the notion of Chinese diaspora, Sinophone does not refer to an identifiable imaginary of China (cultural and/or national) as a place of origin or homeland; it instead connotes a transoceanic imagined community consolidated through the circulation of Sinitic-language cultural production. My reading of Shaw Brothers' productions within a Sinophonic rather than diasporic framework entails a paradigmatic shift away from their standard positioning within a diasporic sentiment versus localized Hong Kong–style dichotomy. Instead, I highlight the instability of the Chinese dream they market, resituating it in relation to a larger multi-nodal network of Sinitic-language-speaking peoples, and away from inhabiting a monolithic center, be it China or Hong Kong.

In addition to moving conceptually to a Sinophonic frame of analysis, I track the affective tensions reflected through the Shaw screen. As

Shih notes, "Sinophone" can be a site of "both a longing for and a rejection of various constructions of Chineseness; it can be a site of . . . nationalism of the long-distance kind, anti-China politics, or even nonrelation with China, whether real or imaginary."[25] It is precisely this affective element—the longing for and rejection of China and Chineseness—that is involved in the formation of Sinophonic structures of feeling illustrated in Shaw productions that I address. In particular, I stress that a Sinophonic affective structure can be identified clearly in one of the Shaw Brothers' most lucrative yet understudied genres, which deals directly with the management of desires: its *yanqing pian* 艷情片, or what Yau Ching and other scholars have called *fengyue pian* 風月片, with its closest U.S. equivalent being "soft-core pornography."[26] As an eroticized genre that markets both collective and individual fantasies, *yanqing pian* serves as a unique medium to trace patterns of desire negotiated and projected through the Shaw Brothers' Chinese dream.

The Shaw Brothers' *yanqing* productions were often genre breaking, mixing martial arts with comedy, or sexploitation with historical epics. Mainstream directors, including Li Han-hsiang 李翰祥, Kuei Chihung 桂治洪, and Chu Yuan 楚原, were known for their *yanqing* productions along with their more serious classics.[27] Celebrities like Lily Ho 何莉莉, Shao Yinyin 邵音音, and Chen Ping 陳萍 starred in *yanqing* films, as well as in more family-friendly productions.[28] Most importantly, because Shaw Brothers was a mainstream film studio, its *yanqing* films were marketed to mainstream theaters rather than to underground studios, unlike U.S. soft-core films or Japanese Pink films, which were predominantly underground.[29]

Besides crossing over as mainstream cinema, with its mixing and matching of its most popular directors, actors, and even plotlines, the *yanqing* genre alludes to, as its title connotes, the *yanqing* literary tradition. This tradition originated in erotic literature in the Han dynasty, developed through the *chuanqi* 傳奇 and *huaben* 話本 literary traditions in the Tang and Song dynasties, and was later popularized in vernacular literature in the Ming and Qing eras.[30] Many of the Shaw Brothers' *yanqing* films borrowed from the late imperial *yanqing* novel *Jin Ping Mei* 金瓶梅 [*The Golden Lotus*].[31] They also erotically restaged canonical

vernacular novels; for example, *Honglou meng* 紅樓夢 [*Dream of the Red Chamber*] was reimagined in films such as *Honglou chunmeng* 紅樓春夢 [*Dreams of Eroticism*] (1977).

However, instead of paying homage to their literary genealogy, the Shaw Brothers' *yanqing* productions mimicked, if only to mock, their literary predecessors. Many of these filmic productions highlighted the porousness of the family boudoir and satirized not only the family's internal hierarchical order, but also the family's supposed external connection to the state and its Confucian orderings. Neighboring lovers would sneak into a heroine's bedroom through a secret passageway under the bed and freely have wild sex, with an overaged husband sound asleep right next to them.[32] A father-in-law would peek into his daughter-in-law's bedchambers to look at her emerging nude from the bath, and later initiate incestuous affairs.[33] Servant boys would dressup as Confucian officials, impregnating the officials' concubines one after another, night after night, with little or no consequence. For, once upon a time in the Shaw Brothers' *yanqing* imagination, family hierarchies and Confucian morals were of little importance. Within the Shaw-produced *yanqing* reverie, every time was bedtime, and no one was off-limits.

These Shaw Brothers' projects were not merely plays of erotic pleasure; they were a reconfiguration of the Chinese domestic boudoir, in terms of the traditional extended family and the imperial state it once mirrored in the *yanqing* literary imagination.[34] Yau Ching argues that such raucous reinventions of the genre functioned as a "subversive force to destabilize firmly established power structures, political, class and moral regulatory forces, using sex sprees as a shield against officialdom and family and political authority charging at them, practising what [Laura] Kipnis . . . called the 'civil disobedience' of pornography."[35] To Yau, these films provided a safe medium for subverting social norms, an amplifier to voice what would be otherwise socially muted.[36] I argue, further, that it is in this very "disobedient" restaging of Chinese cultural signifiers that the Shaw Brothers loosened attachments toward Chinese cultural-nationalist and ethno-nationalist orthodoxy.

Such decentering of Chineseness is apparent in the ways the courtesan figure, in particular, is appropriated from a devoted Chinese

yanqing literary trope to become a defiant erotic icon on the Shaw screen. The Chinese courtesan figure has long been idealized in classical vernacular literature as being a client's most loyal companion.[37] The Shaw Brothers restage this character into a hypersexualized carnal icon who embodies domestic boundaries—be they the family boudoir or the Chinese imperial state—if only to mark them as literally penetrable.

In order to outline the ways such permeable imaginations manifest through the Shaw Brothers' reformulated courtesan figure, I first take a close look at director Li Han-hsiang's popular *yanqing* comedy *Junfa qushi* 軍閥趣史 [*The Scandalous Warlord*] (1979). In this pornucopic portrayal of early republican Chinese history, a warlord spends all his time visiting brothels in the name of inspection, and relentlessly marrying courtesans under the guise of bettering the nation-state. The licentiously framed relationship between the warlord and his many courtesan companions traces an affective structure that not only ridicules but rejects both familial and historical fidelity. The characters' outlandish liaisons generate what I argue to be a particularly Sinophonic affective structure, one which challenges the Chinese nation-state as an authoritative site for belonging.

Such an irreverent, or what I read as Sinophonic, expression can be discerned with further complexity if viewed through the lens of queer theory. Similar to Sinophone studies, queer studies problematizes notions of origins or, more specifically, national origins, which often underlie a heteronormative analogy of a reproductive nation-state. Taking this approach to the Shaw Brothers' film empire, I subsequently analyze same-sex desires depicted through the courtesan figure, Ainu, in *Ainu* 愛奴 [*Intimate Confessions of a Chinese Courtesan*] (1972) and its remake *Ainu xinzhuan* 愛奴新傳 [*Lust for Love of a Chinese Courtesan*] (1984). Ainu's performance of desire for her lover, Madam Chun, reworks a queer conception of intimacy that rejects a heteronormative progression of home, family, and nation. I go on to argue that this queer Sinophonic affective structure lies at the heart of the Shaw Brothers' marketing of a collective identity, thus reordering their viewers' Chinese dreams.

THE SCANDALOUS WARLORD AS
SINOPHONIC FANTASY

Directed by award-winning director Li Han-hsiang, *The Scandalous War-lord* is a classic example of Li's many *yanqing* productions that make light of both national and historical types of authority. The film, appearing to be an account of early republican Chinese history, opens with the narrator describing the chaos of the times: "As documented in history, within the seventeen years of the Northern Government Warlord period, China has already had thirty-two cabinet ministers, with the number of warlords reaching even higher numbers." The statistics presented in this opening scene seem to establish the legitimacy of the film. Yet, almost immediately, the narrator's initially objective tone becomes hyperbolic: "Although each warlord might have gained power under different circumstances, they were almost always unreasonable . . . even if they were to do anything beneficial for their people, it would only be by accident. They stir up so many outrageous stories that people think of 'warlords' as being absurdly hilarious figures." This shift in tone, from the official to the affectual, from documented numbers to dramatized ridicule, characterizes the film's overall negotiation between the historical, sensual, and comical. Portrayed as an "absurdly hilarious figure," the warlord—the archetype who historically serves as a stand-in patriarch for the nation-state—is the tale's protagonist for the sole purpose of being scorned.

Bald, obese, and wearing a fake mustache, the clumsy, hot-tempered, and barely literate warlord is the butt of the humor of the film. He spends all of his time meddling with sex workers: visiting brothels under the guise of inspection, scouting out fallen women through the ploy of trying decency cases, or relentlessly taking in sex workers as concubines under the banner of making them honest women. To add to the absurdity, a number of his comical doubles appear whenever he frequents brothels. At first, it is his look-a-like brother who impersonates him while he sits in the next room listening to the action. Later on, the warlord himself impersonates his "cousin" (by merely taking off his fake mustache) when revisiting brothels, thus allowing his official self to be seen as law-abiding while his impersonated double

pursues licentious satisfaction. Through this series of incongruous substitutions—from the absurd warlord standing in for state patriarchy, to the look-a-like "brother's" mirrored appearance, to the warlord's flawed impersonation of his promiscuous cousin—patriarchy is satirized. The warlord's authenticity and authority are, through this sequence of substitutions, one more outrageous than the next, deemed indeterminate and irrelevant.

The warlord's dubious identities are evoked, in particular, when he comes into contact with the film's sex workers. His uncontrollable attraction to his many sex worker companions spurs him to dislocate his executive self from his disorderly other. In the courtroom, trying a sex worker's decency case, the warlord outrageously fluctuates between being the just official and the lustful double. The case is about a young woman (Chen Yinbao 陳銀寶) who was forced into sex work after her husband, Mei Youli 梅有利 [No Strength], discovered her adulterous affair with his younger brother, Mei Youxin 梅有新 [No Heart].[38] Standing steadfast on his podium, the warlord inspects not the validity of the adulterous affair but the virility of the husband. The warlord is interested not in the wife-turned-sex-worker's act of infidelity, but the reasoning behind her desire to find sexual companions outside of wedlock. In other words, the warlord is concerned with whether No Strength had, in fact, "no strength" in bed. While the crowd roars with laughter because of the warlord's outrageous inquiry, the warlord almost immediately reestablishes his authority as he reclaims the courtroom's sonic space with the pounding of his gavel. One moment he cracks dirty jokes; in another, he violently reclaims his power. The warlord's swings between hilarity and legality are exacerbated by his attempts to get to the root of the sex worker's needs and desires.

Such capricious depictions of the warlord's authority, destabilized by his attraction to the film's sex worker characters, deride not only the prescribed legitimacy of the film's patriarch but also the cogency of the early republican era as a pivotal time of Chinese nation building and modernization. The film's delegitimization of this historical moment is brought into focus when the warlord tries to pin down the meaning of "decency" as it pertains to the figure of the sex worker in the presumably modernizing republican era. During the trial, the

warlord disregards what the old mother and husband have to say (two authoritative figures within a Confucian household); he scorns their sense of propriety, calling it old-fashioned. He scolds Yinbao's mother for kowtowing in front of him, mocking her for living in the wrong era. He reprimands the husband, No Strength, for arranging a marriage with a young woman and expecting her to be faithful when he himself is old and impotent. To follow up with his ridicule, when No Strength advises his brother with the ancient saying, "one shouldn't expose family affairs," the warlord tells him to "save some strength, since you [No Strength] apparently have none." Here, we see an explicit mocking of Confucian, read as traditional, tropes of propriety (reproduction of patriline and respect for patriarchy placed above individual pleasure) as if in favor of Enlightenment, read as modern, logics of egalitarianism and free love.

Though the warlord's remarks seem to reflect a progressive imagination of the early republican era—shifting from traditional Confucian notions of family ethics to a modern egalitarian emphasis on individual agency—the warlord's actions defy such a clean sense of linear progression. At the end of the trial, No Heart is given a beating. Yinbao is banned from prostituting herself in public, but in private, the warlord asks for her address so that he can "personally inspect" her. The family patriarch is punished in public if only to fulfill the desires of the regional patriarch, the warlord, in private. The progressive fable of early republican egalitarianism set up at the beginning of the trial is dissolved by the end of it.

While the film satirizes the early republican era, it also ridicules the high moments of the Chinese empire. The grandeur of Han-centric premodern history is defamed when Yinbao eventually enters the warlord's family as a concubine. At the height of the celebrations, the warlord's father demands that the Chinese opera performed must be altered to show the Han dynasty hero Guan Gong 關公 battling the Tang dynasty hero Qin Qiong 秦瓊. Though the dynasties, along with the two heroes, are often considered leading symbols of Han Chinese power, they are historically hundreds of years apart. Either due to the patriarch's ignorance in history or mere abuse of power, centuries of Chinese history are arbitrarily reordered in this scene as a ridiculous

improv. As heroic figures that the warlord is expected to emulate in his own time, Guan Gong and Qin Qiong become laughable under his reign.

Not only does the film anachronistically recast symbols of Han orthodoxy, it also intercuts the opera sequences with racy scenes of infidelity. While the patriarchs of the family are busy rewriting history, their prostitutes-turned-concubines are busy fornicating with their adjutants. As the sequence vacillates between a scene ridiculing ethno-nationalist history and an act defaming familial patriarchy, sonically, they interpenetrate. The rising crescendo of the opera singer harmonizes with the intensifying moans of the adulterers. In this scene, historical, national, and familial patriarchy are put into crisis by the mental and physical impotence of its supposed stand-in, the warlord; the warlord's impotence is accentuated by the infidelity of the prostitute-turned-concubine who he fails to satisfy.

The sex workers propel the film's narrative as the warlord's most sought-after companions; they show the farcicality of not only the warlord's historical presence but also of the historical orthodoxy he represents. Moreover, the licentious company complicates the Shaw Brothers' Chinese dream. By marketing symbols of Han Chinese orthodoxy as permeable fantasies that oscillate between patriotism and commerce as well as history and absurdity, the film loosens attachments between Sinophone communities who consume these fantasies and the geopolitical reality of the Chinese nation-state. Relaxing these cultural and historical binds allows for the emergence of a Sinophonic affective structure. This Sinophonic expression conveys a sense of collectivity that hinges on the very destabilizing of notions such as China or Chineseness.

To read *The Scandalous Warlord* as a Sinophonic expression allows for a more irreverent reading of the Shaw Brothers' repackaging of Chinese signifiers that doesn't necessarily generate cultural-nationalist nostalgia. To perceive the Sinophonic in *The Scandalous Warlord* is to take seriously the anachronistic and profane reorderings of historical and patriarchal authority in the tale, and to identify generative potentials in this degeneracy. Locating the emergence of a sense of Sinophonic expression of identity does not mobilize, but, in fact,

disrupts, heteronormative analogies of a reproductive Chinese motherland and/or a lasting patriarchal state. As such, the Sinophonic lens works, in a way, to "queer" the Chinese diasporic framework within which the Shaw Brothers' productions are frequently understood.[39]

I use "queer" here as an unstable concept that, in the words of Andrea Bachner, "stands in opposition to the very notions of dualism, clear-cut boundaries, and categorical purity."[40] In the context of my Sinophonic reading of the Shaw screen, I activate this idea of "queerness" as a way to visualize a certain contingent relationality between sexual identities on the margins of heteronormativity and cultural identities straddling the edges of hegemonic discourses of nationhood or modernity. A queer relationship, between the sexual and the cultural, is essential to locating a Sinophonic affective structure that approximates yet unsettles Chinese orthodoxy. Howard Chiang argues:

> Situated at the double margins of East Asian and queer scholarly inquiries, the notion of queer Sinophonicity suggests that both Chineseness and queerness find their most meaningful articulations *in and through* one another. When brought together, the Sinophone and the queer promise to denaturalize each other continuously . . . the two signifiers intersect less so in a cumulative sense, than as mutual epistemological referents.[41]

From this perspective, the Sinophonic and queer together provide a unique paradigm that allows for Chineseness and queerness to emerge as cultural constructions that mutually intervene and continually coproduce.

Without reducing "Sinophonic" and "queer" into interchangeable terms with identical interventions, I focus on the elastic conjoining of the two critical lenses, or what I read as "queer, Sinophonic liaisons," to unpack generative potentials of this relationality. With the concept of liaisons, I envision the "flexible, volatile, and yet effective links" that Bachner calls for that don't "[curb] each term's creative energy."[42] As such, I read the Sinophone and the queer not as descriptive terms of fixed identity but as oscillating paradigms, or liaisons, that, through their relational pull, create emergent affective structures that are in a constant process of becoming.

QUEER SINOPHONIC LIAISONS

One of the clearest lenses through which to visualize this liaison between the Sinophone and the queer is that of historiography. Ari Larissa Heinrich argues, "For Sinophone studies to 'queer' Chinese studies . . . it must begin by queering time; it must re-examine those chronologies, like the structural imperatives of diaspora, in which China is always already the point of origin or that place where a point of origin must be identified."[43] Similar to Sinophone studies, queer studies problematizes notions of "origins," or, more precisely, "national origins," which often underlie a heteronormative analogy of reproductive historical progression, its membership frequently disciplined by patriarchal logics of the family and the state. Elizabeth Freeman's concept of "erotohistoriography" intervenes in such heterotypical chronotopes. Freeman sees sex itself—as bodily practice and erotic desires—as a way to perceive different genealogies of places and times that do not neatly follow heterosexualized chronotopes of home, family, and nation.[44] Through what she terms "erotohistoriography," Freeman sees queer practices of pleasure as critical portals of historical rethinking and means for historical rewriting.[45] Erotohistoriography, to Freeman, indexes how queer acts of pleasure can be thought of as temporal practices that produce alternative forms of fixity, dispersion, and continuities in time (and even historical consciousness) across bodies and bodily desires.

Using Freeman's interpretation as my base, I see an erotohistory linking the Shaw Brothers' *yanqing* production of *Intimate Confessions of a Chinese Courtesan* and its remake, *Lust for Love of a Chinese Courtesan*, released a decade later. Juxtaposing the original with the remake, a queer genealogy, or rather an "intergenerational quasi-relationality," if put in Carla Freccero's words, helps us think through and across questions of historical, cultural, and sexual normativity by an indexing of carnal relationality.[46] By tracing a queer pattern of Sinophonic expression through these two films, I approach queering and Sinophonicity as more than pure deconstructive moves of celebratory negation. Instead, this queer Sinophonic liaison is a generative paradigm that formulates patterns of belonging less detectable through dominant arrangements of time, kinship, and history.

Intimate Confessions of a Chinese Courtesan *(1972)*

In *Intimate Confessions*, the Shaw Brothers' Chinese dream is simulated in "once upon a time in ancient China," obscuring geopolitical realities of the Chinese nation-state as it pulls cultural tropes, in this case the "Chinese courtesan," center stage. The film tells the story of *Ainu* 愛奴 ("love slave," if directly translated), a country girl abducted and forced into prostitution at the infamous Four Seasons brothel. It is run by Madam Chun, a sultry taskmaster trained in martial arts who takes a serious liking to the heroine. At first, Ainu violently refuses Madam Chun. Then, a deadly failed escape changes her mind; Ainu decides to take advantage of the madam's favor, seducing her as she gains her affection and obtains her skills in martial arts. Empowered by her newly acquired status, Ainu goes on a killing spree, seeking revenge on not only the four men who raped her but ultimately on Madam Chun, who both took away and invested power in her. In the end, however, Ainu's downfall comes from a moment of affection toward the madam. As she gives the madam a farewell kiss, Ainu is poisoned by the lethal pill hidden between Chun's lips, resulting in a double kill.

To some film critics, the intimate relationship portrayed between Ainu and her madam served as a bold and provocative storyline.[47] However, representations of same-sex relations, instead of being particularly new or daring, can be traced back to premodern Chinese popular novels from seventeenth-century fantastic tales like *Liaozhai zhiyi* 聊齋誌異 [Strange tales of Liaozhai], to late imperial *yanqing* stories, such as *Pinhua baojian* 品花寶鑑 [Precious mirror of ranking flowers].[48] Charlotte Furth explains that, at a time when Chinese culture placed the passing down of patriline above individual pleasure, male same-sex love "was perhaps imprudent in its wasteful expenditure of vital essence, but it was not in principle incompatible with proper male sexuality."[49] Male same-sex relations were, in other words, not read as necessarily running counter to the Confucian family structure. They were intrepreted as an impulsive or perhaps "wasteful" act in regard to the patriarch's energy and "vital essence."

Though not alien to the *yanqing* literary genealogy, representations of same-sex love nonetheless are transformed in *Intimate Confessions*,

focusing not on male, but on female same-sex desires. Film critics of the time rationalized this homoerotic restaging in various ways—the most common was to see the movie as a scientific investigation of homosexuality, a topic perceived as being a progressive or modern inquiry in the West by Hong Kong critics. *Nanguo dianying* 南國電影 [Southern screen] claimed that *"Intimate Confessions* explains the psychology of the issue of homosexuality which is now of global concern."[50] Similarly, *Xianggang yinghua* 香港影畫 [Hong Kong movies] stated that "homosexuality, which is now common in contemporary Euro-America, is by now a very well-known phenomenon. . . . In depicting the homosexual relationship between Lily Ho [Ainu] and Betty Pei Ti [Madam Chun], director Chu Yuan has drawn from a mass amount of contemporary studies from psychologists."[51] The homoerotic was thus framed as a performance of global modernity or, more accurately, as a demonstration of the Shaw Brothers' ability to be on time and on par with Western developments of inquiry. While a trend of "porno-chic" was set in motion in Euro-American markets shortly after Denmark's legalization of pornography in 1968, the Shaw Brothers' initiation and popularization of its *yanqing* genre in the 1970s can also be read as itself an attempt to be "on time" with this sensual, highly marketable wave.[52] In the case of *Intimate Confessions*, imaginations of premodern female same-sex desire—if read as a part of the Shaw Brothers' production of a culturally contained Chinese dream—marketed not only modernist impulses but also cultural drives to produce a queer Sinophonic temporality. Juxtaposing premodern content (courtesans in ancient China) and modernist intent ("homosexuality" as assumed modern inquiry), the Shaw Brothers' release of *Intimate Confessions* staged a world that was both "out of time *and* of the time," both attached to *and* detached from China as a cultural sign.[53]

The queer framing of this modern-ancient tale is demonstrated in the film's setting. The story is set within the walls of a brothel, a deviant "other" space unconcerned with either national or familial patriarchy. Shrugging off her male admirer Baohu, Madam Chun proclaims that she is "just not interested in men," and that she only has eyes for Ainu, in whom she sees her younger self. Generated through this intimate relation is not the anxiety of passing down any patriline

(as commonly portrayed in classical *yanqing* literature) but a "queer" imagination of connection—queer in the sense that it is an attachment not formed by any patrilineal origin or sustained by any heterosexual exchanges of "vital essence." By loving and training Ainu, Madam Chun creates her double, conceiving a next generation of her self within the confines of her brothel, tucked away from state governance.

Madam Chun's desire for generative communion is seemingly reciprocated by Ainu. Ainu continually fuels the madam's affections, stating "you and I are now one being, without you there would be no point in living." She even justifies her killing sprees as an attempt to become closer to the madam: "Perhaps I've just become more like you [madam], and have started to hate men. That's why I seek revenge on them. This could also mean that I'm falling more in love with you, in a sense that I can't stand any other man's affection." Mirroring Ainu's expression of attachment, the madam shows her trust in their bond as she chooses to defend Ainu against the male keepers of the brothel, explaining that she and Ainu "are one and the same person now." What is exchanged here is Madam Chun's dream of an alternative and containable alliance that is generative without the need to mobilize heteronormative forms of reproduction.

This queer desire, which cuts across both sexual and cultural axes of narration, is most pronounced in the film's sex scenes, as they are the intended orgasmic climax of the tale's cultural fantasy. In the two heroines' moment of intercourse (see figure 3.1), they are fully clothed in stereotypical Chinese costume and visually framed by layered drapes enclosing their bedchamber. The sequence is also securely engulfed within the sonic space of the film's theme song; their caressing bodies are blurred outright when the song strikes its finishing crescendo. Coupled with this depiction of same-sex ecstasy are decorations of cultural unity, with the two heroines' performance of desire positioned within an identifiably "Chinese," but temporally obscure, space of imagination. A queer "Chinese" space that lies apart from narratives of patrilineal procreation emerges: a queer topography of Chinese-like cultural memory adorns the heroines' bodies and a self-contained queer temporality is measured by the heroines' escalation of intimacy.

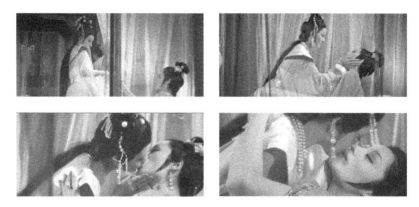

FIGURE 3.1 The two heroines' pinnacle moment of intimacy in *Intimate Confessions of a Chinese Courtesan*

The layering of cultural signifiers in this scene could easily be read as a nostalgic call for a return to a premodern time of Chinese, even if not heteronormative or particularly patriarchal, unity. However, restaging female same-sex desire within layers of cultural tropes engenders a reordered longing for union that strays from given familial, cultural, or national frameworks of emoting. Ainu and Madam Chun's culturally embellished performance of same-sex desire evokes affective structures that do not translate, necessarily, to that of nostalgia for a queer Chineseness, but rather a reinvented desire for queer Sinophonicity that destabilizes attachments to cultural or national origins.

This reformulated desire can be found in Ainu's performance of love for Madam Chun. Parallel to the madam's wish to be "one and the same person" with Ainu is Ainu's desire to take revenge or, in other words, sever the madam from her self. In the end, Ainu claims that her affection for the madam was a mere disguise, a means to break the coalition between the madam and her admirer/brothel co-owner Baohu: "At first, I wanted to use hatred for revenge, but I failed. Then I came up with a brilliant idea, to use love to take my revenge. . . . To bring down the Four Seasons brothel, I used love to come between you and Baohu. Who would have thought, love can be more lethal than hate?" This scene illuminates the possible duplicity brought about by Ainu's performance of love. Rather than dutifully signifying attachment, the

performance allows for detachment. Instead of being a nostalgic reproduction of same-sex affection long found in premodern *yanqing* literary traditions, the scene is a performative reinvention that betrays the original *yanqing* literary formula, which expects unreserved loyalty from the courtesan figure. Ainu's disloyal performance of affection also diverges from Madam Chun's original intent of same-sex unity. Put differently, by reading this scene through the lens of performative reinvention, we shift our attention away from "attachment to the original" to that of "detachment via the theatrical."

To be precise, I am drawing from both the deconstructive and theatrical usage of the term "performative."[54] While Paul de Man suggests the necessarily "aberrant" relation between meaning and the performance of any text, Eve Kosofsky Sedgwick stresses "the torsion, the mutual perversion, as one might say, of reference and performativity."[55] For de Man and Sedgwick, the concept of performativity deconstructs linear cause-and-effect relationships between text and meaning. They emphasize, instead, the potential "torsions" and "perversions" of meaning that occur in the acts of performing and staging that contort relations between intention and affect, origin and telos.

This performative reinvention, or destabilizing, of meaning through the act of theatrical staging is apparent in the histrionic ending of *Intimate Confessions*. Upon her death, Madam Chun tests Ainu's affections for her one last time. While Madam Chun secretly hides a poisonous pill in her mouth, she claims she loves Ainu unconditionally and asks only for a farewell kiss. With tears in her eyes, Ainu is moved to grant the madam an affectionate kiss, a kiss that ultimately brings Ainu to her own demise. At this moment of hesitation, both women betray their intended desires and take on, for a moment, each other's yearnings. Uttering "you are not like me after all, you still have a conscience, you still have love" before she dies, the madam betrays her desire for indifferentiation by killing off her double, Ainu, to prove their difference. With a final kiss, Ainu also suspends her own need for revenge by fulfilling the madam's desire for unity, ultimately dying by her side. The film's dissolution distorts relations between the heroines' intent and affect, highlighting the "torsions" and "perversions" of meaning in the heroines' performance of desire.

These moments of staged infidelities found throughout *Intimate Confessions* express a queer Sinophonic affective structure that twists frameworks of cultural nativity often found in diasporic readings of the film. Such Sinophonic expressions pervert ethno-nationalist portrayals of patriarchy frequently interpreted to be at the heart of the Shaw Brothers' restagings of "ancient Chinese" narratives. By taking seriously the torsions of desires in the film, this Sinophonic reading strays away from linear understandings of the relation between the tale's cultural origin and desired telos. Through the queer Sinophonic liaisons found in the narrative—the heroines' disparate performances of same-sex desire and the heroines' culturally framed yet temporally obscured "Chinese" context—the film unsettles representations of sexual desire as well as national and cultural belonging. This volatile relationality between "Chinese" and queer narratives in the tale mirror the capricious imaginations of "China-as-sign" the Shaw Brothers repackaged as a Sinophonic dream: a queer imagination of unity built upon the destabilization of Chinese cultural orthodoxy and Confucian sexual patriarchy. We can see this Sinophonic undermining of Chineseness further intensified in the film's remake, *Lust for Love of a Chinese Courtesan*, a decade later.

Lust for Love of a Chinese Courtesan *(1984)*

The Shaw Brothers had director Chu Yuan remake their 1972 hit *Intimate Confessions* in the hopes of replicating its success, but not without some drastic retelling. In the film's reincarnation, *Lust for Love,* "China" as a cultural sign is no longer an orthodox site for queering. The remake shows no serious attempt to define a cohesive sense of Chineseness and seems to even flaunt its ahistorical hybridity as part of the movie's sensual performance. The film no longer dresses the heroines in conventional, heavily layered "ancient costume"; they wear contemporary-looking strapless nightgowns, glittery nail polish, and florescent-colored hair clips. We see in figure 3.2, for instance, that the setting is no longer framed with layers of Chinese signifiers, but with an amalgam of various erotic or exotic symbols from an Egyptian-style statue to a quasi-Greek-style vase, to a bed illuminated by modern-day

FIGURE 3.2 Image of various exotic signifiers staged in the heroines' semipublic bedchambers in *Lust for Love of a Chinese Courtesan*

nightlights. No longer are the heroines positioned within a fully enclosed interior; now, they inhabit a semipublic private sphere, with the door to their bedchamber always open. The desire to allude to and appropriate a Chinese dream in the original *Intimate Confessions* is left behind more and more in the remake, gradually disintegrating into competing fantasies that no longer hold conceptions of China as their predominant site of imitation or appropriation.

This shift in imagination—away from a queering of Chineseness—can be detected perhaps most clearly through the changed relationship between Ainu and Madam Chun. The sex scenes in the sequel, for instance, are radically renarrated from a culturally contained site of queer intimacy into a culturally "promiscuous" hetero-bi (not to mention hyper) sexual fantasy. Inserted into the two heroines' relationship is a male figure, Xiao Yeh—a man portrayed as Madam Chun's childhood love who has been quietly guarding her since then. "Didn't you say I look a lot like your sister Chun when she was young?" says Ainu as she seduces Xiao Yeh in the garden. The scene becomes a montage of Ainu's sexual act with Xiao Yeh in the bushes and flashbacks of his first time with the madam in an outdoor bathtub (see figure 3.3). The characters' clothes come off seconds after the background music starts to swell. Shots quickly switch from takes of sexual positions (from woman-on-top, to missionary, to doggy style) and fellatio, all

FIGURE 3.3 The two heroines' same-sex intimacy reframed as hetero-bi-hypersexual desire in *Lust for Love of a Chinese Courtesan*

while hypersexual close-ups of the two heroines' faces are swapped in every so often. Having no reoccurring theme song, the soundtrack at this moment is a compilation of fragmented arrangements, and even those melodies are obscured by the overpowering volume of the characters' moans and groans. This layering of different times, places, and multiple people's desires plays out multiplicities in motion; it unsettles spatial and temporal borders as well as mental and sensual boundaries. As their nude bodies wrestle within the semipublic sphere of the garden, the scene focuses on the characters' sexual act itself, stripped of the Chinese signifiers present in the original film.

The film pushes aspirations for a culturally containable narrative to the background, and the characters' intermingling desires rise to center stage. In the original, Ainu's attachment to the madam is ambiguously portrayed, keeping one guessing even after the concluding kiss whether they bore genuine affection for one another. In the sequel, however, Ainu's seduction is clearly driven by manipulation. Her enticement of Xiao Yeh aims to provoke feelings of loss and jealousy in the madam, instigating fissures among the three characters. This seduction, though alluding to a past moment of perfect unity between the madam and Xiao Yeh, is orchestrated not to recover any such "origin" but to splinter it. The fantasy stages a titillating three-way, performing perhaps what See Kam Tan and Annette Aw term "almost

heterosexual"—a notion that recognizes a narrative's heterosexual framing without foreclosing its queer openings.[56]

This opening up of the readapted tale, along both sexual and cultural axes of narration, reflects the transformation of the Shaw Brothers' targeted Sinophone audience in the 1980s. As the demographic of moviegoers shifted to a new generation, many of whom were born outside of China, a growing local consciousness emerged within each respective community, a consciousness that could imagine cultural affiliation beyond that of an alternatively "Chinese" fantasy. Using Hong Kong as an example, Esther Yau notes that, near the end of the Cold War, "hyperbole, parody, and reinvention became prevalent modes of creation [in Hong Kong cinema] to draw ideas and stylistic references from diverse sources. These modes help break down the notion of bounded cultures, so that the cultural entities that once appeared to be historically and geographically intact are often taken apart and reassembled."[57] In *Lust For Love*, we see this "break down . . . of bounded cultures" through the ways in which the fantasies of Chineseness queered in the original *Intimate Confessions* are reassembled to be "almost heterosexual" as well as "almost Chinese." Stripped of the Chinese signifiers that framed both the setting and the heroines' sexual performance in *Intimate Confessions*, the remake reordered Chineseness to the point of disintegration.

Such dissolutions of Chineseness mirror structural changes in local film industries in various Sinophone regions.[58] Entering the 1980s, the Shaw Brothers' market in Hong Kong and Taiwan was shrinking due to the emerging strength of local film industries. Moreover, the diasporic market in Southeast Asia was unstable due to continuous surges of nationalism and communist revolutions.[59] The Shaw Brothers' markets in Chinatowns across the Euro-American world also faced challenges from the rising fame and accessibility of competing regional industries.[60] By the end of the Cold War, the Shaw empire was on a drastic decline as it competed with the dominance of Hollywood and Japanese films and, at the same time, the rise of local new wave cinemas budding in Hong Kong and Taiwan.

With their Sinophonic audiences' general detachment from China and Chineseness in mind, the Shaw Brothers' restaging of Ainu's tale

in *Lust for Love* regenerates the studio's cultural legacy by, incongruously, heralding their Chinese dream's timely demise. The slow death of the Shaw Brothers' marketing of Chineseness, and the subsequent rise of Sinophonic expressions detached from it, are clearly located in the morphing figure of the courtesan/sex worker. From a promiscuous character who challenges both state and historical authority in *The Scandalous Warlord* to a deceptive seductress who queers the relation between cultural and sexual bounds in *Intimate Confessions*, the courtesan/sex worker figures slackened fidelities toward Chinese orthodoxy and set the stage for the clear articulation of Sinophonic identity embodied through the reincarnated Ainu figure in *Lust for Love*.

Alluding to a past in which the original *Intimate Confessions* marked the Shaw empire's height, in both cultural ideology and market, *Lust for Love* revitalizes such origins if only to reassemble them. In *Lust for Love*, Ainu transforms into a figure that unapologetically detaches herself from both her cultural and sexual genesis in *Intimate Confessions* and, perhaps most importantly, lives to tell the tale. As the sole survivor at the end of the film, Ainu legitimately inherits both the brothel and the stories behind it. She ascends as the authoritative narrator of the tale, entitled to articulate its legacy as she pleases. Ainu, who is framed as a culturally and sexually queer figure in the original *Intimate Confessions*, rises to the center—not the margins—of *Lust for Love*'s Sinophonic universe, unburdened by the binds of Chineseness or Confucian patriarchy that her previous incarnation in *Intimate Confessions* had resolved to queer.

Ainu's shift from a deconstructive to a formative figure can only be identified if we take seriously the queer genealogy, or "intergenerational quasi-relationality," between her two incarnations.[61] By unsettling the original Ainu's performance of a queer Chinese dream in *Intimate Confessions*, the reincarnated Ainu embodies the potential for a sustainable Sinophonic future that reorders the original's queer Sinophonic liaison from serving as the tale's deconstructive margin into its constructive center. In this sense, in reading *Intimate Confessions* and *Lust for Love* together, we are able to recognize the intertextual dynamism with which queerness and Chineseness are activated to mutually intervene and restructure, if not to directly or permanently connect.

The Sinophonic and the queer in the two films work as oscillating paradigms that, through their relational pull, generate the emergence of a clearly articulated Sinophonic affective structure via Ainu's reincarnated figure: one that legitimately releases, even rejects, the burdens of Chinese cultural patriarchy. The dynamism of the Shaw Brothers' Chinese dream is one that is captured perhaps most clearly through the elastic conjoining of queer and Sinophonic lenses. It is precisely the temporal convergence and restructuring of these cultural and sexual rims that drives this central articulation of Sinophonic vitality.

In this chapter, I have identified ways in which the figure of the Chinese sex worker morphs from a flexible, transnational character in the early twentieth century (part 1) into a defiant icon during the Cold War: the figure performs a particularly Sinophonic affective structure that embraces infidelities toward cultural and historical orthodoxy, preventing the Chinese nation-state from being a privileged, homogenous, and/or fixed site for belonging. In the next chapter, I show how this decentered affective pattern is localized in Taiwan, a region that was itself stripped of its nation-state status by the same NATO allies it joined with during the Cold War. I take a close look at how the Sinophonic affective structure explored in this chapter is amplified in Taiwanese literature, which I argue queers not only attachments to "Chinese motherland" imaginations but also "mother-tongue" discourses at the end of the Cold War.

4

OFFENSE TO THE EAR

Hearing the Sinophonic in Wang Zhenhe's

Rose, Rose, I Love You

Since the Cold War break between the Chinese Communist Party (CCP) and the Nationalist Party (KMT), Mandarin language users have been divided by two orthographies: the simplified script standardized by the CCP and implemented in the People's Republic of China (PRC, or mainland China) and the traditional script promoted by the KMT in the Republic of China (ROC, or Taiwan), commonly used by Sinophone communities outside of mainland China. The divide between simplified and traditional scripts is a material manifestation of the Cold War split between the "two Chinas," as it splintered the Mandarin language through the written word as well as its naturalized association with two separate renditions of the "Chinese" nation. The use of particular orthographies operates as a performance of allegiance with either mainland China or the Sinophone communities at large. That is to say, Sinophone communities' distinction from mainland China is reflected in and impacted by the rift between spoken Mandarin and its disparate scripts. The concept of "Sinophone," as an articulated rejection of mainland Chinese orthodoxy, manifests through discordant evocations of so-called Chinese national language.[1]

As the Nationalist Party's home base, Taiwan operated as the central hub for the standardization of the traditional script known as *guoyu* 國語, or "national language." Yet, the use of Mandarin, or even Mandarin's association with Taiwan as a Chinese nation-state, did not come

naturally to its *benshengren* 本省人 ["native" Taiwanese people who lived on the island before the KMT's occupation in 1945].[2] Unlike for many *waishengren* 外省人 [Taiwanese citizens who followed the KMT from mainland China and arrived in Taiwan after 1945], Mandarin was neither a common nor native language for the *benshengren* who had just come out of fifty years of Japanese colonial rule (1895–1945) and decades of Japanese-language assimilation campaigns.[3] Among these *benshengren*, a majority identified the Southern Min topolect as their mother tongue. While the Japanese government suppressed the Southern Min topolect during the colonial era, KMT delegates evoked it as a way to express a certain intimacy, or genealogical connection, between Min and Mandarin. Jing Tsu notes that Mandarin-language reformer Wei Jiangong 魏建功 "recognized that *guoyu* required a reassociation of intimacy with Mandarin in order to strip the idea of national language of its Japanese content. He made an appeal by using a familial analogy that separates Japanese and Taiwanese by two degrees of kinship while likening the relation between Mandarin and Min to siblings."[4] Wei mobilized a genealogical motherland discourse, which naturalized Mandarin as a privileged language innately bound to the Southern Min topolect, as if the two languages were biologically related in a genealogy of Chinese cultural descent. The KMT unification of post-Japanese colonial Taiwan through language reform therefore relied on a naturalized connection with *and* a subordination of local tongues under Mandarin; Mandarin operated as a unifying national language promoted through analogies of a familial state.[5]

This contiguous kinship between local tongues and national language remained uneasy throughout KMT rule. A pivotal flashpoint occurred in the 1970s to 1980s, when the very idea of a "national language" was called into question. In October of 1971, the PRC entered the United Nations, replacing the ROC as the sole representative of China. The PRC instituted the "One-China policy" that pressured the international community to deny Taiwan's status as an independent sovereign state. Taiwan's expulsion from the United Nations, coupled with the death of KMT leader Chiang Kai-shek just a few years later in 1975, opened up the island's identity to substantial redefinition. Literature became a

prominent and contested site of articulation, as did the language used in it, to represent an emergent Taiwan-specific consciousness.[6]

Debates between the modernist and nativist literary camps were critical. Modernist writing in Taiwan generally started with the publication of the literary journal *Xiandai wenxue* 現代文學 [Modern literature] in 1960.[7] In addition to translating major works from the Western modernist canon (e.g., Thomas Mann, James Joyce, Virginia Woolf, William Faulkner, and Franz Kafka), contributors to *Xiandai wenxue* appropriated many forms and features found in these works into their writing. For instance, modernist writers—including Bai Xianyong 白先勇, Wang Wenxing 王文興, and Li Yongping 李永平—were interested in linguistic and formal experiments. Their emphasis on aesthetic experimentation, some have argued, became a mechanism both to sidestep domestic censorship from the Nationalist government and to gain global visibility at a time when Taiwan was losing political standing internationally.[8]

However, nativist writers—including Chen Yingzhen 陳映真, Wang Tuo 王拓, and Huang Chunming 黃春明—frequently argued that *Xiandai wenxue*'s literary modernism was apolitical, rootless, and nonresistant to Western cultural imperialism. Sung-sheng Yvonne Chang notes that "the subversive elements of [modernist] works were easily coopted by hegemonic cultural forces and their critical impact consequently diluted," since most of the modernist writers advocated artistic autonomy from political rhetoric.[9] The modernist's subscription to aestheticism, Chang submits, eventually became deeply at odds with the predominantly lyrical sensibility of ordinary Taiwanese readers. To nativist advocates in particular, writers' experimentation with Western concepts of literary modernism reflected Taiwan's own subordinated status in the Cold War structure, in which the only way for Taiwanese writers to gain global recognition was to apply Western aesthetic forms.

This modernist "literary exercise" was, moreover, mostly reserved for the literary elite, a privileged group disproportionately composed of *waishengren*, who wrote fluently in Mandarin, as opposed to *benshengren*, whose identity was often dislodged from such a China-centric "national language." In response, a nativist movement arose on Taiwan's

literary scene that conveyed anti-imperialist and anti-capitalist sentiments with the frequent use of local vernacular. Deliberately displaying sounds of their mother tongue through Mandarin script, nativist authors wrote stories about humble rural folk whose lives had been deeply attached to Taiwan's soil and who had been largely disenfranchised by the Japanese and Nationalist Party rule alike.

Despite the two literary camps' aesthetic and ideological differences, common sentiments of loss, longing, and victimization run through their works. For instance, prostitution was, for both literary camps, a well-worn metaphor. Often depicted as a vulnerable commodity drifting alongside geopolitical and commercial flows, the figure of the sex worker embodies the helpless dislocation of Chinese mainlanders in exile, a common theme in modernist texts. For instance, modernist writer Bai Xianyong often chose dancing girls and sex workers as his stories' protagonists. In "Jindaban de zuihou yi ye" 金大班的最後一夜 [The Last Night of Taipan Chin], the lead dancing girl Jolie Chin mourns her desolate fate. She reminisces about her golden years in Shanghai's Paramount Ballroom when "she had to use her toes, let alone her fingers, to count up the numbers of big wheels who worshiped at [her] feet."[10] A similar nostalgic sentiment is portrayed through the sex worker Fragrant Cloud Number Six in "Gulian hua" 孤戀花 [Love's Lone Flower]. In the tale, Fragrant Cloud Number Six longingly projects her lost relationship with fellow sex worker Baby Five back in Shanghai onto her bond with Taiwanese bar girl Dainty, whom she decides to take in and protect. Bai depicts his fallen heroines as desperate yet dignified women who, having been displaced from mainland China to Taiwan, persistently long for their lost loves and mourn their glorious pasts.

While Bai's protagonists embody the sorrows of geopolitical displacement, sex workers under nativist writer Huang Chunming's pen are predominantly *bensheng* rural women victimized by Taiwan's Japanese and Chinese Nationalist colonial past as well as by its capitalistic advancements. In "Kanhai de rizi" 看海的日子 [Days of gazing at the sea], the sex worker Baimei's fate follows the ebb and flow of Taiwan's economic development. Huang writes: "Along with the various peddlers, the prostitutes and the red-headed flies all follow the schools of

fish and arrived at the harbor."[11] The prostitutes are framed as being an intrinsic part of Taiwan's industrializing ecosystem. In the tale, Baimei struggles to reinvent herself and to lift her family out of poverty, mirroring Taiwan's economic strides. In addition to reflecting Taiwan's economic development, the prostitutes' service to Japanese sex tourists in "Sayonara! Zaijian" 莎喲娜啦. 再見 [Sayonara! Goodbye] evokes the historical issue of Taiwan's postcolonial predicament. The sex workers' disenfranchised fate in the story reflects Taiwan's historical ravishment by competing colonial and capitalist aggressions.

Claimed by both modernist and nativist literary camps, Wang Zhenhe 王禎和 is often considered part of a younger generation of writers who assimilated the technical sophistication of the modernists and displayed a social awareness as a result of the nativist influence.[12] In addition to using Mandarin script to convey local tongues, Wang frequently mixed a variety of "high" and "low" dictions to create a satirical narrative that illuminates the everyday politics of Taiwan's sociolinguistic landscape. In *Kuaile de ren* 快樂的人 [The happy person], Wang deliberately appropriates grandiose lines from famous classical Chinese poetry to emphasize the superficial, apathetic lifestyle of the middle-class heroine in comparison to her working-class cleaning lady. In *Jiazhuang yi niuche* 嫁妝一牛車 [An oxcart for a dowry], Wang employs military, educational, and diplomatic jargon to depict the main character's economic and diplomatic predicament: he relies on the charity of his wife's middle-class lover to provide him with the oxcart he has always dreamed of owning as an impoverished peasant.

Wang's signature stylistic parody is apparent throughout his work; however, his final novel, *Meigui meigui wo ai ni* 玫瑰玫瑰我愛你 [Rose, Rose, I Love You] is a tour de force. In *Rose, Rose, I Love You*, Wang also alludes to the trope of "Taiwan as prostitute" seen in earlier modernist and nativist works, but he alters its affective connotation. Unlike his predecessors, who commonly depicted the prostitute figure as the embodiment of loss and subjugation, and thus a rallying point to articulate nationalistic sentiment (be it Bai's nostalgia for a "Chinese" past or Huang's call for a dignified "Taiwanese" future), Wang's sex workers ridicule discourses of national sovereignty altogether. Wang uses an amalgam of Mandarin and English script to transliterate his sex worker

figures' disorderly voices: an unruly arrangement of local dialect and Japanese sounds that splinter the national language–mother tongue division carried out in modernist and nativist debates. Wang's sex workers denaturalize both literary camps' investments in the nation-state as site of ideological debate, be it the modernists' nostalgia for a Chinese motherland conveyed through the Nationalist Party's promoted "national language," or a nativist resistance to such China-centricism with the use of local dialects to convey exclusive inheritance of a specifically "Taiwanese" state.

In Wang's novel *Rose, Rose, I Love You*, his sex workers' insubordination ruptures the relationship between literary content and form, sound and script, and, most importantly, the constructed relation between literary discourse and national ideology. The sex workers in Wang's text talk back to the governing authorities by their use of unauthorized languages (e.g., unofficial dialects, curse words, and inscrutable grunts). I suggest that, by characterizing the sex workers as disquietly defiant figures, Wang evokes sentiments that do not claim to neatly generate loyalties to cultural heritage centered on reproductive notions of national purity or nativist states. I argue that, with his cacophonous play of sounds and scripts, Wang amplifies the Sinophonic affective structure introduced in chapter 3, which rejects the Chinese nation-state (be it the PRC or the ROC) as a privileged, homogenous, and/or fixed site for belonging.

Analyzing *Rose, Rose, I Love You* through a Sinophonic affective structure moves the discourse away from a place-bound analysis of Taiwanese literature, which often naturalizes the texts' attachments to Taiwan as territory, locality, or nation. Instead, an affective analysis situates Wang's novel within a larger multinodal network away from inhabiting a monolithic center, be it mainland China or Taiwan. Tracing a Sinophonic affective structure highlights the instability of place-bound perceptions at the heart of the "two-China" political debate and Taiwanese independence discourse. I argue that Wang's evocation of a Sinophonic affective structure—through the sex workers' voices that unsettle hierarchies between local sounds and national script—is amplified in his choice to close the tale with the song "Rose, Rose, I Love You," which the sex workers are asked to sing.

Therefore, in the second half of the chapter, I shift my focus from Wang's novel to the transpacific, translingual, and transmedial mutations of the song version of "Rose, Rose, I Love You." I discuss the ways this particular tune "moves," both spatially and affectually, beyond the written page. The song's movements across time, place, and medium don't just reflect, but expand, the Sinophonic expressions located in Wang's novel. Reading music as a medium through which affective structures are generated and dispersed, I answer Tsu's call to take the "phone" in Sinophone seriously.[13] I listen to the ways a Sinophonic affective structure offends univocal calls for national and cultural authenticity, but also destabilizes Sinophone-as-concept's own articulatory boundaries.

ROSE, ROSE, I LOVE YOU ON THE PAGE

First published in 1984, *Rose, Rose, I Love You* details a day in the life of a Taiwanese coastal city, Hualien, during the Vietnam War period (1955–1975). As the residents of Hualien receive word that three hundred American GIs might soon arrive for a weekend of rest and recreation, the town's English teacher, Dong Siwen 董斯文, quickly organizes local politicians, intellectuals, and brothel owners to set up a bar complete with local sex workers trained to meet international standards so to entertain the dollar-laden U.S. troops. Arranging classes for them from English language and anti-union legislation to American sexual customs and bartending, these leaders spare no effort to prepare select sex workers to serve their American clients appropriately.

The sex workers' "crash course for bar-girls-of-international-standards" is inaugurated at Mercy Chapel, which Wang describes as adjacent to the "Sino-American Theater . . . located on China Avenue in downtown Hualien, a scant few hundred yards down the street and around the corner from the city's red-light district."[14] Wang unambiguously brings out his signature satire and details a historical topography of Taiwan's place in the theater of Cold War politics. Here, Mercy Chapel becomes a satirical microcosm of Taiwan; its questionable location mirrors that of Taiwan's own dubious global positioning

during the Cold War—a democratically sanctioned buffer zone within the Sino-American theater of war that doubled as an (underground) international sexual tourism site.[15] Wang makes sure his readers do not miss his critical tone as he takes to task people in power who endorse the problematic situation of Mercy Chapel (or, for that matter, Taiwan).

Hualien's intellectual, political, and scientific leaders—Dong Siwen (aka, the mastermind behind the bar-girl-diplomacy project), his conspirer Councilman Qian 錢議員, and their friend Doctor Yun 惲醫師—are Wang's most evident targets. Dong Siwen is portrayed as a greed-driven English teacher who forces local bar girls to serve U.S. GIs in the name of diplomacy. Councilman Qian is presented as an absurdly illogical politician who strips naked to manipulate the polls. Doctor Yun is described as a morally bankrupt physician who publically molests his patients in order to "educate" them about modern science. With these caricatured power figures, Wang takes to task issues of cultural imperialism, questions of the democratic system, and the politics of modernity. In turn, he creates a world in which people in power are unambiguously degraded and who simultaneously culturally prostitute the powerless.

The actual sex workers, though not innocent virgins or helpless victims, are the simple yet sane characters of the tale. The bar girls frequently usurp the credibility of not only the characters in power but even the narrator himself; they emerge as the tale's most reliable voices. We see this in the conversation between the pimp Big-Nose Lion 大鼻獅 and his ex-prostitute lover A-hen 阿恨 in chapter 12. As Big-Nose Lion tells A-hen about his meeting with Dong Siwen, he complains:

> Bar girls are people, so how can they be products? That's a good question. But that's exactly the way our Teacher Refinement put it. Who cares if it makes sense or not? . . . Just hear me out. He said, ". . . who are the clientele for our bar girls? American soldier boys, right? OK, now that we've identified our clientele, in other words, we've positioned our product"—right, our dear teacher peppered his speech with lots of American, but that fucking word is the only one I jotted down. Do you want to listen to me or don't you? OK; listen. It came

out *po-li-xiang* [smashing ideals]. Isn't that a riot? . . . He might as well have said *mo-li-xiang* [no ideals]![16]

Big-Nose Lion renarrates, mocks, and even appropriates Dong's speech, undermining Dong's clout as a lecturer. Moreover, Big-Nose Lion disregards the authority that supposedly comes with the use of English, or what he calls "American." While Dong educates the pimps on the value of product placement with the English term "positioning of product," Big-Nose Lion mistranslates—from sound to script—the English word "position" into the Mandarin term *po-li-xiang* 破理想 [smashing ideals]. By reinterpreting Dong's theory of "positioning products," Big-Nose Lion undermines Dong's narrative and replaces it with an interpretation that is closer to Big-Nose Lion's thoughts—that it "smashes ideals." According to Big-Nose Lion, instead of positioning "bar-girl-diplomacy" as *po-li-xiang*, one might as well say it has *mo-li-xiang* 莫理想, which means "no ideals" in Southern Min topolect. By appropriating "position" into *po-li-xiang* in Mandarin and then to *mo-li-xiang* in Southern Min topolect, Big-Nose Lion disrupts the authority of the English language and, simultaneously, illuminates the dominance of the Sino-script over local tongues. Big-Nose Lion disrupts the meaning-making process of the English word "position," first with the use of Mandarin, and then with the sound of Southern Min topolect written through Mandarin script. Wang highlights, then disrupts, the hierarchy of languages, which follows the order English, Mandarin script, Mandarin sound, and Southern Min topolect.

In this episode, Wang satirizes Anglo- and Sino-centrism simultaneously. He invokes the permeability of the English language and the Chinese script vis-à-vis other linguistic sounds and their different meaning-making logics (in this case, Mandarin then Southern Min topolect). Wang sheds light on the politics of cultural translation through the appropriation of sound and script between languages and the characters that articulate them. Writing in Chinese script, Wang incorporates words or phrases borrowed and translated from English, Japanese, and local Taiwanese dialects. In so doing, his writing reflects the contentious complexity of Taiwan's cultural-linguistic

landscape created by the island's histories of colonization, trade, and migration.

Wang's play with cultural-linguistic hierarchies is amplified by the supposedly voiceless prostitutes' significant silences. As in Big-Nose Lion's monologue cited above, A-hen is given no voice by the narrator, yet she is still able to disrupt Big-Nose Lion's rants with her questions, objections, and, at times, apathy. She does so literally *in between the lines* of Big-Nose Lion's description. Her (non) voice inhabits the gaps and spaces of Big-Nose Lion's and the narrator's depictions. As the tale develops, the other sex workers are also able to disrupt and re-code the narratives used to incorporate them. This is evident when Big-Nose Lion describes the bar girls' reaction to Dong's mandate restricting them from serving other local customers so they stay clean for their international guests:

> The girls would have none of it and *refused to quiet down*. They said the only reason they were in the business was to earn enough to take care of their families and they insisted we let them go on working. . . . At first he [Dong Siwen] didn't say a word, until the *girls started getting out of hand and shouted for freedom and democracy for all, equality of the sexes*, crap like that, really letting out all the stops.[17]

Despite being spoken for—their labor being arranged around Dong's plot, and their reactions being renarrated through Big-Nose Lion's words—the bar girls, as Big-Nose Lion puts it, "refused to quiet down" and were "getting out of hand." They foul Dong's clean plot for diplomacy and fluster Big-Nose Lion's descriptions with the clamor of their own narratives. They appropriate the same political language of "freedom and democracy for all, equality of the sexes" that Dong utilizes to exploit their bodies, appropriating it to vie for their labor rights and to exchange their bodies on their own terms. As a result, Wang's depiction of the "Taiwan as prostitute" trope departs from that of his modernist and nativist predecessors, whose portrayals often centered on issues of lost Chinese origins or denigrated Taiwanese innocence.

Wang, instead, emphasizes the bar girls' labor *as* sex workers, depicting them not merely as helpless victims but as active agents who work to manipulate the discourses used to exploit them.

These narratives of "cleanliness" and "diplomacy" are precisely what A-hen uses to reject Big-Nose Lion when, at the end of the chapter, she is finally granted a voice. As Big-Nose Lion continues to complain about Dong's project, A-hen uses her need for beauty sleep as an excuse to stop his rants. When he tries to undress her for a quickie before sleep, she pushes his hand away:

> "Not tonight!"
>
> "It won't take long."
>
> "I said, not tonight. Didn't you tell me Teacher said we couldn't turn tricks, in order to keep our bodies clean?"
>
> . . .
>
> "I said no. If I contaminate my body, how will I ever face those GIs?"
>
> . . .
>
> "Didn't you say I was a reserve? What if I was called to duty with an unclean body?"
>
> A-hen shrugged her shoulders, the hint of a grin on her face.[18]

Wang's use of language and voice creates a liminal space in which discourses are allowed to clamor and transform. The voiceless sex workers' resistance to—as well as appropriation of—Dong's exploitation, Big-Nose Lion's requests, and the narrator's exclusion, marks the sociolinguistic inequities behind Wang's staging of this tale of "bar-girl diplomacy." In particular, Wang's writing creates passages in-between languages and produces discursive networks that challenge their power dynamics. He focuses on the power relations between languages, discourses, and signs and creates a "translational" voice that confronts the irreducible multiplicity and the hierarchies built into Taiwan's cultural-linguistic history. Here, I draw from Lydia Liu's take on the study of translation. To Liu, translation elucidates "the dynamic history of the relationship between words, concepts, categories, and discourse," which

are, moreover, always political.[19] By adapting, appropriating, and re-coding one language to another, Wang confronts the hierarchical and contested politics of cultures that prompt these translingual exchanges.

Translating Taiwanese Feeling into a Sinophonic Affective Structure

Analyzing Wang's work through the lens of translation allows us to problematize discussions of Taiwanese identity politics that have long centered on disputes over geopolitical attachments; these authenticity discourses underpin the modernist and nativist literary debates on the use of national language and/or mother tongues.[20] Nativist writer Song Zelai 宋澤萊, for instance, evokes this essentialized discourse when interpreting what he calls *Taiwan ganqing* 台灣感情 [Taiwanese feeling]. To Song, the making of "Taiwanese feeling" depends on the utilization of local tongues, particularly the Southern Min topolect, which he considers to be the "native Taiwanese language," as opposed to the Mandarin "national language." The "mother tongue," he argues, is "the first step toward understanding Taiwan."[21] Song expresses a nostalgic yearning for an original, naturalized linguistic home—the "mother tongue"—to support expressions of cultural belonging.

What Song invokes is perhaps similar to a sense of what Jing Tsu terms "linguistic nativity," or when language, particularly one that someone is "born into," and therefore legitimately "inherits," becomes perceived as the natural site of identity.[22] Underlying such notions of "linguistic nativity" is a gyno-political analogy of identity formation hinging on normative logics of cultural descent. Building on Tsu, Andrea Bachner states: "The mother tongue, this embodiment of language in its 'natural' state, as innate rather than acquired, remains an important mainstay of essentialism and identity politics, even in an age in which identity has been (theoretically) challenged—or 'deconstructed'—in so many ways."[23] General subscriptions to the authority of the mother tongue as a sign of nativity have simplified Taiwan's linguistic diversity; more importantly, they have glossed over the internal politics operating underneath Taiwan's diverse cultural-linguistic landscape—an island on which basic access to the mother tongue is, to many, more a privilege than a birthright.

By analyzing *Rose, Rose, I Love You* through an attention to translation, I emphasize the constructed relations between language and identity formation rather than take for granted naturalized notions of linguistic nativity or political fidelity. To be precise, I adopt Tsu's view of language as a "medium of access rather than as a right to identity," and treat "linguistic nativity . . . as a currency instead of a stamp of authenticity."[24] Drawing from Tsu's reading of translation, I trace the unnatural kinships and unlikely genealogies that Wang creates *between* the many legitimized and unauthorized languages he puts into contact in the novel.

Moreover, the politics of translation is not only historically conditioned but affectively driven. Using a concept similar to what Dipesh Chakrabarty terms "translational histories," I approach Wang's novel as a translational archive that allows hegemonic discourses to be continually retranslated by affective, and often incommensurable, expressions.[25] Wang's sex workers frequently express affective narratives that defy and mediate the official discourses—specifically those of international diplomacy, nation-building, modernity, and democracy—that the story's leaders use. Though often spoken for or left out by the narrator, the bar girls' (non)voices, through silent interruptions, apathetic dismissals, or the recoding of authoritative discourse, challenge the continuity of the narratives that aim to co-opt them.

The sex workers' negotiating powers are most clearly depicted in the second half of the novel, when they all reluctantly attend the open ceremony of Dong's "Crash course for bar-girls-of-international-standards." Sitting half-awake in Mercy Chapel, the girls respond to the leaders' ceremonious praises for each other with yawns, laughs, and, at times, utter disdain. As Dong presses them to pay "heartfelt tribute" to the pimps' investment in this diplomatic project, the girls bite back disparagingly:

> "We're the ones who filled the Big 4 managers' pockets with all that money. Heartfelt tribute? Bullshit!" Even in a whisper, her comment was audible to the girls around her, and drew a round of sniggers.
>
> . . .

"I thought they were going to give us some extra money to make up for our losses during these training sessions."

. . .

"Fat chance!"

All the girls who heard this exchange laughed spiritedly—tee hee hee, tee hee hee—keeping their voices so low that some of the laughter sounded like coughs from next door.[26]

The girls continue with their remarks and muffled laughter, the sound of which disrupts and, at moments, completely overrides the authorities' speech onstage. The power struggle over Mercy Chapel's sonic space continues throughout the ceremony, as the sex workers' affective narratives—laughter, protests, and snores—battle the solemn discourse of praise on stage, and the sporadic shouts from the pimps for them to "shut up," offstage.

This power struggle between competing discourses reaches its height when Dong takes the stage to teach the girls, what he calls, "Bargirl English." Prioritizing their customers' linguistic comfort, Dong gives the girls new English names because, he argues, it's "too much to ask the Americans to pronounce the names in Chinese," for "how can we expect [American GIs] to distinguish among all those *zhi chi shi, zi ci si, yi* and *yü* sounds?"[27] Here, the hierarchy between English and Mandarin is ordered along the interests of business. Dong instructs the girls to learn from his puckered, English-speaking lips. However, the girls are either annoyed and curse "What the hell is he saying?" or are amused and tease Dong for having a "*Kawain e*" ["cute" in Japanese] mouth.[28] In the face of Dong's attempts to indoctrinate them to value the English language, the girls reply with sounds of ridicule and apathy.

Ignorant of the girls' indifference, Dong enthusiastically gives the name Patricia to the bar girl Li Shunü 李淑女:

"*Now, repeat after me: My name is Patricia.*"

Nothing

"*Speak.*"

"Ma —" As her face crimsoned, student Li seemed to be calling for her mother [in Mandarin] before her voice gave out.

. . .

Miss Li looked up, her eyes filled with embarrassment, and stammered:

"Ma, ma, ma-nee—"

"Mai, mai, it's pronounced mai, not your mama."

. . .

Sweat began to drip from her scalp into the corners of her eyes, then continued down her cheeks and onto her neck; the crystalline marks looked like tear streaks. "Ma—Ma—"

. . .

"What's this, *ma nee* [give you hell], *ma nee*?" Siwen tore off the Christian Dior tie Councilman Qian had given him and swirled it over his head like a whip. "Ma nee, ma nee, that's exactly what I ought to do, give you hell!"[29]

Student Li's struggle to articulate the first word of the English self-introduction taught by Dong is here reflected in the narrator's depiction—being peppered with silent "nothings," ellipses, and fragmented dashes. For as long as nine pages, student Li struggles with the pronunciation of the word "my" without much success. She instead articulates the sounds of *ma* ["mother" in Mandarin], or *ma nee* ["give you hell" in Mandarin]. While Li and the narrator scuffle to piece together a cohesive sentence in English, elaborate depictions of the characters' affective reactions dominate the page. From detailed descriptions of Li's sweat that "began to drip from her scalp into the corners of her eyes, then continued down her cheeks and onto her neck," to that of her quivering body, to her bursts of tears, and to the "two clear streams of snot [that] snaked out of her nostrils," Li's affective reactions develop, and, in turn, govern the narrative.[30]

Finally, after nine pages of stutter and silence, snot and tears, Li eventually pieces together a string of words that sound similar to Dong's English sentence. However, her pronunciation has a different meaning when understood as a mixture of Mandarin and Southern Min topolect:

[Li Shunü] forced herself to raise her tear-streaked face; her lips quivered, until she finally managed to do as she was told. "Ma nee yee si ba—"

. . .

She chewed on her lip and whimpered for a moment, then pressed on to the finish and got the whole alien name out. It sounded to everyone as if she had said *ba dee kee she ya* [I'll beat you to death]!

. . .

Teary-eyed Li Shunü looked down at the flower basket Siwen had knocked over. "*Ma nee yee si si ba dee kee she ya* [I'll give you hell and beat you to death]!"[31]

In response to Dong's violent training, Li seems to have articulated her adopted English introduction. Yet, in her accented performance, she simultaneously reserves sounds for her audience to piece together alternative meanings. In addition to sounding like an introduction of Li's new identity—Patricia—in English, Li's defective pronunciation also retains the sound of her cursing "I'll give you hell and beat you to death" in a mixture of Mandarin and Southern Min topolect. These unruly sounds, captured by Li's peers giggling, and by the narrator scripting it on the page, were inaudible to Dong, who was too busy feeling beside himself with joy. "Who cared if her pronunciation was a little off?" Dong thinks to himself. "She'd done it, she'd said the whole thing!"[32] he proclaims. In this scene we hear the coexistence of separate yet interpenetrating narratives. We detect the hegemonic discourses that celebrate the leaders' investment in their "diplomatic project" and tell the story of Dong's successful instruction of "Bar-Girl English." We also hear affective narratives articulated through the apathetic and, at times, defiant sounds from the girls, in the refined depictions of Li Shunü's tears of embarrassment and fear, and finally through her accented sounds of disobedience with her "English" introduction. The narratives are allowed to coexist and, at moments, remain incommensurable with each other in terms of meaning, and untranslatable in terms of sound. The sex workers' affective expressions work to puncture, and even reject, totalizing enterprises of knowledge production attempted by the tale's leaders.

The way Dong's official discourse and the bar girls' affective narratives negotiate and mediate in this scene reflects Wang's ability to negate the novel's main storyline of "bar-girl diplomacy." Although the whole novel centers on a detailed description of Dong's preparations

for the American GIs' arrival, the sex workers' defiant reactions to his elaborate arrangements call this focus into question. At the end, we hear two girls discussing whether there is indeed a need for all this training:

> "I'm scared. . . . I don't know how I'm supposed to twist my tongue around all those wild sounds."
>
> . . .
>
> "Simple, don't say anything."
> "Then how do I do business with those big-nose guys?"
> "Simple . . . take off your pants."
> "Aiyo, you crack me up!"
> "I'm not joking. Take off your pants, and you're in business! You have to be nuts to waste time with that ridiculous Ma nee yee si si ba dee kee she ya!"[33]

Inaudible to Dong amidst the ceremonious activities on stage, the two sex workers' private question-and-answer session complicates Dong's endeavor to launch, as well as the narrator's effort to narrate, these "crash courses for bar-girls-of-international-standards." One of the girls exposes Dong's training sessions to be a frivolous show. She disillusions his high and mighty rhetoric of "international diplomacy" and "cultural exchange" as she asserts, "Take off your pants, and you're in business!" Moreover, the story ends before we find out whether or not the American GIs—the purported bearers of decadence, modernity, and material affluence—even arrive at the shores of Hualien. Judging from the tale's disregard to either Dong's project or the American GIs' potential arrival, Wang is disinterested in "bar-girl diplomacy." Instead, he emphasizes the competing narratives that are played out, negotiated, and ultimately rejected through its arrangements.

Characterizing the sex workers as disquietly defiant characters, Wang deconstructs what Song Zelai calls a "Taiwanese feeling," which connotes sustained fidelity to cultural and linguistic nativity. Wang accentuates an *infidelity* between language and the articulation of national identity. As Wang orchestrates a cacophony of discourses—dominant and minor, official and affective—he tells a bastardized tale

of Taiwan nation building at a time when the island's legitimacy as a sovereign "Chinese" nation was called into question by Taiwan's expulsion from the United Nations and subsequently severed relationship with the United States. Uninterested in reclaiming Taiwan's geopolitical legitimacy on an international stage, Wang's bar girls express sentiments that do not neatly generate loyalties to cultural heritage or national purity. With his cacophonous orchestration of the girls' voices, Wang amplifies a Sinophonic affective structure; it disorders clear analogies of either a reproductive Chinese motherland or a nativist Taiwanese state.

Wang's evocation of a Sinophonic affective structure—by unsettling fidelities between sound and script through the sex worker figure—is, I stress, most vocal in his choice to close the tale with the song "Rose, Rose, I Love You," which the girls are scripted to sing. The song expresses but, more importantly, *echoes beyond* the Sinophonic structure of feeling located in Wang's novel.

SINOPHONIC SERENADES

Rose, Rose, so sweet and charming,
Rose, Rose, so lovely to view,
Flowering on the bush each spring and summer,
Rose, Rose, I love you.[34]

As the ceremony comes to an end, the novel closes with Dong having a "stroke of genius" during Dr. Yun's lecture about the latest venereal disease, Saigon Rose. Listening in on the infectious powers of the Saigon Rose, Dong fantasizes about another rose, the popular song "Rose, Rose, I Love You." As a tune that already had Mandarin and English versions, it was, in Dong's mind, the perfect song to sing to welcome the American GIs. Dong imagines how the girls might raise their voices to sing, with "strong affection and deep love," first in Mandarin, then in English:

Rose, Rose, with your slender stem,
Rose, Rose, your prickly thorns,

Wound the tender stem and precious bud,
Rose, Rose, I love you
The heart's vow, the heart's affection, a sacred and pure
 light shines above
The heart's vow, the heart's affection, a sacred and pure
 light shines above
Rose, Rose, I love you.[35]

As the basis of the novel's title, the song's lyrics echo the novel's satirical aim. The "sweet and charming" roses allude to the sex workers who are about to sing about them (flowers being a traditional metaphor for courtesans in Chinese/Sinophone literature) and, arguably, the sexual love they are to market, as they allure their clients to "wound [their] tender stem and precious bud."[36] Thought of by Dong during Dr. Yun's sexual hygiene lesson, the rose becomes a convenient metaphor of the "Saigon Rose," which indeed bears "prickly thorns" in terms of being an aggressive venereal disease resulting from a thorn-ridden form of cultural exchange: "international diplomacy" by name, glorified prostitution by game. Furthermore, the Mandarin pronunciation for rose, *mei gui*, sounds eerily similar to the word for "the United States" *mei guo*, especially if sung out loud.

Additionally, the translation of "Saigon" (*xigong* 西貢) in Mandarin looks and sounds identical to the Mandarin term for "Western tribute." This resemblance adds a layer of satire to this tale about "infectious" tides of "Western tribute" during Cold War Taiwan. It is as if *xigong* (Western tribute/Saigon Rose) was a disease that the characters need to risk catching in order to make a living in such a thorny political climate. The tune bears the name of, and literally closes, Wang's novel about the prostitution of Taiwanese *mei gui* (roses) in service for *mei guo* (American) clients; the song "Rose, Rose, I Love You" rings of illicit similes and sounds that, despite and in spite of translation, call for a wider, perhaps slightly mischievous, reading of the tale beyond the printed page.

Wang's novel was once called "trash" by Wang's wife, "dirty" by his daughter, and *bukan ru'er* 不堪入耳 [an offense to the ear] by literary critic and later cultural minister of Taipei, Long Yingtai 龍應台.[37] It is

precisely these dirty resonances and sullied accents that I lend an ear to in the last section of this chapter. Jing Tsu notes, "How the ear could be the assaulted organ in an act of reading refocuses attention on the literary language as an uneasy union between aurality and script."[38] My analysis of Wang's novel follows the meaning-making processes the tune "Rose, Rose, I Love You" (lyric and music) itself offers. The English translation of Wang's novel includes an afterword by the translator, Howard Goldblatt, which details the half-century trans-pacific, translingual, and transmedial history of the song.

Goldblatt's ending is a way to begin analyzing this aural genealogy. Jacques Attali writes, "the technology of listening in on, ordering, transmitting, and recording noise . . . is the ability to interpret and control history, to manipulate the culture of a people, to channel its violence and hopes."[39] Music is never completely detached from politics or history. Josh Kun argues, moreover, that "music creates spaces in which cultures get both contested and consolidated and both sounded and silenced—double acts of delinquency that question both the geopolitical boundaries of the modern nation-state and the disciplinary boundaries that govern its study in the academy."[40] Kun highlights the geopolitics of music with attention to its circulation across and around national borders. In addition to tracking a tune's audio-spatiality, it is also imperative for us to listen closely to the structures of feeling the song echoes. Even if music is not "expressly political," Kun maintains, it is "usefully emotional."[41]

This affective element of music is what I focus on in my analysis of the song "Rose, Rose, I Love You." I read the song as a medium through which the Sinophonic affective structure, expressed through the sex workers in Wang's tale, is generated, dispersed, and reordered beyond the written page. Focusing on the ways the tune "moves" both spatially and affectually, I depart from the assumption that the song has any fixed origin or intended audience, or that there is a direct relationship between its performed intent and perceived affect. Instead, the unexpected transfigurations of the tune can be heard as part of a larger orchestration of Sinophonic sentiments that not only shuffle univocal calls for national and cultural authenticity but disorder Sinophone-as-discipline's own articulatory boundaries.

Music That Moves: "Rose, Rose, I Love You"

"Rose, Rose, I Love You" was originally composed by Chen Gexin 陳歌辛, with lyrics by Wu Cun 吳村. The song was first recorded in Mandarin in 1937 and gained popularity when performed by well-known sing-song girl Zhou Xuan 周璇 in the 1940 movie *Tianya genü* 天涯歌女 [Wandering songstress].[42] Popularized through "soft," or "entertainment," cinema, as opposed to left-wing "hard," or revolutionary, cinema, "Rose, Rose, I Love You" was considered *huangse yinyue* 黃色音樂 ["yellow" or "pornographic music"]—a hybrid of American jazz, Hollywood film music, and Chinese folk melody most notably pioneered by Zhou Xuan's mentor, Li Jinhui 黎錦暉.[43] Left-wing intellectuals and the Nationalist government dismissed such "yellow music" as it thrived during the Second Sino-Japanese War (1937–1945).[44] The tunes were regarded as *mimi zhi yin* 靡靡之音 [decadent sound]: a sound created by commercial excess and that was seen, in effect, as promoting political passivity, as it seduced citizens away from the pressing tasks of nation building and anti-imperialist resistance.[45] The condemnation of "yellow music" at a time when China's national boundaries were in crisis amplified the contentious cacophony between governed calls for national sovereignty and popularized noises that coexisted with, contested, and even transgressed the supposed tidiness of such geopolitical borders.

Indeed, after the Communist take-over in 1949, "yellow music" was banned from mainland China, only to reemerge in different forms across geopolitical precincts. The English version of "Rose, Rose, I Love You" was released by Columbia Records in 1951 and reached third place on the *Billboard* magazine music charts soon after. Written by British radio presenter Wilfred Thomas and performed by American singer Frankie Laine, this English version of the same tune told a fairly different story:

Rose, Rose, I love you with an aching heart
What is your future? Now we have to part
Standing on the jetty as the steamer moves away
Flower of Malaya, I cannot stay

Mei Gui, Mei Gui, oh, make way for my Eastern Rose
Men crowd in dozens everywhere she goes
In her rickshaw on the street or in a cabaret
"Please make way for Rose" you can hear them say

All my life I shall remember
Oriental music and you in my arms
Perfumed flowers in your tresses
Lotus-scented breezes and swaying palms

Rose, Rose, I love you with your almond eyes
Fragrant and slender 'neath tropical skies
I must cross the seas again and never see you more
'way back to my home on a distant shore

All my life I shall remember
Oriental music and you in my arms
Perfumed flowers in your tresses
Lotus-scented breezes and swaying palms

Rose, Rose, I leave you, my ship is in the bay
Kiss me farewell now, there's nothin' to say
East is East and West is West, our worlds are far apart
I must leave you now but I leave my heart

Rose, Rose, I love you with an aching heart
What is your future? Now we have to part
Standing on the jetty as the steamer moves away
Flower of Malaya, I cannot stay

Rose, Rose, I love you, I cannot stay [46]

The song was one of the first popular Chinese songs rewritten in English. It became a minor hit in the United States as well as among British troops stationed in Hong Kong.[47] Circulated shortly after World War II came to an end, the song morphs into a swan song sung

by a Western soldier who is "standing on the jetty as the steamer moves away" bidding his "Eastern Rose" farewell. Through the song's "translation" one can detect what Jones interprets as the "curious doubleness of yellow music"—in which "yellow" signifies both pornography and racial identity, eroticism and Chineseness—emerging and transforming in a post–World War II transpacific setting.[48]

We can identify a "Madam Butterfly-ish" Orientalist imagination in which the speaker's "Eastern Rose" is exotically and erotically depicted, with emphasis on her "almond eyes" and her body as "fragrant and slender 'neath tropical skies." The land in which she roamed is given a similar ex/eroticized treatment; it is depicted as a land in which *"Oriental* music" (my emphasis) lingered among *"Lotus-scented* breezes and swaying palms" (my emphasis). While absent in the Mandarin antecedent, this version is an aural fantasy that stresses essentialized and culturally marked difference: the "Oriental" in front of music, the "Eastern" in front of "Rose." In this postwar English rendition, tones of Asia's colonial history spurred by Orientalist imaginations of the "East" emerge, as does an intimate account of Western military involvement in Asia during the two world wars.

In the context of Wang's novel, the song's narrative of an ill-fated East-West liaison works as an analogy not only of the Vietnam War at large, but also of Taiwan's broken relations with the United Nations and the United States. Though not specifically mentioned in Wang's narrative, the song's "English" history—with its allusions to Asia's intimate encounter with Western colonialism, imperialism, and military and diplomatic involvement—sets the tone for Wang's satirical account of Taiwan's Cold War era *xigong* [Western tribute].

However, the most immediate source of Wang's inspiration is perhaps 1950s Hong Kong filmic remakes of the popular Shanghai song, circulated roughly around the same time as its English counterpart.[49] The Mandarin version of "Rose, Rose, I Love You" resurfaced in Hong Kong in the Shaw Brothers' film *Hong meigui* 紅玫瑰 [*Red Rose*] in 1952 and was said to have reached its apex of popularity within Sinophone communities after the 1959 release of the Cathay Color blockbuster *Longxiang fengwu* 龍翔鳳舞 [*Calendar Girls*].[50] As many musicians in Shanghai migrated to Hong Kong after 1949, Hong Kong became a new hub for

Mandarin popular songs that had originated in Shanghai.[51] In Taiwan, *haipai* 海派 [Shanghai school] or *haigangpai* 海港派 [Shanghai-Hong Kong school] Mandarin music was promoted by the Nationalist government so it could carry out its de-Japanization and Mandarin-speaking movements.[52] Appropriating the party's own condemning narrative of "decadent sound" from back in 1930s Shanghai (which referred to the very "yellow music" that it now promoted), the Nationalist government used the same rhetoric to instead repress Taiwanese popular music performed in Southern Min topolect. For the party officials, popular music in the Southern Min topolect exemplified Japanese colonial influence and neglected Mandarin, which they were institutionalizing as Taiwan's unified national language.[53] After multiple layers of "translation"—from 1930s Shanghai "yellow music" to its remakes as 1940s Shanghai "soft" cinema to 1950s Hong Kong filmic representations—Mandarin classics like "Rose, Rose, I Love You" were redeemed as "clean and healthy" media to articulate unified, healthy, yet entertaining anti-Japanese and anti-Communist sentiments.

Read in light of the genealogy of transpacific, translingual, and ideological mutations of "Rose, Rose, I Love You," Wang's tale of Taiwan nation building and international affairs is further complicated. Wang's novel is about the marketing of one of Taiwan's most lucrative Cold War-era industries of cultural exchange (sex work in and around GI R&R camp towns); its title mirrors the song whose English and Mandarin renditions took part in another affective industry contingent to the R&R business circuit: musical entertainment.[54] Shin Hyunjoon and Ho Tung-hung state that popular music flourished alongside the boom of GI clubs during the Vietnam War. Being a U.S. anti-communist ally, Taiwan became a rear base popular among GIs.[55] The Cold War circulation of "Rose, Rose, I Love You" is thus attached to the Nationalists' project of Taiwan nation-building. Its Mandarin version was propagated to fuel anti-Japanese and pro-Mandarin unification, and its English version, as depicted in Wang's novel, was performed to solicit lucrative "intimate relations" with the United States and its GIs. The popular circulation of the song—in and out of Wang's novel—magnifies the international affairs involved in voicing Taiwan's identity detached from China, and in performing Taiwan's relationship, however illicit, within a global imaginary.

Therefore, the riotous genealogy of "Rose, Rose, I Love You" amplifies Sinophonic sentiments beyond those that reject Chinese orthodoxy. It reverberates in a larger global history of empire and conquest that defies fidelity to any singular, centripetal definition of national sovereignty, be it that of China or Taiwan. From its inception, the song was itself a "delinquent" sound of love that desired the wrong subject— that is, a romantic instead of a patriotic subject—if heard as part of the Nationalist and the left-wing intellectuals' rally for a unified Chinese nation. As such decadent sentiments were translated into English, after being banned from mainland China, the song expressed Orientalist desires for a "yellow" (eroticized and exotified cultural difference) fantasy. Through it, we hear tones of Asia's ill-fated encounter with Western colonialism and imperialism, as well as military involvement in the two world wars. Moreover, with the filmic reemergence of the song's Mandarin lyrics, we detect the Nationalist government's attempt to consolidate a centralized national language in Taiwan. It also echoes Taiwan's shattered alliances with the United Nations and the United States. The tune's respective transmutations thus archive the many untidy liaisons that at times sound, and at other times silence, supposedly univocal calls for genetic or political authenticity.

With the song "Rose, Rose, I Love You" as an example, calls for Taiwanese identity detailed in Wang's novel can be seen as part of a Sinophonic movement that intervenes in articulations of Chineseness— whether it be Sino-centric longings for a motherland that fits comfortably within the geopolitical boundaries of a Chinese nation-state, or Euro/Anglo-centric perceptions of Chineseness as a persistent marker of cultural and ethnic difference. Moreover, with its movements across time, space, and medium, "Rose, Rose, I Love You" reverberates with larger movements of global "infidelities" that offend centripetal articulations of political allegiance and national sovereignty. The tune not only amplifies the Sinophonic structure of feeling located through the sex workers' disorderly voices in Wang's novel, it also expands the affective structure into a similarly defiant but globally circulated orchestration of illicit affairs.

Wang's novel, published in 1984, came out at a historical juncture when Cold War divisions were on the verge of collapse and neoliberal renditions of global connectivity were on the rise. Read in this context,

Wang's *Rose, Rose, I Love You* (both the novel and his use of the song) heralds a wider, more global ear that picks up minor, less legitimized, chords of transnationalism. Thus, while I've traced the ways in which Sinophonic expressions are intensified through Wang's novel, in chapter 5 I show how this defiant affective structure transforms into a localizing articulation of identity in the neoliberal era. To be precise, I locate the emergence of a minor transnational affective structure that challenges the centrality of both the nation-state and global economic flows, an affective structure I identify as "dwelling."

PART III

DWELLING DESIRES
AND THE NEOLIBERAL ORDER

5

DWELLING

Affective Labor and Reordered Kinships in
The Fourth Portrait and *Seeking Asian Female*

M any have analyzed the increase in economic liberaliza-
tion, across the globe, since the end of the Cold War.[1]
Advocates of this restructured, often called neoliberal,
world order celebrate the opening up of national borders that makes
way for international market flows, hybridization of cultures, and the
supposed expansion of democracy and universal human rights. Within
this logic, individual agency is tied to the liberalization of the market-
place.[2] Jodi Melamed argues that the neoliberal political paradigm in-
corporates the rhetoric of civil rights to declare "economic rights" as
the most fundamental civil right. It portrays neoliberal policies of de-
regulation and privatization as the key to a post-racial world of free-
dom and opportunity.[3] In contrast, critics of neoliberalism stress the
uneven accessibility and distribution of material resources within the
global market due to colonial legacies and neocolonial policies. They
argue that the presumption of a leveled playing field masks the way
capital flows more readily to first-world nations and economic elites.
To its critics, neoliberalism's universalistic promise of socioeconomic
freedoms contradictorily upholds unhindered freedoms for the privi-
leged few.[4]

While contemporary forms of globalization are by no means a purely
or cohesively neoliberal phenomenon, such debates about neoliberal-
ism often overlook the many fissures and unexpected reconstructions
of power involved in the globalizing process. The concept of "affective

labor," as some argue, plays a central role in a late capitalist mode of production. It addresses both dominant and resistant means of capital accumulation.[5] For instance, Michael Hardt describes affective labor as being "embedded in the moments of human interaction and communication."[6] To Hardt, affective labor "is immaterial, even if it is corporeal and affective, in the sense that its products are intangible: a feeling of ease, well-being, satisfaction, excitement, passion—even a sense of connectedness or community.... What affective labor produces are social networks, forms of community."[7] Breaking down distinctions between the immaterial and the material, Hardt argues that the immaterial form of affective labor is how deterritorialized information flows circulate within a global market economy. It is a means of capital accumulation; it also has the potential to resist capital, since affective labor produces a wide range of alternative communities.[8] Affective labor is, thus, what allows for subject and social forms to manifest, whether alongside, against, or tangential to the flow of economic capital.

With Hardt's attention to a double-edged politics of affective labor in mind, I read the sex worker as being a particularly significant affective laborer. The sex worker traffics in, pushes back against, and also reorders domestic (familial and national) boundaries in relation to the neoliberal marketplace. With affective labor, the sex worker illuminates dominant and resistant forms of capital accumulation; this figure also shows unexpected workings of power within and across national borders. In focusing on the sex worker figure, I explore a form of what Françoise Lionnet and Shu-mei Shih call "minor transnationalism," which highlights "the complex and multiple forms of cultural expressions of minorities and diasporic peoples and ... [the] micropractices of transnationality in their multiple, paradoxical, or even irreverent relations with the economic transnationalism of contemporary empires."[9] Lionnet and Shih highlight a jagged form of transnational connection that recenters the uneven histories and expressions of those who are often glossed over within neoliberal logics of global, marketized, connectivity. By identifying the varied forms of affective labor that the sex worker performs, I shift my focus from a dominant-resistant or active-reactive model of analyzing neoliberal capital to one

of a minor—that is, less legible, or emergent—form of intervention in it.

The chapter examines two texts in particular. First, I discuss Taiwanese director Chung Mong-hong's 鍾孟宏 feature film *Di si zhang hua* 第四張畫 [*The Fourth Portrait*] (2010), which tells the tale of a broken family in Taiwan held together by the mother: a China-born immigrant bride-turned-prostitute. I then compare Chung's film with Asian American director Debbie Lum's film *Seeking Asian Female: A Documentary* (2012). The film details the life of Sandy, who immigrates to the United States from China to respond to white American Steven's online call for a Chinese woman open to marriage. I approach these two texts with a broader connotation of sex work that goes beyond prostitution as an occupation. Both heroines teeter on the border of citizenship by exchanging their bodies in and out of state-sanctioned family institutions in Taiwan and the United States, respectively. The heroines' management of desires on the borders of legalized sexual citizenship allows for intimate relations that intervene in neoliberal market flows to emerge and reorder themselves.

These emergent interactions are highlighted by the kinship structures produced by the films' heroines. In *The Fourth Portrait*, there are the volatile relationships among the Chinese new immigrant mother, her Taiwanese husband from a second marriage, the toddler from her second marriage, her son from her first marriage, and the ghost of her eldest son (also from her first marriage). In *Seeking Asian Female*, there are the shifting intimacies formed among Sandy, the Chinese immigrant bride; Steven, her American husband; and Debbie, the Asian American documentary director. In both cases, the kinships created are founded on contingency, instead of biological or cultural continuity. The relationships produced by the heroines' affective labor are characterized by fissures and discontinuities, rather than clear origins or commonalities. These are family structures that capriciously navigate state regulations. These are intimacies that are endured, not nurtured.

These heroines, I argue, generate forms of "dwelling." It is through the films' unorthodox kinships that I propose "dwelling" as a methodological approach. By dwelling, I refer to both the structural and

affective registers of the term. Structurally, the concept ties in with ideas of home, house, and residence. Affectively, it alludes to excessive attachments to, or constant restructuring of, memories. As such, it can be understood as a noun (i.e., residence, home, and house) as well as a verb (i.e., to reside, to ruminate). To read it as a verb opens up affective and structural dimensions at the same time: to dwell is to reside continuously in the past. It is simultaneously immaterial and material, invisible and visible. It is actively inactive: constantly in a state of suspension, relentlessly becoming, with no apparent origin or endpoint.[10]

In using the term "dwelling," I do not conceive a rooted relation between self and one's place of residence. Instead, I emphasize a relation between place and identity that is unstable and recursive. In tracing affective structures of dwelling across *The Fourth Portrait* and *Seeking Asian Female*, I locate minor forms of subject and community formation through the immigrant and sex-worker heroines' bodies trafficked across national, cultural, and linguistic precincts. As a precariously suspended emotion, dwelling complicates issues of agency and sociality beyond the dichotomous framework of top-down construction versus bottom-up resistance, for or against the neoliberal marketplace. It reveals a more entangled mapping of power that is animatedly suspended and ambivalently endured.[11]

In particular, I identify how Chineseness operates as a nascent form of neoliberal desire that dwells in the two films.[12] I demonstrate the ways Chineseness is excessively packaged, marketed, and navigated through the heroines' bodies. Chineseness, I argue, works as a continually re-used affective interface on which the two film's new immigrant and sex-working heroines localize their identities against the flows of transnational capital, without generating heteronormative analogies of reproductive nationalisms for their host countries (Taiwan and the United States). Unlike the transnational expression of Chinese identity (the affective structure of Pacific Crossing) galvanized through competing nationalisms, dwelling as a structure of feeling dismisses the centrality of the nation-state, as well as global economic flows, with its consistent state of affective suspension. It generates a minor

transnational affective structure that stalls and, in so doing, reorders familial and national attachments within an actively expansive global economy.

THE FOURTH PORTRAIT (2010)

The Fourth Portrait tells the tale of Young Xiang 小翔, who, after the death of his father, moves in with his mother, a mainland-born Taiwanese new immigrant who is a sex worker (played by mainland actress Hao Lei 郝蕾). Young Xiang soon discovers that the home he has moved into is much more crowded than he originally expected. He finds his mother housing her Taiwanese husband from a second marriage (played by Taiwanese actor Leon Dai 戴立忍), their newborn baby, as well as the ghost of Young Xiang's older brother, Young Yi 小翼. We later learn that Young Yi was secretly killed by the stepfather three years earlier.

Focusing on the mother and the brother's ghost, I argue that the film reconfigures forms of intimacy built not necessarily through visible or physical origins (such as blood, house, the living), but through the affective pull of what is not (like proximity, memory, and hauntings). The mother's labor as a sex worker is what provides her family with a physical dwelling place. The way she emotionally dwells over her missing son is what incentivizes her to reconnect with Young Xiang. Moreover, the lingering presence of Young Yi's ghost (how he dwells in the house) is what haunts the stepfather and compels him to accept Young Xiang into the house. In other words, an affective structure of dwelling manifests through the mother's and brother's affective labors, generating a conception of intimacy that is situated, even if persistently capricious.

The Four Portraits

We can see this affective pull in the film's plotline. The tale's narrative development is driven by what lingers or, more precisely, the memory of both the characters and the audience. The protagonist, Young Xiang, draws the four portraits that frame the tale from memory.

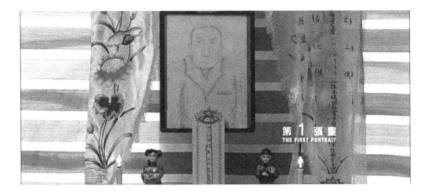

FIGURE 5.1 Image of Young Xiang's first portrait of his deceased father

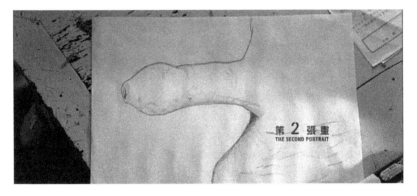

FIGURE 5.2 Image of Young Xiang's second portrait, a sketch of his friend Nadou's penis

The film's first portrait is that of Young Xiang's deceased father (figure 5.1). Young Xiang drafted a portrait of his father by memory since he couldn't find any photographs to put on the mantel for the father's funeral. The second portrait is a drawing Young Xiang sketched for a school project: an art assignment on "friendship." Young Xiang drew what he considers to be his friend Nadou's 納豆 most distinct characteristic, his penis (figure 5.2).

As Young Xiang tries to justify his choice in subject matter to his teacher, he admits that it is not a particularly accurate portrayal. He explains that he couldn't catch a clear sight of Nadou's actual organ,

and so he had to use his own penis as a model. Here, we see how, by grafting these images through memory, Young Xiang drafts a sense of connectedness, a materiality of relationships: him and his father, his penis with Nadou's penis. This relationality is based not on what is visible, tangible, or present, but rather on what dwells: a personalized abstraction *and* embellishment of memory. In the case of the portraits, memory is materialized through the image. That is to say, immaterial forms of dwelling (memories that linger) are given a material dwelling place in the portraits.

This labor of grafting meaning through memory is similar to the work demanded of the film's audience. The portraits are sequenced in such a way that meaning can only be recollected later, instead of being instantly perceived. For instance, we do not understand why Young Xiang was drawing his father's portrait before the funeral until we see it placed on the mantel four minutes later. We are not given clues as to why Young Xiang draws a penis, let alone whose penis it is, until three minutes later, when the teacher probes. It is as if the film elicits the same affective labor from the character Young Xiang and his audience: we are invited to dwell.

Young Xiang dwells over his relationships and recollects memories in order to draw his portraits. Similarly, the film beckons its viewers to piece together clues planted throughout the narrative to make sense of the paintings. The act of dwelling opens up possibilities that distort linear cause-and-effect relationships between text and meaning. This is evident in the scene, occurring two minutes after the appearance of the second portrait, where the mother takes care of her colleague's unwanted customer. It is one of the film's early moments, when the mother establishes herself as the prominent affective laborer—sex worker and caretaker. Demanding service for his penis from a girl who was unwilling, the customer throws a tantrum until the mother takes over and agrees to enter the back room with him. After a few thrusts from behind, the patron's penis softens. The mother then slaps him in the face and shoves him into the wall, exclaiming "What? Aren't you supposed to be all so powerful? . . . How do you expect to get a hard-on after all that drinking?" In this scene, the penis-as-symbol goes through a series of mutations. Minutes earlier, it was framed as a symbol of

shared intimacy between Nadou and Young Xiang, as their penises were the subject matter for Young Xiang's school project on friendship. Then, the client's penis also signified shared intimacy, but one embedded within an unequal power dynamic. But, seconds later, the penis softened into a sign for ridicule as the mother regains her power over the customer, grounding her retort about the potency (or lack thereof) of the organ.

This reading of the scene that connects the penis, affective labor, and agency can only emerge if we dwell on the image of the second portrait. The film creates relationships among characters and viewers that are not materialized through linear or visible continuity. Drawing from Deleuze and Guattari's spatial concept, these connections are rhizomorphic, since they are based on recollections of the temporary, intangible, and mutable.[13] Most importantly, the creation and maintenance of these relations are laborious—laborious as in the act of drafting portraits in the case of Young Xiang and in the audience's acts of meaning making.

Perhaps the biggest reveal is when the viewer pieces together the meaning of the third portrait (see figure 5.3). We eventually learn that the figure sketched in this portrait is Young Yi, Young Xiang's deceased brother. Furthermore, we find that it is a portrait drafted not through Young Xiang's actual memory of their relationship. The mother points

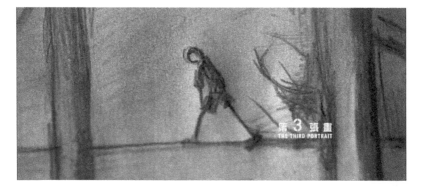

FIGURE 5.3 Image of Young Xiang's third portrait, a sketch of his deceased brother walking on a levee

out that Young Xiang was only a baby when the brother left, so he wouldn't have experienced such a scene. We later discover that the drawing is of Young Xiang's recurrent nightmare: the scene of Young Yi walking the levee, on constant replay.

Mother and Son as Dwellers

Details about the brother's haunting are slowly revealed. Toward the end, we realize clues have been planted all throughout the tale; the brother's ghost has been driving the narrative all along. We see early signs of the brother's ghostly presence at the beginning of the film, soon after Young Xiang moves into the house, before we know Young Xiang even had a brother (see figure 5.4). Sitting around the dining table, the stepfather and mother look uneasy while they eat. They look out to the other room as if startled by something unknown—what we later learn to be the lingering ghost of Young Yi. Though the brother's ghost is invisible here, it is the dominant force that frames the action and direction of this scene. It is what provides suspense and drives the narrative before we, as viewers, even know of its existence.

We do not realize that they are looking for Young Yi's ghost until the stepfather verbally admits to the ghost's presence, forty minutes later (see figure 5.5). Here, the stepfather is securely positioned within

FIGURE 5.4 Early clues of Young Yi's presence: a scene where Young Xiang's mother and stepfather look uneasily out of the room

FIGURE 5.5 Scene where Young Yi's ghost visits the stepfather and takes form in the corner for the first and only time

the domestic sphere. Framed by layers of windows and doors, he rests at the dining table, which is the communal center of the house. The camera then slowly moves into the dining room, entering and passing through those same windows and doors that secure the stepfather's space and position. It is only when the father starts talking—and we see the ghost slowly materialize in the corner—do we realize that we were just now taking on the perspective of Young Yi's ghost. We dwelled within and with the ghost. The stepfather, while waiting for the ghost's arrival, states: "I know you are back. . . . I'm really sorry. . . . You haunt your brother in his dreams, and I've always known you were real and are here. Even though I can't see you, I sense you are near." The ghost's affective labor, of dwelling, generates alternative forms of connection. With his brother, the ghost haunts his dreams. With the stepfather who murdered him, the ghost dwells in his home/living space. By dwelling in the house and within the dreams and fears of Young Xiang and the stepfather, the ghost creates a relationship based not on visual or tangible contact but the "sense that you are near." This attachment is created not by continuity (biological connection), but contingency, or, in this case, proximity.

The ghost's labor of dwelling coincides with the mother's affective labor as the family caretaker and breadwinner through sex work. The first sign of the ghost's haunting is sequenced immediately after the scene of the mother peeling vegetables, as she is herself heavily framed within the walls of the haunted house (see figure 5.6). At first glance, the brother's ghost and the mother both seem marginalized. The ghost is invisible, and its presence is not revealed until the very end. The mother, here, is visually caged within the house. However, sequenced

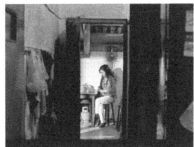

FIGURE 5.6 Sequence of mother peeling vegetables immediately after the first sign of Young Yi's ghost haunting

side by side, the scenes show how the mother's and the ghost's labors are, in fact, the dominant pull holding and restructuring the characters' relationships, as with their connections to the house.

The mother's labor as a sex worker is what provides her family with a physical dwelling place: a house to reside in. And, because Young Yi's ghost dwells in the house and haunts Young Xiang's dreams, Young Xiang leaves its walls and seeks refuge with his mother at the nightclub where she works. The mother asks Young Xiang, "Were you scared, walking here alone at night?" Young Xiang answers, "No, I'm only scared when I'm in your house at night." The mother recognizes that Young Xiang is not scared of the house, per se; he fears the nightmares he has while dwelling in it. We see a movement out of what is conventionally considered a place of rest (the house) to a temporary refuge—a makeshift dwelling place (the nightclub)—where Young Xiang is finally able to sleep. After Young Xiang awakens, he finds his mother resting in a drinking room herself, unable and unwilling to go home. The two characters open up to each other, finally, at this moment. In this way, the ghost's lingering presence is what mobilizes Young Xiang and the mother, physically and emotionally.

Seeing that Young Xiang is tormented by nightmares, the mother is prompted to protect Young Xiang from, not the brother's ghost, but the stepfather's wrath. She warns Young Xiang, "You ought to stay away from [your stepfather], you hear me?" The way the mother dwells over (emotionally unable to let go of) her missing son is what incentivizes

her to reconnect with Young Xiang. The presence of Young Xiang brings back memories of the brother's tragedy, and pushes the mother into confronting the stepfather: "I say Young Xiang *must* live with us. . . . He is just a kid. . . . You know well enough what you have already done." The ghost's lingering presence stirs a sense of care between Young Xiang and his estranged mother. The mother's care work, along with the ghost's presence, is what forces the stepfather to accept Young Xiang's company. That is, the affective labor of Young Yi's ghost, and the mother who dwells on it, reconfigures relationships out of the conventional domestic quarters and beyond biological connections.

Affective Labors, Kinships Restructured

This restructuring of kinship is highlighted in how the stepfather is eventually coerced into repositioning himself within the family structure. Near the end, the stepfather intimidates Young Xiang by confessing that he did indeed kill Young Yi. As he comes clean, the stepfather pleads: "Young Xiang, you are a smart kid. Let's forget that any of this happened. Let's just get through life, together. OK? Just get through life. . . . Your mother is almost home. Let's all eat dinner together." What the stepfather is proposing is a companionship based on physical proximity and affective contingency. What the stepfather asks for is a mode of coexistence that simply "gets through life, together," sharing food and sharing space; that is all. Thus, as the tale unfolds, the ghost and the mother reassemble family relations not through biophysical connection but through affective pulls (proximity, memory, and haunting).

This is summed up in the fourth and last portrait, for which the film is named. Young Xiang has been assigned to draw a self-portrait. As he takes out his mirror to sketch his own reflection, he looks into the camera and slowly closes his eyes. A black screen is what follows; no drawing, just darkness (figure 5.7). That is the end of the film. It is as if Young Xiang is calling the viewer to act as his mirror and to graft an image of him through the viewer's memories of his character, sprinkled throughout the film. This is the affective labor the film has trained us to do all along: the labor of grafting meaning through memory, of

第 4 張 畫
THE FOURTH PORTRAIT

FIGURE 5.7 Image of Young Xiang's fourth portrait, darkness

structuring relations without actually seeing, of generating connec-
tions with the tale based on speculative contingency. The film asks us
to dwell: to recycle and reconnect memories of Young Xiang to draft
an ending to the tale.

Furthermore, the film asks us to defy the relatively visible and
continuous interpretive structures of blood kin, family, and nation,
interpretive structures that have long governed studies of Taiwanese
cinema dating back to its "native soil" (*xiangtu* 鄉土 or *bentu* 本土)
connections in the early 1980s.[14] The movie casts mainland as well as
Taiwanese actors as main characters, and the Chinese actress Hao Lei's
mainland status—as that of the character she plays—is far from glossed
over. The viewer is constantly reminded of the mother's Chineseness,
whether through her exaggerated accent or the way her pimps call her
"mainland sister." In the scene where Young Xiang's schoolteacher asks
the mother about Young Yi, she starts the conversation with a question
about her mainland accent. In response, the mother reveals herself to
be a new immigrant from mainland China. Holding up her Taiwanese
identification card for the teacher to see, the mother explains:

You know why I am showing you my Taiwanese ID card? I went
through so much hardship just to obtain this. When I came here ten
years ago, I thought I would finally have a good life. . . . I soon real-
ized that that wasn't the case. The first thing I did when I got my

Taiwanese ID card was take Young Yi away with me. . . . After that, I was put in jail for a while . . . then, my current husband told me that the child went missing.

Despite her having obtained Taiwanese residency, the mother's Chineseness dwells in the narrative. It lingers in the language she speaks, in the inevitability of her partaking in the underground economy of sex work, and in the way her body is packaged by her pimps. The Chineseness that haunts the mother dwells also at the heart of Young Yi and Young Xiang's story as "Taiwanese boys" whose fates are intricately tied to their mother's migration across the Taiwan Strait, alongside the unequal flow of the neoliberal market economy.

It would seem as if the Sinophonic structure of feeling that fractured Chinese cultural and national centrality in Cold War–era cultural production is reordered here as a localizing affective structure. Instead of rejecting Chineseness, this affective structure allows for it to dwell through minor transnational contact between bodies on the border of legalized or legible citizenship. That is to say, Chineseness functions as a nascent dwelling affective structure in the film; it reterritorializes kinships against legitimized flows of global connectivity without reproducing biophysical or cultural-national orthodoxy.

The film emphasizes this reassembly of nativity and citizenship near the end, when we witness a cemented shoe print, just minutes before we see the fourth portrait (figure 5.8). Since the scene is sequenced right after the stepfather confesses to Young Yi's murder, this shoe print is presumably what remains of the murder victim. Yet, the victim's identity remains ambiguous. Some viewers read the shoe print to be Young Yi's, others take it to be the stepfather's (23.5 is an adult size), and still others interpret it as Young Xiang's in the future; they read this as the reason his fourth "self-portrait" was sheer darkness—presuming that he later gets murdered by the stepfather or commits suicide. However, I argue that it is this ambivalence, this very darkness with which we are left, that is at the heart of the film. It prompts us to dwell on, in Amy Kaplan's words, "the ever-shifting boundaries between the domestic and the foreign, between 'at home' and 'abroad,'" and, by extension, between life/selfhood and death.[15] The only thing

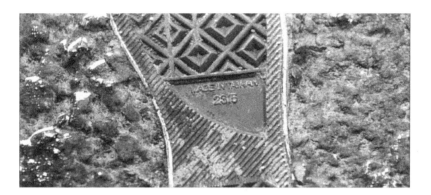

FIGURE 5.8 Image of cemented shoe print with "Made in Taiwan" logo, at the levee

put to rest with certainty is the cemented logo of "Made in Taiwan"—the clear sign of origin, cultural nativity, and national productivity—on the lost shoe, buried.

Here, we see the film's invisible characters generate affective labor that localizes a sense of contingency. Their labors exhibit the dwelling effects of nativity (i.e., the mother's dwelling "Chineseness," and the "Made in Taiwan" logo haunting the sons' tale) without cementing centripetal logics of blood kin, family, and nation. Dwelling restructures the characters' and, by extension, viewers' attachments to familial and national forms of domesticity. Dwelling brings attention to repurposed torsions of intimacy that stall the pace and scatter the directions of nation-focused interpretive structures (whether of mainland China or Taiwan); it also highlights the reassembly of marketized exchanges within which the new immigrant and sex-working mother and her offspring's narratives are entangled.

SEEKING ASIAN FEMALE: A DOCUMENTARY (2012)

The affective labor of dwelling—imminent recyclability and prosthetic contingency—destabilizes signs of cultural and familial nativity in *The Fourth Portrait*. In *Seeking Asian Female: A Documentary*, the act of dwelling challenges the filmmaker's approach to the framing of the "native."

The film documents Chinese American filmmaker Debbie Lum's search for men who exhibit what is often called "yellow fever," when a man not of Asian descent is exclusively attracted to Asian women. She finds Steven, a sixty-year-old white American parking-lot attendant who has long desired to marry a young Chinese woman. He scours the Internet in search of potential "native Chinese" brides. After agreeing to be filmed, Steven invites Debbie into his home, exclaiming, "You look . . . Chinese!" Debbie responds, "What does that even mean?" Through this exchange, we see a double framing of the characters: the filmmaker's intended exposure of Steven as having a classic case of yellow fever, and Steven's reading of Debbie as characteristically "Chinese."[16]

Debbie found Steven through her online search for men who proclaim to date only Asian women. First, she contacts them using Adult Friend Finder sites and through personal ads on sites like Craigslist; then, she invites them to her studio for an interview. "It really makes no difference where she's from within the Asian subcontinent," one of her interviewees explains. Another subject exclaims, "With Asian women, it's just hot. Bam!" While these two men fail to pinpoint the logic behind their attraction, one thing is clear: Asian women are interchangeable and erotic to them. Other interviewees are able to go into more detail. One explains that "it's their hair. It's the long black hair that is really eye catching." Another man maintains that "it's the whole mysterious kind of look, dark eyes." Yet another interviewee insists that it is because "they are kind of subtle and kind of quiet." For Steven, it is "this little thing right underneath the eye . . . the eyelid. . . . It just knocks me out." He goes on to state that what drives his attraction for Asian women is the idea that they are submissive and ready to serve. He recalls watching the movie *The Scent of Green Papaya* and being infatuated with the "idyllic servant girl who would cook these beautiful meals," and thinking that that would be what it is like to have an Asian wife. Steven's reading of Asian women as "idyllically" submissive is similar to the view of another interviewee, who insists, "[Asian women] give more consideration to how the man feels than sometimes themselves." Perhaps not surprisingly, these are all traits—exotic, erotic, and subservient—that reflect "old" Orientalist stereotypes of Asian women.

Such contemporary Orientalist sentiments show how racial and sexual structures dwell: they linger and are repurposed. The film shows how identity markers such as "Asian-ness" (or in this particular case, Chineseness) are recoded from legacies of colonial discourse and repackaged for a neoliberal moment that hails technological progressivism. The Chineseness that Steven and Debbie dwell over, for different reasons, operates as a remastering of racialized and sexualized discourses over the Asian female body for the seemingly "post-body" and "post-identity" information age.[17]

Dwelling Over the "Chinese Native"

In *Seeking Asian Female*, the recoding of Chineseness operates as the spectacle of difference driving Steven's project of seeking Chinese brides and Debbie's documentation of it. Steven states, "I don't look at blonds or redheads, I always look at Chinese." Although he started out dating Japanese and Filipino women, Steven asserts that he now wants a Chinese woman. "There seems to be an endless supply of women over there [China]," Steven says. He gloats, saying, "Over the course of the last five years, there must be hundreds of Chinese girls in China who I've been writing to." For Steven, Chineseness signifies interchangeable, black-haired, almond-eyed women who are abundant in supply and always available.

This dwelling of Orientalized identity markers is evident when we see Steven, through his online persona on AsianFriendFinder.com, retain the privilege to typify, categorize, and seek "Chinese natives" according to Orientalized logics. The women's visibility online is intimately attached to how easily they fit into and recycle Orientalist "types."[18] Their cyber-mobility hinges on how well their "tags" signal racialized and sexualized logics. Steven has the privilege of dwelling in his fantasies. He admits, "everything seems wonderful to me. I can do that same transposition [attraction to a particular Chinese woman] onto the next person, as well, because nothing has really happened. It's all in my imagination." The women who surface are exactly the interchangeable, black-haired, almond-eyed Asian women that Steven perceives to be submissive, sexually available, and ready to serve his desires.[19]

The Asian Friend Finder website promises the potential of interacting with what Steven projects as the "native Chinese female": an exotic/erotic other who in the digital world is just a click away. Steven rejoices, "I get home from work at two o'clock in the morning, and it is six o'clock at night in China . . . it is something to look forward to." In this scene, we see Steven relishing the pleasures of crossing the cyber-frontiers of global connectivity into a cyber-cosmopolitanism, or what Wendy Hui Kyong Chun calls "high-tech Orientalism," that promises transcultural and sexual potential.[20]

What dwells, in addition to persistent racial/sexual structures, is the issue of reorienting subjectivity: the resituating of the self-other divide. Chun argues that "high-tech Orientalism is not simply a mode of domination but a way of dealing with—of enjoying—perceived vulnerability."[21] Vulnerability, here, can be read as the act of interacting with the unknown; it is the recoding of boundaries between the self and other and, by extension, between private and public across this cyber-frontier. Consequentially, the definitions of the "domestic," and the individual's positionality in relation to it, are recalibrated. Similarly, Thomas Keenan argues that the window is a structural analogy of what separates and breaches the public-private divide and the human subject's reflection of self-other in relation.[22] The computer window, Chun stresses, works similarly, yet with less reflexivity. She explains:

> The computer window seems irreparable and unpluggable. In contrast to its predecessors, the jacked-in computer window melts the glass and molds it into a nontransparent and tentacling cable. If "the philosophical history of the subject or the human is that of a light and a look, of the privilege of seeing and the light that makes it possible," the light that facilitates the look can no longer be seen; we no longer see through the glass that connects, separates, and breaks.[23]

Chun argues that the computer window generates fewer reflections. The user behind the screen runs less a risk of being unwillingly exposed to the "others" on it. This is similar to Nakamura's statement that "When we look at cyberspace, we see a phantasm which says more about our fantasies and structures of desire than it does about the

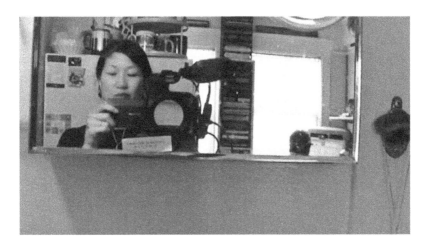

FIGURE 5.9 Image of Debbie in front of the mirror filming the back of Steven in front of the computer

'reality' to which it is compared by the term 'virtual reality.' "[24] In other words, the user's "self" is allowed to be hyperconstructed, seamlessly coded to fit into one's projected fantasy.

By documenting a new media practice—Steven's structuring of self through his search for the "Chinese other" online—with an "old" medium (film), Debbie casts a mirror over this seemingly opaque computer window. Her camera exposes the backstage engineering of Steven's cyberprosthetic "self" while reflecting the constructedness of both Steven's projection of the Chinese native and Debbie's own framing of him as a quintessential bearer of yellow fever (figure 5.9).

The documentary starts with Debbie physically breaching the boundaries of Steven's house, as she pushes open and walks through his door with her camera in hand. Inviting her into his small, cluttered, rundown apartment, Steven says, "This is so embarrassing. . . . What is it about you, Debbie, [that] makes me want to expose myself to ridicule like this?" He answers his own question when he eagerly reaches for his camera to take pictures of Debbie as she enters. "Your hair looks cute, very Chinese, the bangs. You know I like that," Steven comments, while giggling. Although Steven allows Debbie's cinematic exposure, he returns the gaze by capturing, for himself, images of Debbie—a woman

he deems "so Chinese"—who is interested in, and in the process of, documenting him. With the cameras aimed at each other, Debbie's and Steven's "selves" are recoded as they step out of the opaque computer window and expose their raced, gendered, and classed bodies to, and in relation to, each other. While it is Steven's obsession with "Chinese natives" that brought Debbie to his doorstep, it is the full-bodied entrance of the Chinese native, Sandy, which beckons a massive recalibration of relationality among all three characters.

Where Have All the Natives Gone?

Sandy, a thirty-year-old Chinese woman from Anhui Province, agrees to Steven's proposal after three months of online dating. She comes to the United States with a three-month fiancée visa to test out their relationship. Upon Sandy's arrival, we see all three subjects reconfiguring the alternate selves they have constructed and projected on one another, be it behind the camera or in front of the computer screen. The subjects recalibrate their own physical and emotional positionality in relation to each other within the actual space of Steven's home. In other words, we witness them restructure ways of dwelling together.

First, the three must deal with vestiges of their online projections of themselves and each other dwelling within the space. Steven still imagines Sandy as an Orientalized "Chinese native," not too different from Debbie, from his online fantasies. Sandy still pictures Steven to be the embodiment of her American Dream. And Debbie projects her own image as a critical, third-party observer of Steven's "yellow fever" and his improbable real-life relationship with "Chinese natives." Dwelling, in this sense, is similar to what Lisa Nakamura calls "after/image." Nakamura explains: "when we look at . . . rhetorics and images of cyberspace we are seeing an after/image—both post-human and projectionary—meaning it is the product of a vision re-arranged and deranged by the virtual light of virtual things and people."[25] That is to say, "after/image" (or "dwelling") is a structured relationality, an ongoing construction of subjectivity that is, and continues to be, deflected from its "virtual beginning."

The dwelling of the characters' online projections is navigated, awkwardly, face to face. The disparity of the characters' after/images is evident in the scene where Steven takes Sandy to see the Golden Gate Bridge. Sandy is beyond excited. She explains to Debbie, in Mandarin Chinese, that she's seen the bridge on television before and has always dreamed of seeing it in person. Steven has delivered an "American" experience that Sandy hoped for on the other end of the computer screen. When Sandy thanks Steven verbally, Steven leans in for a kiss. Shocked by this plea for intimacy, Sandy pulls away. Abruptly, the pair's after/images collide; Sandy's hope for Steven to deliver the American Dream clashes with Steven's desire for Sandy to embody the openly available "Chinese native" of his dreams. Steven leans in for a kiss a few more times, while Sandy continues to brush him off. Frustrated, Steven responds: "It's ok, it's American!" Steven's response frames Sandy's rejection as a result of fixated cultural difference. He Orientalizes Sandy's reaction as being foreign, exotic, and non-American. His statement also reminds us that their tenuous relationship ultimately hinges on the promise of her physical and emotional availability. The affective labor that Sandy needs to perform in order to dwell in the United States, and under Steven's roof, is that of fulfilling Steven's dream of a "Chinese" woman who cooks fine meals and is sexually available. As if proof of their compatibility, Steven gloats to his friends, "I've lost sixteen pounds. Sex and vegetables, I recommend it." In this early stage of their relationship, Steven understands their compatibility to be dependent on how well Sandy works as an affective laborer to serve him food and pleasure.

The contingency built into Sandy and Steven's relationship is where the second sense of dwelling comes into play: the characters' cohabitation. The couple's fragmentary conversations happen in front of the computer screen as they use a translating program to communicate. While they reside under the same roof, they create a kinship contingent on the partial navigation of their languages, bodies, and emotions. Yet, built into this relationship is Debbie's role as human translator, negotiator, and friend. Despite wanting to remain an objective observer, Debbie becomes the affective laborer who documents and holds the relationship together. Sandy states, "If it weren't for Debbie, I would

be back in China now." Debbie's presence is the glue that holds their relationship together from the beginning: she was the first person to welcome Sandy to the United States at the airport, and she is the only "Chinese-looking" face that makes Sandy feel at home. Being the only person in Sandy's new life in the United States who can speak a little bit of Mandarin Chinese, Debbie quickly becomes Sandy and Steven's negotiator when conflicts arise and the translation program can't suffice.

Conflict occurs when the characters' after/images are challenged: when dwelling in the second sense (contingent cohabitation) rubs up against dwelling in the first sense (after/images that linger). The couple's first series of fights occur when Sandy challenges Steven's after/image of her as just another "Chinese native" in his online search box. When Sandy finds pictures of Steven's previous online Chinese girlfriend Molly, Steven asks Debbie to come to the house and help mediate the argument. Since Debbie has only a limited command of Mandarin Chinese, the argument is put together through a series of mistranslations, lost words, facial expressions, and grunts from all parties. Sandy complains, and Debbie translates: "In China, if you break up with someone, then you can no longer be friends. . . . If you understand Chinese culture, you'd get it. Chinese people cannot casually accept precious gifts from other people. . . . Stupid! You don't get Chinese culture. Stupid!" Sandy reclaims Chineseness from signifying interchangeable and consistently available Chinese women in Steven's after/image to conveying an obscure particularity to which only she has access: "If you understand Chinese culture, you'd get it. . . . Stupid!"

Sandy regains control over her own representation as a "Chinese native." She disorients Steven's Orientalism while relying on a similar process of essentializing Chineseness to direct her own narrative. In fact, Debbie's difficulty in smoothly translating Sandy's thoughts—the pauses, stutters, and grunts—proves Sandy's point of her exclusive access to "Chinese culture." We see how Chineseness dwells as an affective structure in this scene: its imminent recyclability is utilized by the self-proclaimed "Chinese native," Sandy, to assert her power over what dwells in Steven's mind (his after/image of Chinese natives) and her

position within their dwelling place (Steven's home). As she packs up and threatens to leave, Steven manages to keep her by throwing away memorabilia from all the Chinese women he has been in contact with. In this scene, Sandy de-typifies herself from the hordes of Chinese females Steven seeks online; she recodes herself as the one and only Chinese native that dwells in his mind and under his roof.

The couple's second series of fights challenges Sandy's after/image of Steven (as her access to the American Dream). It quickly dawns on Sandy that Steven has, in her words, "no house, no car, no money." Wedding arrangements, Steven's old debts, and Sandy's inability to find work legally without a green card all add to the poor living situation Steven started out with when single. Sandy confides in Debbie: "We might not even have enough money to eat. How did we end up here? I'm so embarrassed to tell other people [in China]. . . . They would probably say, 'What's the point of going to America, you should've stayed in China.'" Sandy acknowledges that the American Dream she hoped Steven would provide is just an after/image, or, as Nakamura puts it, "the phantasmatic spectacle or private image-gallery which bears but a tenuous relationship to 'reality.'"[26] The idea of "China," in turn, resurfaces as a preferable dwelling place. Steven's reality, which Sandy has now entered into, is one that is "quite hard," Debbie explains to Steven.

This harsh reality drives the couple into fierce arguments over housekeeping—how to save, what to throw away, what to clean up, what and when to eat—that are often explained away as resulting from cultural differences. Frustrated over their living situation, Sandy complains, "How can one wash clothes only once a month and save them all for one huge load? We Chinese cannot behave like that. We wash whatever we wear that very day. Also, Americans get up in the morning and eat breakfast before washing their face!" Sandy uses Chineseness as a means to contrast Steven's "Americanness" and, by extension, justify her dissatisfaction. Again, we see Chineseness as a dwelling affective structure that allows for the couple's looming discontentment to take shape. "There is no going back," says Sandy, as she mourns her attachments to Chinese culture while remaining at an impasse. In Sandy's narrative, Chineseness resurfaces as a form of dwelling: an

emotional state that she cannot go "back to" but within which she continues to reside as an affective destination.

At this point, Debbie decides to leave the couple's household and end the documentary project. Debbie explains to her audience:

> They think I'm helping them, but I think my role here has become questionable. Somewhere along the way as I was filming them, I got so caught up in their story, that I started trying to make their relationship succeed, even though I thought it was a crazy idea to begin with. I thought that Sandy needed my help. But so many of my assumptions about her have been wrong and what if I've actually made things worse.

She acknowledges that her own after/image of Sandy as a helpless "Chinese native," along with Debbie's perception of herself as an objective observer, have also been challenged. She, too, was "caught up" in this relationship. She, too, took part in the building of this kinship that she thought "was a crazy idea to begin with." She has been, from the start, a participant in a kinship structure that dwells on its very contingency. Furthermore, this sense of contingency allows for the consistent recoding of Chineseness and "the Chinese native" as it drives the characters' continual repositioning of relationality in response.

Kinships Dwelling

"I stopped filming them, but I can't stop worrying about them," Debbie explains toward the end of the film, as she rewinds old footage of the couple with herself in the frame. Here, a third type of dwelling—the inability to detach—appears. Debbie shows that she dwells within Steven and Sandy's story, as well. She already *has* been, from the beginning. Just three months after she leaves the couple, Debbie decides to revisit their relationship.

Sandy expresses a similar sense of inextricable attachment at the end of the documentary. Months after her wedding to Steven, Sandy finds old photos of other Chinese women in Steven's e-mail. As a result, Sandy insists on a divorce. Yet, when Debbie asks Sandy if she ever loved

Steven, Sandy breaks down and cries: "Everyone thinks I married him for the green card. Last night I cried the whole night. I didn't fall asleep until 7 A.M. If I didn't care about him, why would I be so sad? And if all I wanted was a green card I could just sleep with him and not care if he dated other women." Sandy acknowledges the sexual labor expected of her as a new immigrant wife, yet emphasizes the emotional attachment that haunts her. "I miss him, how strange," Sandy says with a grin. She goes on: "We just had a fight yesterday, and now I miss him. I keep wondering: Has he eaten? When did he go to bed? What did he eat? Is he eating right?" Details of the domestic—of their daily routines of eating and sleeping—linger as tokens of care and sustain their attachment.

Steven's reaction to their marital crisis is similar. "I need to turn things around. I'm in love with her. I love her. I got my whole life invested in her. I'm dead without her," he explains to Debbie. When asked what has made the difference now that they are together in real life and not just online, Steven explains:

> Some things I've done the same way for twenty years. . . . Well, she has a new order for them, and I go "Huh . . . ok!" Sometimes I'll come home, and she'll be hiding behind the refrigerator . . . sometimes she'll be hiding in the closet back in the clothes, and she lets me look around . . . and I go "Honey? Where are you?" and she would be in the closet smiling. It's just funny. The days are just full of things like that. It is easy to share.

The literal rearranging of domestic space—moving of furniture and the finding of Sandy amidst it—allows their intimacy to manifest. This shifting contingency, as opposed to any solidified continuity between the couple, drives their relationship. And it is exactly this ephemeral connectivity that brings Debbie back to their doorstep, time and time again.

Debbie's documentary starts off as a quest to investigate Steven's obsession with Chinese women. However, their kinship develops not from the uncovering of "deep truths" but the *surfacing* of what dwells. What makes the characters' relationship stick are not thick origins but

the residual refractions of after/images that move and transfigure on the screen. Debbie found Steven due to their projections of each other: Debbie's framing of Steven as the native bearer of "yellow fever," and Steven's reading of Debbie as not too different from the "Chinese natives" he eagerly sought to marry. What draws Steven and haunts Debbie is a reading of Chineseness that is "skin deep": one that dwells on the fixity of ethnic origins, cultural difference, and which consolidates along visual, or physical, lines (e.g., the almond eyes, black hair, and bangs). With Debbie's camera lens pointed at Steven and his computer screen, this kinship was formulated not through "truth value" but what Helen Grace calls "face value": "the tendency to take for granted the reality of the image, knowing . . . that it *is* an image, which has the capacity to both reflect and produce reality."[27] Exposed are not deep truths or fixed origins of either Steven's "yellow fever" or Debbie's investigation of it, but the refractions bounced off of their screens and the after/images that result.

Similar to Steven's relationship with Debbie, his relationship with Sandy reflects an intimacy that thrives from being "screen deep." It starts online, an interface through which everything is an appropriated copy and, as Grace explains, "every subject is abstracted by the rate of compression, and every clip becomes a kind of quotation, either by being sourced from previously existing material and re-presented or, in the case of original material, simply by being uploaded into a stream of pre-existing material."[28] That is to say, Steven and Sandy's relationship is not necessarily grown from roots of affection. Rather, it is germinated along performative and projective routes that start from the online virtual interface.

The performative routes through which the characters recode Chineseness, in relation to the domestic, enable the affective structures, and resulting kinship, to surface. Instead of signifying a veiled exotic mystery that beckons exposure, Chineseness functions as a visible and recyclable surface that is rhizomorphically recoded. This is evident in Steven and Debbie's recalibration of their after/images of themselves in relation to Sandy, the "Chinese native." It is also reflected in the way Sandy reclaims Chineseness as a means to reposition her power and place within the relationship, resurfacing as a form of dwelling.

Chineseness emerges as a mode of relationality characterized by its imminent recyclability; it is consistently in a state of suspension, relentlessly recalibrated with no definite origin or endpoint. As such, it appears as an emotional state that the characters can never "arrive at," but resides as a privileged affective destination around which they consistently reposition themselves. It is precisely this repositioning, or dwelling, that permits Sandy to stall the pace and splinter the direction of her otherwise smooth exchange as a "Chinese native" trafficked through a hypothetically interconnected and undiscriminating neoliberal marketplace.

I have juxtaposed *The Fourth Portrait* and *Seeking Asian Female*, two seemingly disparate films, in order to illustrate the recursive and colliding relationships that dwelling reveals. The films' new immigrant and sex-working figures traffic, endure, and reorient themselves within the global marketplace as they dwell upon and within imaginations of Chineseness. Chineseness, in particular, is repackaged in the two films as a visible and recyclable interface on which the heroines localize their identities against the flows of transnational capital without generating a heteronormative analogy of reproductive nationalism for their host countries, Taiwan and the United States. As a volatile yet suspended affective structure, dwelling as a critical paradigm makes room for a more complex mapping of sociality and individual agency.

As an affective structure, dwelling emerges as a minor transnational mode of social formation in a neoliberal age, one that echoes but is unlike the transnational affective structure of Pacific Crossing identified in the early twentieth century (part 1). While Pacific Crossing is galvanized by competing nationalisms, dwelling as a structure of feeling is relatively detached from the nation-state and is disinterested in discourses of cultural and national authenticity. Dwelling, thus, brings attention to twisting forms of intimacy that reorder the centrality of the nation-state (similar to the Sinophonic structure of feeling examined in part 2), yet also hinders the pace of marketized exchange, beckoning us to dwell just a while longer.

CODA

What Dwells

Xingfu 幸福 *[Happiness]*[1]

你若問我 什麼是幸福叫阮怎樣講
If you asked me what happiness is, what would I say
阮若是千金小姐 好命攏嫌不夠
If I were a rich lady, my good life wouldn't be enough
你若問我 什麼是人生叫阮怎樣回
If you asked me what life is, how would I respond
阮不是在家閨秀 幸福欲叼位找
I am not a proper lady, where am I to find happiness

啊～ 阮是野地的長春花
Ahh~ I'm a wildflower in the field
幸福是風中的蠟燭 咱要用雙手捧
Happiness is a candle in the wind; we need to protect it with both hands

啊～ 阮是野地的長春花
Ahh~ I'm a wildflower in the field
人生是暗夜的燈火 帶咱行向前
Life is the light in a dark night, guiding us forward

雖然是乎人看輕 行著這條路
Even though I have been looked down on all this way

阮嘛是飼家賺食 有什麼通見笑
I've provided food and shelter, what is there to be embarrassed
　　about
紅燈路頭街巷 暗暗孤單行
I walk alone amidst the red lights and the shadows
唉喲 換來一家的吃穿
Ahh~ I've provided for my family
我的人生喲～
This is my life Ahh~

I return to the song "Xingfu" 幸福 [Happiness], discussed at the opening of the book, as a way to move toward the project's closing. The song's enduring affective impact is shown in the tune's afterlife online. The song now has a web page on Streetvoice (a music-sharing and -streaming website), where users exchange transnational and translingual bonds of empathy. One Mandarin-speaking listener wrote in the comments section, "It is a pity that I can't understand Southern Min topolect, but I am still deeply moved by the tune. If only I could understand the lyrics!"[2] A fellow listener responded by translating the lyrics from a transliteration of Southern Min topolect to Mandarin, noting that "there are layers of meaning that get lost in translation."[3] In this online exchange, the Mandarin speaker expresses the song's affective impact even without linguistic understanding, prompting the fellow listener to bridge their linguistic gap without ignoring their persisting differences. That is, the song operates as an affective interface through which translingual fissures are recognized and reordered.

The tune rallies an expression of empathy across linguistic as well as geopolitical differences. One listener noted, "Recent events in China's Dongguan prefecture got me thinking about this song again," referring to the 2014 crackdown of sex industries in Dongguan. A fellow listener echoed this sentiment, exclaiming, "Good luck, friends in China. . . . We in Taiwan are in a very similar situation; we are all struggling against corporate and government manipulation. . . . Keep up your efforts, we are here alongside with you."[4] Addressing the Chinese

people as "friends" and not "family," reassuring them that they struggle "alongside" and not in unity, the Taiwanese-identified commentator expressed sentiments of solidarity that do not collapse distinct positionalities. The song offers a makeshift affective structure that shelters similarly "unhappy" subjects across the Taiwan Strait. It created an online dwelling place for shared, if contingent, empathy for sex workers caught within the flows of governmental and corporate reconfiguration.

The song "Xingfu" stirs the dwelling structure of feeling identified in the previous chapter that localizes minor transnational kinships against the centrality of both the nation-state and global economic flows. This nascent affective structure emerges in how the online commentators dwell over the tune when addressing recent events in Dongguan, China. It echoes in how the tune offered Li-jun's mourners a shared space of dwelling as they sang the song, together, at Li-jun's memorial. It shows also in my own desire to dwell on the figure of the sex worker by writing this book, in the wake of the passing of Taiwanese sex workers and activists Li-jun and Guan-jie.

Transpacific Attachments puts pressure on the national, cultural, and disciplinary boundaries that bind us by recognizing and amplifying the cultural-political work activated by the sex worker figure. I identify Chineseness as a particularly "sticky" (i.e., persistently affecting) expression of collectivity and track its historical formations in relation to ever-morphing representations of the sex worker. This book addresses those formations by first recounting how, in the early twentieth century, the "Chinese sex worker" appeared as an elastic transnational character that galvanized expressions of Chinese identity *across* nations—that is, the affective structure I term "Pacific Crossing." The figure transformed into a defiant icon during the Cold War era, *rejecting* the nation-state altogether and expressing what I argue to be a particularly Sinophonic structure of feeling. Finally, in the neoliberal contemporary era, the figure morphs into a localizing symbol that *reterritorializes* kinships against narratives of global connectivity, without signifying a dominating return of the nation or nationalism; doing so performs the affective structure I call "dwelling." These affective structures are held in tension with one another through this

genealogy, so we can capture the dynamism created when they are conceived in relation to each other. By centering on the affective labor of the sex worker—a figure that is not often comfortably housed within imaginations of "Chineseness"—the book loosens the hold of such centripetal discourses and gestures toward their ongoing reassembly.

There are certain risks in tracing a genealogy of Chineseness through the figure of the sex worker. For one, Chineseness may be assigned too much power and cohesion in the very act of locating a history, even if that location aims to complicate and challenge the concept. In addition, by organizing analysis around the sex worker figure, the affective labor done by real-life sex workers and the figure's cultural representations may be elided or conflated.

Real-life sex workers' livelihood strategies and struggles often expose social injustices in which gender/sexuality, race/ethnicity, and national/global citizenship are organizing principles; however, the workers are frequently spoken for by advocates. They often work as cultural mediums so that others can articulate competing claims for social and human rights, but their own needs are easily drowned out by the outpour of affective engagement that they galvanize. Because the sex worker is such an affectively charged figure, those of us who attempt to study their affective impact must be conscious of both our analytical and social entry points.

That means I need to continually grapple with my own middle-class upbringing and transpacific mobility. My parents were labor rights activists/academics who organized alongside the COSWAS collective in Taiwan during the 1990s. They engaged in protests and rallies that exposed me to the relationships among state power, the policing of social morality, and the limits of global mobility. The courage of the sex workers/activists taught me to reject narratives of criminalization and/or recue, which stigmatizes those who are already socially marginalized and forecloses any sign of agency on their own terms. Yet these lessons were learned from a distance. I do not bear the weight of social stigma or state violence on my own body. I can critique the limitations of sexual citizenship and its ties to ethno-nationalist discourses largely because I have the luxury to move across cultural and national borders as what Aihwa Ong calls a "flexible citizen."[5]

Keeping in mind my positionality, I have attempted with this project to feel out forms of ethical engagement. I've aimed to leverage my social and cultural mobility to bring together—and hold tensions among—disparate histories and disciplinary fields that affect and are affected by the sex worker. It is my hope that the tensions created illuminate ways in which, as Sara Ahmed puts it, "feelings might be how [social] structures get under our skin."[6] I've identified the mechanics by which mass-mediated feelings allow for social norms to manifest publically and, in turn, "get under our skin" as if they are naturally bound to our private identities. Such affective analysis highlights the artificiality of social structures; moreover, it illuminates the ways in which social norms are coproduced through the affective pulls of divergent social relations and expressions.

By identifying affective constructions of Chineseness created between sex workers (in real life and representation) and those who are affected by them (e.g., advocates, clients, viewers, readers), I denaturalize the concept and pull it out from "under our skin." That is, I read real-life sex workers, those who portray them, their cultural representations, and their readers and viewers as all part of the social infrastructure that generates—through its relational pulls—affective structures like Chineseness. The book thus offers an alternative history of social formation not simply by deconstructing or posing different readings of Chineseness. Instead, it poses an affective genealogy that displays the concept's malleability as well as its sociality.

Such relational affective readings of social construction are central to an understanding of power in our increasingly individuated, information- and image-based era of late capitalism. Neoliberal ideologies often tie individual social liberties to individualist freedoms of consumption and ownership, relegating signifiers of identity (e.g., race, gender, sexuality) into the realm of personal rather than public responsibility.[7] An affective analysis challenges such privatization of identity politics with its interpersonal focus. It contextualizes identity formation within larger histories of social and material relations. Something as individuated as people's understandings of their own bodies and emotions are, under an affective lens, deprivatized as historically situated notions that are socially produced. Moreover, many

argue that affective labor has become a dominant mode of production in the contemporary informational economy.[8] It is thus crucial for us to develop ways to locate the complex topographies of affect, value, and power that operate in relation to old and new styles of economic, technological, and cultural forms.

Transpacific Attachments endeavors to offer such a study. With an oceanic paradigm, the book traces the ebbs and flows of affective forms created when unevenly stratified bodies, discourses, and spaces are put into contact. Instead of necessarily negating social constructions (e.g., Chineseness or sexual citizenship), the book locates divergent histories of social formation and sets them into motion. While *Transpacific Attachments* focuses on representations of sex workers in relation to transpacific creations of Chineseness, I hope the book opens up further inquiries about the temporary worlds that we are in the process of co-creating. The book maps another ripple moving toward a reordering of conceptual borders: a reassembly of meaning that, one day, may allow us to shelter the many affecting ghosts who dwell with and in us.

NOTES

INTRODUCTION: SEX WORK, MEDIA NETWORKS, AND TRANSPACIFIC HISTORIES OF AFFECT

1. 詞: 日日春關懷互助協會; 黑手那卡西　曲: 陳柏偉 [Lyrics: Collective of Sex Workers and Supporters, Black Hand Nakasi; Music: Chen Bo-wei].

2. For more on the history of Wenmeng Brothel, see Guan Zhongxiang 管中祥, ed., *Gongmin bu lengxue: Xinshiji taiwan gongmin xingdong shijian bu* 公民不冷血: 新世紀台灣公民行動事件簿 [The people are not cold hearted: Notes on Taiwanese citizen activism in the new century] (Taipei: Under Table Press, 2015), 184–93.

3. "Zhuisi qian gongchang Lijun! 200 ren qi bi zhongzhi: Jiquan yundong jingshen busi" 追思前公娼麗君! 200人齊比中指: 妓權運動精神不死 [Remembering former sex worker Lijun! 200 people collectively raised their middle fingers. Long live the sex worker rights movement], *SETN News*, August 25, 2014.

4. Sara Ahmed, *The Promise of Happiness* (Durham, N.C.: Duke University Press, 2010).

5. Ibid., 11.

6. Here, I am drawing from and reworking Raymond Williams's concept of "structure of feeling," which he defines as a "particular quality of social experience and relationship, historically distinct from other particular qualities, which gives the sense of a generation or of a period." Raymond Williams, *Politics and Letters: Interviews with New Left Review* (London: Verso, 2015), 131.

7. For more on Li-jun, see "Li-jun de gushi" 麗君的故事 [Story of Li-jin], COSWAS website, accessed June 23, 2017, http://coswas.org/archives/category/02sex worker/3storyoflijun.

8. For more on Taiwan's sex worker rights movement in the 1990s, see Guan, *Gongmin bu lengxue*, 178–93; Xia Linqing 夏林清, ed., *Gongchang yu jiquan yundong* 公娼與妓權運動 [1998 world action forum for sex work rights] (Taipei: Collective of Sex Workers and Supporters Press, 2000); Wang Fangping 王芳萍 et al., eds., *Yu chang tongxing, fanqiang yuejie* 與娼同行, 翻牆越界 [In solidarity with sex workers, we cross borders] (Taipei: Juliu tushu, 2002); Hans Tao-Ming Huang, *Queer Politics and Sexual Modernity in Taiwan* (Hong Kong: Hong Kong University Press, 2011), 201–5; Josephine Ho, "Sex Revolution and Sex Rights Movement in Taiwan," in *Taiwanese Identity From Domestic, Regional and Global Perspectives*, ed. Jens Damm and Gunter Schubert (Münster: LIT, 2007), 123–39; and Josephine Ho, "From Anti-Trafficking to Social Discipline, or the Changing Role of Women's NGOs in Taiwan," in *Trafficking and Prostitution Reconsidered: New Perspectives on Migration, Sex Work and Human Rights*, ed. Kamala Kempadoo, Jyoti Sanghera, and Bandana Pattanaik (Boulder, Colo.: Paradigm, 2005), 83–105.

9. For more on how Taiwan's sex worker rights movement operates in conjunction with other labor and sexual rights movements, see Collective of Sex Workers and Supporters, *Jinü lianheguo* 妓女聯合國 [Sex worker united nations] (Taipei: Collective of Sex Workers and Supporters Press, 2007); and Kamala Kempadoo, Jyoti Sanghera, and Bandana Pattanaik, eds., *Trafficking and Prostitution Reconsidered: New Perspectives on Migration, Sex Work and Human Rights* (Boulder, Colo.: Paradigm, 2005).

10. For more on Guan-jie, see "Guan-jie de gushi" 官姐的故事 [Story of Guan-jie], COSWAS website, accessed June 23, 2017, http://coswas.org/archives/category /02sexworker/2storyofguanjie.

11. This sex worker rights movement centralized middle-aged licensed sex workers resisting regulation and advocating for their right to labor. It diverged from previous antitrafficking movements in Taiwan organized mostly by antiprostitution NGOs that featured underaged girls in their demonstrations to further a "rescue" agenda. See Ho, "From Anti-Trafficking to Social Discipline," 92–93.

12. "Gongchang doushi Guanjie, shi fu Jilong: yijiao xiuzi renchu shenfen jing yi yanshi tiaohai" 公娼鬥士官姐, 屍浮基隆: 衣角繡字認出身分警疑厭世跳海 [Sex worker activist body found in Ji-long: Identity verified by name knit on shirt, police suspect suicide], *Apple Daily*, August 17, 2006.

13. *Apple Daily*, August 17, 2006; *Dongsen xinwenbao*, August 17, 2006, and *Lianhe wanbao*, August 17, 2006.

14. See Louise Shelley, *Human Trafficking: A Global Perspective* (Cambridge: Cambridge University Press, 2010), 141–73.

15. Many argue that this compliance with "international human rights standards" leads to not only a universalization of the liberal Western legal

tradition but also a moralizing measure of punitive-preventative social control. See Ho, "From Anti-Trafficking to Social Discipline"; and Hans Tao-Ming Huang, "State Power, Prostitution and Sexual Order in Taiwan: Towards a Genealogical Critique of 'Virtuous Custom,'" in *Inter-Asia Cultural Studies Reader*, ed. Kuan-Hsing Chen and Chua Beng Huat (New York: Routledge, 2007), 364–94.

16. See Ho, "From Anti-Trafficking to Social Discipline," 97–98.

17. I am building on discussions about roots (ethnicity) and routes (cultural identity) set forth by works such as Paul Gilroy, *The Black Atlantic: Modernity and Double Consciousness* (Cambridge, Mass.: Harvard University Press, 1993); and James Clifford, *Routes: Travel and Translation in the Late Twentieth Century* (Cambridge, Mass.: Harvard University Press, 1997).

18. See Brian Massumi's *Parables for the Virtual: Movement, Affect, Sensation* (Durham, N.C.: Duke University Press, 2002); Eve Kosofsky Sedgwick, *Touching Feeling: Affect, Pedagogy, Performativity* (Durham, N.C.: Duke University Press, 2003); and Gregory Seigworth and Melissa Gregg, "An Inventory of Shimmers," in *The Affect Theory Reader*, ed. Gregory Seigworth and Melissa Gregg (Durham, N.C.: Duke University Press, 2010), 1–25.

19. Deleuze and Guattari reformulate Spinoza's notion of "affectus" and argue that affects are visceral forces, generated between social bodies that shape the social field, as opposed to what they read as "privatized" emotions that are shaped by external forces. For more, see Gilles Deleuze and Félix Guattari, *A Thousand Plateaus: Capitalism and Schizophrenia* (Minneapolis: University of Minnesota Press, 1987), 240.

20. Massumi, *Parables for the Virtual*, 28.

21. Ibid.

22. This interpretation of affect as being autonomous, pre-personal, and extratextual is how Massumi departs from his poststructuralist predecessors. He challenges poststructuralist approaches to language, power, and subjectivity, which he sees as identifying points on a stable map of the already known. See Massumi, *Parables for the Virtual*, 12.

23. See Lili Hsieh, "Interpellated by Affect: The Move to the Political in Brian Massumi's Parables for the Virtual and Eve Sedgwick's Touching Feeling," *Subjectivity* 23 (2008): 219–35; Clare Hemmings, "Invoking Affect: Cultural Theory and the Ontological Turn," *Cultural Studies* 19, no. 5 (2005): 548–67; Sara Ahmed, "Collective Feelings: Or, the Impressions Left by Others," *Theory, Culture & Society* 21, no. 2 (April 2004): 25–42; and Sara Ahmed, *The Cultural Politics of Emotion*, 2nd ed. (New York: Routledge, 2015), 204–33.

24. Hemmings, "Invoking Affect," 561–62; and Sara Ahmed, "Embodying Strangers," in *Body Matters: Feminism, Textuality, Corporeality*, ed. Avril Horner and Angela Keane (Manchester: Manchester University Press, 2000), 85–86.

25. Audre Lorde, "Eye to Eye: Black Women, Hatred, and Anger," in *Sister Outsider: Essays and Speeches by Audre Lorde* (Freedom, Calif.: Crossing Press, 1984), 145–75, quotation on 147–48.

26. Hemmings, "Invoking Affect," 564.

27. Ahmed, *Cultural Politics of Emotion*, 215.

28. Ibid., 208.

29. Ibid., 11.

30. See Colleen Lye, *America's Asia: Racial Form and American Literature, 1893–1945* (Princeton, N.J.: Princeton University Press, 2005), 10–24; and Eric Hayot, *The Hypothetical Mandarin: Sympathy, Modernity, and Chinese Pain* (Oxford: Oxford University Press, 2009), 8–14.

31. See, for instance, Stephen Yao, *Foreign Accents: Chinese American Verse from Exclusion to Postethnicity* (Oxford: Oxford University Press, 2010); Eric Hayot, *Chinese Dreams: Pound, Brecht, Tel Quel* (Ann Arbor: University of Michigan Press, 2012); and Yunte Huang, *Transpacific Displacement: Ethnography, Translation, and Intertextual Travel in Twentieth-Century American Literature* (Berkeley: University of California Press, 2002).

32. See Andrea Bachner, *Beyond Sinology: Chinese Writing and the Scripts of Culture* (New York: Columbia University Press, 2014), 19–55. Also similar is Soviet film director Sergei Eisenstein's use of Chinese ideograms as a way to illustrate a purportedly unconventional logic of film editing. See Christopher Bush, *Ideographic Modernism: China, Writing, Media* (Oxford: Oxford University Press, 2012); and J. Marshall Unger, *Ideogram: Chinese Characters and the Myth of Disembodied Meaning* (Honolulu: University of Hawai'i Press, 2003).

33. Haiyan Lee, *Revolution of the Heart: A Genealogy of Love in China, 1900–1950* (Stanford, Calif.: Stanford University Press, 2007), 7.

34. Lisa Rofel, *Desiring China: Experiments in Neoliberalism, Sexuality, and Public Culture* (Durham, N.C.: Duke University Press, 2007).

35. For instance, Rey Chow situates discussions of sentimentality within the global economy of transnational Chinese cinema. See Rey Chow, *Sentimental Fabulations, Contemporary Chinese Films: Attachment in the Age of Global Visibility* (New York: Columbia University Press, 2007).

36. Wang Gungwu, "A Single Chinese Diaspora?" in *Diasporic Chinese Ventures: The Life and Work of Wang Gungwu*, ed. Gregor Benton and Hong Liu (New York: Routledge, 2004), 157–58; Jing Tsu and David Der-wei Wang, "Introduction: Global Chinese Literature," in *Global Chinese Literature: Critical Essays*, ed. Jing Tsu and David Der-wei Wang (Leiden: Brill, 2010), 1–14; Shu-mei Shih, *Visuality and Identity: Sinophone Articulations Across the Pacific* (Berkeley: University of California Press, 2007), 1–39; and Shu-mei Shih, "Against Diaspora: The Sinophone as Places of Cultural Production," in Tsu and Wang, *Global Chinese Literature*, 29–48.

37. Tsu and Wang, "Introduction: Global Chinese Literature," 6.

38. Shih, *Visuality and Identity*, 30.

39. Sau-ling Wong, "Global Vision and Locatedness: World Literature in Chinese / By Chinese from a Chinese-Americanist Perspective," in *Global Chinese Literature: Critical Essays*, ed. Jing Tsu and David Der-wei Wang (Leiden: Brill, 2010), 49–76, quotation on 51.

40. With this concept of the "transpacific," I build on the pioneering work done by others, including Rob Wilson and Arif Dirlik, eds., *Asian/Pacific as Space of Cultural Production* (Durham, N.C.: Duke University Press, 1995); David Palumbo-Liu, *Asian/American Historical Crossings of a Racial Frontier* (Stanford, Calif.: Stanford University Press, 1999); Yunte Huang, *Transpacific Displacement*; Yunte Huang, *Transpacific Imaginations: History, Literature, Counterpoetics* (Cambridge, Mass.: Harvard University Press, 2008); Chih-ming Wang, *Transpacific Articulations: Student Migration and the Remaking of Asian America* (Honolulu: University of Hawaiʻi Press, 2013); and Janet Hoskins and Viet Thanh Nguyen, *Transpacific Studies: Framing an Emerging Field* (Honolulu: University of Hawaiʻi Press, 2014).

41. Huang, *Transpacific Imaginations*, 2.

42. Hayot, *Hypothetical Mandarin*.

43. Wang, *Transpacific Articulations*.

44. See Sucheng Chan, "The Exclusion of Chinese Women, 1879–1943," in *Entry Denied: Exclusion and the Chinese Community in America, 1882–1943*, ed. Sucheng Chan (Philadelphia: Temple University Press, 1991), 94–146; Yu-fang Cho, *Uncoupling American Empire: Cultural Politics of Deviance and Unequal Difference, 1890–1910* (Albany: State University of New York Press, 2013); and George Peffer, *If They Don't Bring Their Women Here: Chinese Female Immigration Before Exclusion* (Champaign: University of Illinois Press, 1999). The U.S. restriction of Chinese women's migration through "antitrafficking" policies mobilized nineteenth-century narratives that non-Western women were commonly forced into prostitution due to the "uncivilized" character of their "native" cultures. Kempadoo states that this occurred not only for Chinese women in the United States under the Page Act of 1875 but also in Canada during the latter part of the nineteenth century. Similar restrictions were also put on Indian women under British colonial rule in the Caribbean after the abolition of slavery. See Kempadoo, Sanghera, and Pattanaik, *Trafficking and Prostitution Reconsidered*, xii.

45. See Sue Gronewold, *Beautiful Merchandise: Prostitution in China, 1860–1936* (New York: Harrington Park Press, 1982); Gail Hershatter, *Dangerous Pleasures: Prostitution and Modernity in Twentieth-Century Shanghai* (Berkeley: University of California Press, 1999); and Gail Hershatter, "Modernizing Sex, Sexing Modernity: Prostitution in Early-Twentieth-Century Shanghai," in *Chinese*

Femininities/Chinese Masculinities: A Reader, ed. Susan Brownell and Jeffrey N. Wasserstrom (Berkeley: University of California Press, 2002), 199–225.

46. For more discussion about the Taiwanese feminist debate, see Huang, *Queer Politics,* 18–24; Naifei Ding, "Prostitutes, Parasites and the House of State Feminism," *Inter-Asia Cultural Studies* 3, no. 3 (2000): 305–18; and Naifei Ding and Liu Renpeng, "Reticent Poetics, Queer Politics," *Inter-Asia Cultural Studies* 6, no. 1 (2005): 30–55.

47. Ahmed, in *The Cultural Politics of Emotion,* argues that "the association between objects and emotions is contingent (it involves contact), but that these associations are 'sticky.' Emotions are shaped by contact with objects. The circulation of objects is not described as freedom, but in terms of sticking, blockages, and constraints" (18n13).

48. Resonance, or echoes, cannot occur without distance and duration of time for sound to bounce between bodies.

1. DESIRING ACROSS THE PACIFIC: TRANSNATIONAL CONTACT IN EARLY TWENTIETH-CENTURY ASIAN/AMERICAN LITERATURE

1. For more on China's significance within the colonial imaginary at the turn of the twentieth century, see Colleen Lye, *America's Asia: Racial Form and American Literature, 1893–1945* (Princeton, N.J.: Princeton University Press, 2005), 10–24; Yu-fang Cho, *Uncoupling American Empire: Cultural Politics of Deviance and Unequal Difference, 1890–1910* (Albany: State University of New York Press, 2013), 77–102; and Eric Hayot, *The Hypothetical Mandarin: Sympathy, Modernity, and Chinese Pain* (Oxford: Oxford University Press, 2009), 8–14.

2. For more on how the U.S. rise as an imperial power was tied to its increased involvement in the Asia Pacific, particularly in China, see Lye, *America's Asia,* 12–46; Cho, *Uncoupling American Empire,* 77–102; and Howard Beale, *Theodore Roosevelt and the Rise of America to World Power* (Baltimore, Md.: Johns Hopkins University Press, 1956).

3. The U.S. neocolonial involvement in China worked as an expansion into the Asia Pacific and as a leveling of force with European powers. This is evident in how the Open Door policy was negotiated not *with* China, but about China with other Western powers. For more on how Asia formed the "back door" to European politics, see Lye, *America's Asia,* 9–22; Beale, *Theodore,* 5–6.

4. See Lye, *America's Asia,* 9–11; Cho, *Uncoupling American Empire,* 1–24; and Mae M. Ngai, *Impossible Subjects: Illegal Aliens and the Making of Modern America* (Princeton, N.J.: Princeton University Press, 2004), 18–19.

5. See Cho, *Uncoupling American Empire,* 77–102.

6. Ibid., 11–12.
7. For more on this triangulated relation between conceptions of white free labor, black ex-slave labor, and yellow slavery, see Cho, *Uncoupling American Empire*, 5–6, 77–102; Lisa Yun, *The Coolie Speaks: Chinese Indentured Laborers and African Slaves in Cuba* (Philadelphia: Temple University Press, 2008); Helen H. Jun, *Race for Citizenship: Black Orientalism and Asian Uplift from Pre-Emancipation to Neoliberal America* (New York: New York University Press, 2011); and Julia H. Lee, *Interracial Encounters: Reciprocal Representations in African and Asian American Literatures, 1896-1937* (New York: New York University Press, 2011).
8. For more on the gradual institutionalization of Anglo-Saxon-centric "whiteness" discourse at this time, see Ngai, *Impossible Subjects*, 23–37.
9. Ibid.
10. For more about the series of Chinese exclusionary laws that barred Chinese female immigrants by equating them to sex workers, see Sucheng Chan, "The Exclusion of Chinese Women, 1870–1943," in *Entry Denied: Exclusion and the Chinese Community in America, 1882-1943*, ed. Sucheng Chan (Philadelphia: Temple University Press, 1991), 94–146; George Peffer, *If They Don't Bring Their Women Here: Chinese Female Immigration Before Exclusion* (Champaign: University of Illinois Press, 1999); Elmer Sandmeyer, *The Anti-Chinese Movement in California* (Champaign: University of Illinois Press, 1991); Lisa Lowe, *Immigrant Acts: On Asian American Cultural Politics* (Durham, N.C.: Duke University Press, 1996); and Erika Lee, *At America's Gates: Chinese Immigration During the Exclusion Era, 1882-1943* (Chapel Hill: University of North Carolina Press, 2003).
11. As Moon-Ho Jung argues, the trope that Asian bodies constituted biological threats "rationalized U.S. expansion abroad, from China and Cuba in the 1850s to the Philippines in the 1890s." Jung, "Outlawing 'Coolie': Race, Nation, and Empire in the Age of Emancipation," *American Quarterly* 57, no. 3 (2005): 698. Stephen Yao goes on to argue that "the trope of biological threat in the form of contagious diseases and filth played an especially important role in the establishment of the Angel Island facility, as well as, indeed, the development of its operational procedures, which in their turn shaped the experiences of immigrants." Yao, *Foreign Accents: Chinese American Verse from Exclusion to Postethnicity* (Oxford: Oxford University Press, 2010), 71. For more on the biopolitics of Asian racial form in America, see Nayan Shah, *Contagious Divides: Epidemics and Race in San Francisco's Chinatown* (Berkeley: University of California Press, 2001).
12. Chan, "Exclusion of Chinese Women, 1870–1943," 138.
13. Cho, *Uncoupling American Empire*, 77–88.
14. Ibid., 81–82.
15. Sucheng Chan maintains that one of the most noticeable characteristics of Chinese immigration to the United States before World War II was the

exclusion of Chinese women by extensive anti-trafficking laws. The imbalance in the sex ratio lasted for more than a century, rather than for just a few decades as was common for other immigrant groups. For more, see Chan, "Exclusion of Chinese Women, 1870–1943."

16. Prostitution was one of the core issues consistently discussed in the Chinese public arena when imagining China's participation in global modernity. For more on the issue, see Gail Hershatter, *Dangerous Pleasures: Prostitution and Modernity in Twentieth-Century Shanghai* (Berkeley: University of California Press, 1999); Gail Hershatter, "Modernizing Sex, Sexing Modernity: Prostitution in Early-Twentieth Century Shanghai," in *Chinese Femininities/ Chinese Masculinities: A Reader*, ed. Susan Brownell and Jeffrey N. Wasserstrom (Berkeley: University of California Press, 2002), 199–225; Sue Gronewold, *Beautiful Merchandise: Prostitution in China, 1860–1936* (New York: Harrington Park Press, 1985); and Christian Henriot, *Prostitution and Sexuality in Shanghai: A Social History, 1849–1949* (Cambridge: Cambridge University Press, 2001).

17. Hershatter, *Dangerous Pleasures*, 245.

18. Chen Duxiu, quoted in Alan Lawrance, *China Since 1919: Revolution and Reform: A Sourcebook* (New York: Routledge, 2004), 2.

19. Partha Chatterjee, *Nationalist Thought and the Colonial World: A Derivative Discourse* (Minneapolis: University of Minnesota Press, 1986), 2.

20. David Palumbo-Liu, *Asian/American: Historical Crossings of a Racial Frontier* (Stanford, Calif.: Stanford University Press, 1999), 1.

21. I would like to thank Andy Chih-ming Wang for bringing my attention to this relationality between national exclusion and the formation of a particular Chinese American identity at this time.

22. I focus on sentiments mobilized across the Pacific Ocean, between those of the United States and China in particular. However, such Pacific Crossings are far from the only modes of transnational imagination of identity that can be traced from these literary works. Embedded in Sui Sin Far's writings, for instance, is also a hemispheric (north-south instead of east-west) imagination of border crossing, evident in her writings about Mexico and Jamaica. For a hemispheric reading of Sui Sin Far's work, see Julia H. Lee, "The Eaton Sisters Go to Jamaica," in *Interracial Encounters*, 81–113.

23. Sui Sin Far's work has been collected in anthologies, including Paul Lauter and Richard Yarborough, eds., *The Heath Anthology of American Literature* (New York: Cengage Learning, 2013), vol. 2; Susan Koppelman, *Women's Friendships: A Collection of Short Stories* (Norman: University of Oklahoma Press, 1991); Judith Fetterley and Marjorie Pryse, eds., *American Women Regionalists, 1850–1910* (New York: Norton, 1992); Eileen Barrett and Mary Cullinan, eds., *American Women Writers: Diverse Voices in Prose Since 1845* (New York: St. Martin's Press, 1992); Wesley Brown and Amy Ling, eds., *Imagining America: Stories from the Promised Land* (New York: Persea Books, 1991).

24. Annette White-Parks, *Sui Sin Far/Edith Maude Eaton: A Literary Biography* (Champaign: University of Illinois Press, 1995), 6.

25. This measuring of Far's literary value with cultural/ethnic authenticity discourse can also be seen in the way her works were brought back into the spotlight in *Aiiieeeee! An Anthology of Asian-American Writers*. The editors emphasized her work's "authenticity," tying her work's subsequent value to a racial-ethnic genealogy of Asian American literature in contrast to the "white tradition of Chinese novelty literature, would-be Chinese writing about America for the entertainment of Americans" that the editors deemed fake. Jeffery Paul Chan et al., eds., *Aiiieeeee! An Anthology of Asian-American Writers* (Washington, D.C.: Howard University Press, 1983), xii–xiii.

26. Though much of early U.S.-based literary scholarship on Sui Sin Far's work has utilized a largely bio-ethnic framework to evaluate Far's literary value, recent scholars have widened their focus to a more layered reading of her racial representation. See, for instance, Cho, *Uncoupling American Empire*, 77–125; Min Hyoung Song, "Sentimentalism and Sui Sin Far," *Legacy* 20, nos. 1–2 (2003): 134–53; Dominika Ferens, *Edith and Winnifred Eaton: Chinatown Missions and Japanese Romances* (Urbana: University of Illinois Press, 2002); Martha J. Cutter, "Sui Sin Far's Letters to Charles Lummis: Contextualizing Publication Practices for the Asian American Subject at the Turn of the Century," *American Literary Realism* 38, no. 3 (2006): 259–75; Shirley Geok-lin Lim, "Sibling Hybridity: The Case of Edith Eaton/Sui Sin Far and Winnifred Eaton (Onoto Watanna)," *Life Writing* 4, no. 1 (2007): 81–99.

27. For more on Sui Sin Far's work through the perspective of mixed-race studies, see Emma Jinhua Teng, *Eurasian: Mixed Identities in the United States, China, and Hong Kong, 1842–1943* (Berkeley: University of California Press, 2013), 168–94; Paul Spickard and Laurie Mengel, "Deconstructing Race: The Multiethnicity of Sui Sin Far," *Books and Culture* 3, no. 4 (1997): 4–5.

28. White-Parks, *Sui Sin Far/Edith Maude Eaton*, 4, 17.

29. Ibid., 4.

30. Ibid., xvi. While Sui Sin Far chose to write under her Chinese pet name, her sister Winnifred Eaton chose to write under a Japanese pen name, Onoto Watanna. For more discussion on the body politics of the Eaton sisters' chosen identities, see Viet Thanh Nguyen, "On the Origins of Asian American Literature: The Eaton Sisters and the Hybrid Body," in *Race and Resistance: Literature and Politics in Asian America* (Oxford: Oxford University Press, 2002), 33–59.

31. Sui Sin Far, quoted in L. Hsuan Hsu, *Mrs. Spring Fragrance: Edith Maude Eaton/ Sui Sin Far* (Ontario: Broadview Press, 2011), 222.

32. Ibid., 225.

33. Ibid., 233.

34. Scholars, including Hershatter and Gronewold, have emphasized the hierarchal differences among high-end courtesans, teahouse sing-song girls, and lower-class streetwalkers. For detailed discussions of these hierarchies, see Hershatter, *Dangerous Pleasures*, 34–65; Gronewold, *Beautiful Merchandise*. Here, I use the umbrella idea of "sex worker" as a way to incorporate this wide range of "fallen" or "sexually deviant" figures and see them as conducting similar affective labors: that of managing economies of shame and desire.

35. Paola Zamperini, *Lost Bodies: Prostitution and Masculinity in Chinese Fiction* (Leiden: Brill, 2010), 100.

36. Hsu, *Mrs. Spring Fragrance*, 68.

37. Zamperini, *Lost Bodies*, 100.

38. Hsu, *Mrs. Spring Fragrance*, 151.

39. Ibid., 152.

40. Ibid., 159.

41. Ibid.

42. Ibid., 160.

43. Ibid., 161.

44. Selections (220 out of 1,640 poems) from these two anthologies have been translated and published by Marlon K. Hom as *Songs of Gold Mountain: Cantonese Rhymes from San Francisco Chinatown* (Berkeley: University of California Press, 1987). I cite Hom's translation in this chapter. The poems were published anonymously, so I cite them according to the page number of Hom's anthology, not by author.

45. Peter Kvidera, "Resonant Presence: Legal Narratives and Literary Space in the Poetry of Early Chinese Immigrants," *American Literature* 77, no. 3 (2005): 511–39, quotation at 513.

46. Hom, *Songs of Gold Mountain*, 170.

47. I use the masculine pronoun because the poets of these collected poems were most likely men. As Peter Kvidera notes, "Predominantly, men immigrate, and the quarters where most of the women stayed burned to the ground in 1940." Kvidera, "Resonant Presence," 533n2. Moreover, most female immigrants of the time were illiterate. See Hom, *Songs of Gold Mountain*, 3–70.

48. Hsu, *Mrs. Spring Fragrance*, 233.

49. Kvidera, "Resonant Presence," 529.

50. Hom, *Songs of Gold Mountain*, 231–51.

51. Ibid., 243.

52. Haiyan Lee, *Revolution of the Heart: A Genealogy of Love in China, 1900-1950* (Stanford, Calif.: Stanford University Press, 2007), 38.

53. See poems #149, #150, #151, #152, #154, and #158, found in Hom, *Songs of Gold Mountain*, 239, 240, 241, 242, 244, 248, respectively.

54. Ibid., 257.

55. For a chart detailing major themes of the poems collected, see Hom, *Songs of Gold Mountain*, 61. The prominence and pervasiveness of poems about sex workers have long bewildered scholars. See ibid., 64–67; Kvidera, "Resonant Presence," 529; Sau-ling C. Wong, "The Politics and Poetics of Folksong Reading: Literary Portrayals of Life under Exclusion," in *Entry Denied: Exclusion and the Chinese Community in America, 1882-1943*, ed. Sucheng Chan (Philadelphia: Temple University Press, 1991), 246–67.

56. I use the feminine pronoun for the sex worker figure in this chapter because the sex workers depicted by the migrant writers were women. See poems #177, #218, and #220, found in Hom, *Songs of Gold Mountain*, 273, 320, 322, respectively.

57. Ibid., 320.

58. See poems #187, #189, #190, and #191, found in Hom, *Songs of Gold Mountain*, 283, 285, 286, 287, respectively.

59. Ibid., 285.

60. Ibid., 317.

61. Ibid., 312.

62. Zamperini, *Lost Bodies*, 100.

2. OVER MY DEAD BODY: MELODRAMATIC CROSSINGS OF ANNA MAY WONG AND RUAN LINGYU

1. See Mae M. Ngai, *Impossible Subjects: Illegal Aliens and the Making of Modern America* (Princeton, N.J.: Princeton University Press, 2004), 15–90; and Erika Lee, *At America's Gates: Chinese Immigration During the Exclusion Era, 1882-1943* (Chapel Hill: University of North Carolina Press, 2003).

2. Ngai, *Impossible Subjects*, 17; Lee, *At America's Gates*, 19–46.

3. Ngai argues, "the national origins quota system proceeded from the conviction that the American nation was, and should remain, a white nation descended from Europe. If Congress did not go so far as to sponsor race breeding, it did seek to transform immigration law into an instrument of mass racial engineering." *Impossible Subjects*, 27.

4. Ngai, *Impossible Subjects*, 37–50.

5. See George C. Herring, *From Colony to Superpower: U.S. Foreign Relations Since 1776* (Oxford: Oxford University Press, 2008), 489–91.

6. For more examples on how U.S.-Asia contact intensified in the realm of cultural production during post–World War I U.S. isolationism, see Christina Klein, *Cold War Orientalism: Asia in the Middlebrow Imagination, 1945-1961* (Berkeley: University of California Press, 2003), 4–5; and Ngai, *Impossible Subjects*, 202–4.

7. For more on how cinema served as part and promoter of technological, industrial-capitalist modernity internationally, see Jennifer M. Bean, Anupama Kapse, and Laura Horak, eds., *Silent Cinema and the Politics of Space* (Bloomington: Indiana University Press, 2014). For the context of Chinese cinema in particular, see Zhen Zhang, *An Amorous History of the Silver Screen: Shanghai Cinema, 1896–1937* (Chicago: University of Chicago Press, 2005); Shuqin Cui, *Women Through the Lens: Gender and Nation in a Century of Chinese Cinema* (Honolulu: University of Hawai'i Press, 2003); and Miriam Hansen, "Fallen Women, Rising Stars, New Horizons: Shanghai Silent Film as Vernacular Modernism," *Film Quarterly* 54, no. 1 (Autumn 2000): 10–22.

8. Hollywood continued to dominate the Chinese market until 1941, with its most secure dominance being in Shanghai. See Laikwan Pang, *Building a New China in Cinema: The Chinese Left-Wing Cinema Movement, 1932–1937* (Lanham, Md.: Rowman & Littlefield, 2002), 148; Yingjin Zhang, *Chinese National Cinema* (New York: Routledge, 2004), 71–72.

9. Cui, *Women Through the Lens*, 9.

10. Zhang, *Amorous History of the Silver Screen*, xxx.

11. See Sheldon Hsiao-peng Lu, "Historical Introduction: Chinese Cinemas (1896–1996) and Transnational Film Studies," in *Transnational Chinese Cinemas: Identity, Nationhood, Gender*, ed. Sheldon Hsiao-peng Lu (Honolulu: University of Hawai'i Press, 1997), 1–31; and Cheng Jihua 程季華, Li Shaobai 李少白, and Xing Zuwen 邢祖文, eds., *Zhongguo dianying fazhan shi* 中國電影發展史 [The historical development of Chinese cinema] (Beijing: Zhongguo dianying chubanshe, 1963).

12. For more on hypersexualized representations of Asian women in early Euro-American media, see Celine Parreñas Shimizu, *The Hypersexuality of Race: Performing Asian/American Women on Screen and Scene* (Durham, N.C.: Duke University Press, 2007); and Kent A. Ono and Vincent N. Pham, *Asian Americans and the Media* (Cambridge: Polity, 2009), 66–70.

13. For more history on U.S.-Sino political negotiations over what Chinese critics considered to be Hollywood's routine denigration of China's image on the silver screen, see Yiman Wang, "The Crisscrossed Stare: Protest and Propaganda in China's Not-So-Silent Era," in *Silent Cinema and the Politics of Space*, ed. Jennifer M. Bean, Anupama Kapse, and Laura Horak (Bloomington: Indiana University Press, 2014), 186–209; and Zhiwei Xiao, "Anti-Imperialism and Film Censorship During the Nanjing Decade, 1927–1937," in *Transnational Chinese Cinemas: Identity, Nationhood, Gender*, ed. Sheldon Hsiao-Peng Lu (Honolulu: University of Hawai'i Press,1997), 35–58.

14. Anna Lowenhaupt Tsing, *Friction: An Ethnography of Global Connection* (Princeton, N.J.: Princeton University Press, 2005), 1.

15. I refer to this left-wing cinematic movement as "Shanghai National Cinema" instead of "Chinese National Cinema" as a way to retain the internal friction

between the Shanghai identity and the "Chinese" national identity that this cinematic movement claimed to simultaneously represent. In so doing, I highlight the particular cultural and political landscape the city of Shanghai provided in order to excite the emergence of this nationalistic cinema, and how its self-avowed national profile did not always reflect the overall sentiments of the Chinese nation. For more on this internal friction between the Shanghai identity and "Chinese" national identity, see Pang, "Shanghai or Chinese Cinema?" in *Building a New China in Cinema*, 165–96.

16. This reading of Sino-American power relations that emphasizes relational navigation instead of oppositional reaction is similar to Yiman Wang's theorization of a "crisscrossed stare." To Wang, early Hollywood and Chinese film industries' ideological negotiation, if read through the concept of crisscrossed stare, encompasses a "reversed, crisscrossed stare and self-reflective, introverted stare, ... [that] inscribe and respond to a colonial power structure that not only hierarchizes but also interconnects the colonizer and the colonized in a mutually constitutive and ever-shifting network ... instigating continuous Self-Other realignment." "The Crisscrossed Stare," 206. Wang highlights the visual element of "staring," with the "crisscrossed" aspect of the metaphor serving a mostly directional connotation. In this chapter, however, I focus on the very dynamism that "crossing" as a metaphor provides. Crossing encapsulates both the physical and affective registers of encounters. Furthermore, it stresses the very materiality of encounters and, as such, expands our analytical focus away from ideological intent and toward potentialities through contact.

17. "The Toll of the Sea," *New York Times*, November 27, 1922, 18.

18. *Picturegoer*, November 29, 1924.

19. As the first Chinese American actress known worldwide, Wong has become the focus of studies investigating U.S. racial stereotyping as well as the limits and possibilities of resistance through performance. See, for instance, Celine Parreñas Shimizu, "The Sexual Bonds of Racial Stardom: Asian American Femme Fatales in Hollywood," in *The Hypersexuality of Race*, 58–101; Cynthia W. Liu, "When Dragon Ladies Die, Do They Come Back as Butterflies? Reimagining Anna May Wong," in *Countervisions: Asian American Film Criticism*, ed. Darrell Hamamoto and Sandra Liu, 23–39 (Philadelphia: Temple University Press, 2000); Anne Anlin Cheng, "Shine: On Race, Glamour, and the Modern," *Publications of the Modern Language Association* 126, no. 4 (2011): 1022–41; Thuy Linh Nguyen Tu, "Forgetting Anna May Wong," *Wasafiri* 19, no. 43 (2004): 14–18; Karen J. Leong, *The China Mystique: Pearl S. Buck, Anna May Wong, Mayling Soong, and the Transformation of American Orientalism* (Berkeley: University of California Press, 2005); Shirley Jennifer Lim, "'I Protest': Anna May Wong and the Performance of Modernity," in *A Feeling of Belonging: Asian*

American Women's Public Culture, 1930-1960 (New York: New York University Press, 2005), 47–86; Yiman Wang, "The Art of Screen Passing: Anna May Wong's Yellow Yellowface Performance in the Art Deco Era," *Camera Obscura* 60, no. 3 (2005): 159–91; and Yiman Wang, "Anna May Wong: A Border-Crossing 'Minor' Star Mediating Performance," *Journal of Chinese Cinemas* 2, no. 2 (2008): 91–102.

20. E. E. Barrett, "Right from Wong," *Picturegoer*, September 1928, 25.

21. "Girl Who Mustn't Kiss!" *Film Favourites*, December 12, 1931, 5–8.

22. Rob Wagner, "Two Chinese Girls . . . ," *Rob Wagner's Script*, November 21, 1936.

23. For more on Hollywood's Orientalist reception and review of Anna May Wong, see Wang, "Art of Screen Passing." For discussion on how American and European views of Anna May Wong varied, see Karen J. Leong, "Anna May Wong and the British Film Industry," *Quarterly Review of Film and Video* 23, no. 1 (2006): 13–22.

24. See *Photoplay*, March 18, 1937. See also "The Chinese Are Misunderstood," in which Wong explained her predicament in taking on demeaning roles. As if a gesture to declare independence from Hollywood, Wong starred in *The Silk Bouquet* (also known as *The Dragon Horse*, 1926)—a film funded by the San Francisco-based, Chinese American company Chinese Six Companies 六大公司. See *Mien Film*, October 1926. For more on Wong's protests against Hollywood representations, see Lim, " 'I Protest': Anna May Wong and the Performance of Modernity."

25. *Dianying zazhi*, November 1925.

26. *Dianying huabao*, May 1925.

27. For more on how Wong was subjected to both Euro-American Orientalism and transpacific Chinese nationalism, see Wang, "Art of Screen Passing," 162–67.

28. For more on the chronopolitics of Euro-American-centered developmentalist discourse, see Homi Bhabha's discussion of non-Western worlds' perceived "belatedness" of modernity in "DissemiNation: Time, Narrative, and the Margins of the Modern Nation," in *The Location of Culture* (New York: Routledge, 1994), 199–244; see also Dipesh Chakrabarty's critique of the idea of a single, homogenous, and secular historical time assumed in much of contemporary European political thought in *Provincializing Europe: Postcolonial Thought and Historical Difference* (Princeton, N.J.: Princeton University Press, 2000), 15–16.

29. Anthony B. Chan, *Perpetually Cool: The Many Lives of Anna May Wong (1905-1961)* (Lanham, Md.: Scarecrow Press, 2007), 227.

30. While Wong's scripted role might have been, as I've critiqued above, Orientalist, Wong's performance itself—which could be read as ironic, or what Yiman Wang calls "yellow yellowface"—shows more agency on her part.

For more analysis on Wong's performative agency, see Wang, "Art of Screen Passing."

31. Protests provoked by the release of *Shanghai Express* can be placed within a larger history of Chinese demonstrations against Hollywood films, such as *Thief of Bagdad* (1924) and *Welcome Danger* (1929), which also represented China and, by extension, Asia in a demeaning light. For more analysis on this history of Chinese protest against Hollywood, see Wang, "Crisscrossed Stare," 192–93.

32. For more on Hong Shen, see Jay Leyda, *Dianying Electric Shadows: An Account of Films and Film Audience in China* (Cambridge, Mass.: MIT Press, 1972), 82. On students, see Jonathan D. Spence, *The Search for Modern China* (New York: Norton, 1999), 283.

33. For more on Paramount Pictures's suspended license, see Ruth Vasey, *The World According to Hollywood* (Madison: University of Wisconsin Press, 1997), 155. It is important to note here that the banning of films was initiated not by the Nationalist government but by May Fourth intellectuals, illustrating a difference between the "nationalistic sentiment" promoted here and the Nationalist Party in power. For more about the May Fourth intellectuals' uneasy relationship with the Nationalist government in the case of film censorship, see Xiao, "Anti-Imperialism and Film Censorship."

34. As early as 1931, Paramount Pictures had planned to buy out all Chinese film studios for $15 million. For more on this, see Xiao, "Anti-Imperialism and Film Censorship," 44.

35. For more on the effects of China's "Anti-Spiritual Pollution Movement" on the Chinese film industry at the time, see Xiao, "Anti-Imperialism and Film Censorship."

36. See Yingjin Zhang, "Prostitution and Urban Imagination: Negotiating the Public and Private in Chinese Films of the 1930s," in *Cinema and Urban Culture in Shanghai, 1922-1943*, ed. Yingjin Zhang (Stanford, Calif.: Stanford University Press, 1999), 170, 301n44.

37. *Beiyang huabao*, December 5, 1931.

38. *Radio Movie Daily News*, June 1932.

39. These reactionary narrations, however, were not fully embraced by left-wing intellectuals. For more about the debate, see Zhang, *Amorous History of the Silver Screen*, 244–97.

40. *Shennü* was produced by Lianhua Studios, one of the largest Shanghai film studios during the 1930s. The studio was known for producing many films considered part of the left-wing cinema movement such as *Lian'ai yu yiwu* 戀愛與義務 [Love and duty], *Chengshi zhi ye* 城市之夜 [Night in the city], *Dalu* 大路 [The big road], and *Langshan diexueji* 狼山喋血記 [Blood on Wolf Mountain]. For more on Lianhua Studios, see Pang, *Building a New China in Cinema*, 24–28, 44–49, 62–63.

41. For a comprehensive history of the overall development of Shanghai National Cinema, see Pang, *Building a New China in Cinema*.

42. Ben Singer defines melodrama as a "cluster concept" involving different combinations of at least five key constitutive elements: strong pathos, heightened emotionality, moral polarization, nonclassical narrative mechanics, and spectacular effects. See Ben Singer, *Melodrama and Modernity: Early Sensational Cinema and Its Contexts* (New York: Columbia University Press, 2001), 7, 44–49.

43. This element of public mobilization on the narrative level is reflected also on the level of filmic form and public spectatorship. Many of the family melodramas produced in Shanghai at this time were silent films. According to Miriam Hansen, silent cinema offered an alternative experience of public participation through a re-imagination of one's interior—whether projections of the private sphere, or one's individual experience—projected from the particular vantage point of the alternative public space of the movie theater. See Miriam Hansen, "Early Silent Cinema: Whose Public Sphere?" *New German Critique* 29, (Spring–Summer, 1983): 155–58.

44. Elisabeth R. Anker, *Orgies of Feeling: Melodrama and the Politics of Freedom* (Durham, N.C.: Duke University Press, 2014), 2.

45. This class-conscious critique of global capital, through the streetwalker or "fallen woman" character, distinguishes *Shennü* from the "maternal melodrama" subcategory of pre-Code Hollywood's "fallen women films" popular at the time. As Lea Jacobs notes, Hollywood's maternal melodramas often downplay the fallen heroine's degradation and decline in favor of upward mobility in terms of class. See Jacobs, *The Wages of Sin: Censorship and the Fallen Woman Film, 1928-1942* (Berkeley: University of California Press, 1995), 12–13.

46. For more on the dual function of National Cinemas, see Lu, "Historical Introduction," 6.

47. According to Linda Williams, melodramas—along with horror films and pornography—are what she terms "Body Genres" in that they all prompt corporeal sensations. See Linda Williams, "Film Bodies: Gender, Genre and Excess," in *Film Genre Reader II*, ed. Barry Keith Grant (Austin: University of Texas Press, 2012), 140–58.

48. Bhaskar Sarkar, "The Melodrama of Globalization," *Cultural Dynamics* 20 (2008): 43.

49. For more on how the tabloids continuously scandalized her private life, see Richard Meyer, *Ruan Ling-yu: The Goddess of Shanghai* (Hong Kong: Hong Kong University Press, 2005), 52–67; "Diary of Li Minwe," *Da zhong dianying*, August 2003, 44–45.

50. Ruan's death was front-page news in papers such as *Huazi ribao*, March 9, 1935; *Shenbao*, March 9, 1935; *Dagongbao*, March 9, 1935; and *Peiping Morning Post*, March 10, 1935.

51. In its coverage, the journal *Variety* observed that the public outpour of sentiment outdid Rudolf Valentino's Hollywood ceremony. See *Variety*, April 24, 1935. For more on the public memorial, see *North-China Herald*, March 20, 1935; and the *North-China Daily News*, March 15, 1935. For more analysis of Ruan's funeral procession, see Kristine Harris, "The New Woman Incident: Cinema, Scandal, and Spectacle in 1935 Shanghai," in *Transnational Chinese Cinemas: Identity, Nationhood, Gender*, ed. Sheldon Hsiao-peng Lu (Honolulu: University of Hawai'i Press, 1997), 291.

52. Ruan, quoted in Meyer, *Ruan Ling-yu*, 61. See also Shen Ji 沈寂, *Ruan Ling-yu: Yidai yingxing* 阮玲玉: 一代影星 [Ruan Lingyu: Movie star of a generation] (Shanghai: Shanxi Renmin Chubanshe, 1985), 177.

53. There is much dispute over whether Ruan actually wrote this note. For detailed discussions about this dispute, see Meyer, *Ruan Ling-yu*; and Shen, *Ruan Ling-yu*. My analysis, however, is concerned less with the authenticity or intentionality of Ruan's notes and more on their social-political impact.

54. See Michael G. Chang, "The Good, the Bad, and the Beautiful: Movie Actresses and Public Discourse in Shanghai, 1920s–1930s," in *Cinema and Urban Culture in Shanghai, 1922-1943*, ed. Yingjin Zhang (Stanford, Calif.: Stanford University Press, 1999), 155.

55. See Meyer, *Ruan Ling-yu*, 59–70.

56. *Central China Daily News*, March 16, 1935; March 15, 1935; March 20, 1935.

57. Pang, *Building a New China in Cinema*, 124.

58. Ibid., 124.

59. Ibid., 124–25.

60. Katherine Verdery, *The Political Lives of Dead Bodies: Reburial and Postsocialist Change* (New York: Columbia University Press, 1999), 28.

61. Ibid., 33.

62. *Huazi ribao*, March 9, 1935; *Shenbao*, March 9, 1935; *Dagongbao*, March 9, 1935; *Peiping Morning Post*, March 10, 1935.

63. A day after the initial death note, "To Society," was publicized, Ruan's ex-partner Tang Jishan released a supposed second suicide note addressed specifically to Ruan's close friends and a few Lianhua directors. A month later, a second set of suicide notes was allegedly disclosed in a privately circulated newsletter, *Siming Business Journal*. For more discussion of the many death notes, see Shen, *Ruan Ling-yu*, 229; Chang, "The Good, The Bad, and the Beautiful," 156; and Meyer, *Ruan Ling-yu*, 59–70.

64. "Ruan Lingyu jinian zhuanhao," *Lianhua huabao*, April 1, 1935, 23.

65. Ibid.

66. For a summary of past discussions of the "New Woman Incident," see Kristine Harris, "The New Woman Incident"; and Sarah Stevens, "Figuring Modernity: The New Women and the Modern Girl in Republican China," *NWSA Journal* 15, no. 3 (Autumn 2003): 82–103.

67. Singer, *Melodrama and Modernity*, 46.
68. Sarkar, "Melodrama of Globalization," 42.
69. My analysis of the political agency of Ruan's corpse finds foundations in feminist post-Cartesian accounts that revise the opposition between "intelligent activity" and "brute passivity." See, for instance, Bishnupriya Ghosh, *Global Icons: Apertures to the Popular* (Durham, N.C.: Duke University Press, 2011); Elizabeth Grosz, *Volatile Bodies: Toward a Corporeal Feminism* (Bloomington: Indiana University Press, 1994); and Pheng Cheah, "Mattering," *Diacritics* 26, no.1 (Spring 1996): 108–39.
70. Bhaskar Sarkar, *Mourning the Nation: Indian Cinema in the Wake of Partition* (Durham, N.C.: Duke University Press, 2009), 30.
71. For more on the fan suicides, see Harriet Sergeant, *Shanghai* (London: Jonathan Cape, 1991), 290.
72. Meyer, *Ruan Ling-yu*, 63.
73. Ghosh, *Global Icons*, 176.
74. Lu Xun, "Gossip Is a Fearful Thing," in *Selected Works of Lu Xun*, vol. 4, trans. Yang Hsien-yi and Gladys Yang (Beijing: Foreign Language Press, 1960), 186–88.
75. Ibid., 188.
76. Zhang, *Amorous History of the Silver Screen*, 266.
77. See *Dianying huabao*, March 1, 1936; *Shidai dianying*, February, March 1936; *Lianhua huabao*, February 1936; *Yisheng dianying*, February 1936.
78. *Diansheng*, November 27, 1935; January 24, February 14, 1936.
79. See Graham Russell Gao Hodges's *From Laundryman's Daughter to Hollywood Legend: Anna May Wong* (New York: Palgrave Macmillan, 2005), 163.
80. *Shenbao*, May 1, 5, 1936; *Diansheng*, May 8, 1936.
81. See Louise Leung, "East Meets West: Anna May Wong Back on Screen After an Absence of Several Years, Discusses Her Native Land," *Hollywood Magazine*, January 1939.
82. *Diansheng*, May 9, 1936.
83. Cited in Leung, "East Meets West."
84. See Hodges, 175–209; Leong, *China Mystique*, 97–105; Chan, *Perpetually Cool*, 89–129; and Lim, "I Protest."
85. Shirley Jennifer Lim argues that Wong's performance in *King of Chinatown* pioneered Chinese American women's film roles. See Lim, "'I Protest.'"

3. EROTIC LIAISONS: SINOPHONIC QUEERING OF THE SHAW BROTHERS' CHINESE DREAM

1. Scholars have argued that the battle between capitalism and communism during the Cold War was an inter-imperial battle between the United States

and the Soviet Union over the right to inherit the legacy of Western imperialism, to articulate their own concepts of Western modernity, and to universalize it. See Odd Arne Westdad, *The Global Cold War: Third World Interventions and the Making of Our Times* (Cambridge: Cambridge University Press, 2007); and Jodi Kim, *Ends of Empire: Asian American Critique and the Cold War* (Minneapolis: University of Minnesota Press, 2010), 16–27.

2. For more on how the Cold War was not a dismantling but an expansion and reconstituting of Western-centric empire, see Kim, *Ends of Empire*, 1–32; Ann Laura Stoler, "Intimidations of Empire: Predicaments of the Tactile and Unseen," and "Tense and Tender Ties: The Politics of Comparison in North American History and (Post) Colonial Studies," in *Haunted by Empire: Geographies of Intimacy in North American History*, ed. Ann Laura Stoler (Durham, N.C.: Duke University Press, 2006), 1–22 and 23–67; Andrew Hammond, "From Rhetoric to Rollback: Introductory Thoughts on Cold War Writing," in *Cold War Literature: Writing the Global Conflict*, ed. Andrew Hammond (London: Routledge, 2003), 1–14; and Christina Klein, *Cold War Orientalism: Asia in the Middlebrow Imagination, 1945-1961* (Berkeley: University of California Press, 2003).

3. Hammond, "From Rhetoric to Rollback," 1.

4. For more on the politics of "Chineseness" between mainland Chinese and the Chinese diaspora during the Cold War, see Allen Chun 陳奕麟, "Jiegou Zhongguoxing: lun zuqun yishi zuowei wenhua zuowei rentong zhi aimei buming" 解構中國性:論族群意識作為文化作為認同之曖昧不明 [Fuck Chineseness: On the ambiguities of ethnicity as culture as identity], *Taiwan shehui yanjiu jikan* 台灣社會研究季刊 [*Taiwan: A Radical Quarterly in Social Sciences*] 33 (1999): 103–31; Allen Chun, "From Nationalism to Nationalizing: Cultural Imagination and State Formation in Post-war Taiwan," *Australia Journal of Chinese Affairs* 31 (1994): 49–69; Kuan-hsing Chen, *Asia as Method: Toward Deimperialization* (Durham, N.C.: Duke University Press, 2010); Chen, "Why Is 'Great Reconciliation' Impossible? De-Cold War/Decolonization, or Modernity and Its Tears (Part I)," *Inter-Asia Cultural Studies* 3, no. 1 (2002): 77–99; Chen, "Why Is 'Great Reconciliation' Impossible? (Part II)," *Inter-Asia Cultural Studies* 3, no. 2 (2002): 235–51.

5. For a detailed history of the Shaw Brothers organization, see Poshek Fu, ed., *China Forever: The Shaw Brothers and Diasporic Cinema* (Urbana: University of Illinois Press, 2008); and the Hong Kong Film Archive's *The Shaw Screen: A Preliminary Study* (Hong Kong: Hong Kong Film Archive, 2003).

6. When the studio was first established in Shanghai, it was called Tianyi 天一 Film Company. For more about the studio's early years, see Poshek Fu, "Introduction: The Shaw Brothers Diasporic Cinema," in *China Forever: the Shaw Brothers and Diasporic Cinema*, ed. Poshek Fu (Urbana: University of Illinois Press, 2008), 2–6; Lily Kong, "Shaw Cinema Enterprise and Understanding Cultural Industries," in *China Forever*, 28–29; Stephanie Po-yin Chung,

"Industrial Evolution of a Fraternal Enterprise: The Shaw Brothers and the Shaw Organization," in *The Shaw Screen: A Preliminary Study* (Hong Kong: Hong Kong Film Archive, 2003), 1–17; Chengren Zhou, "Shanghai's Unique Film Productions and Hong Kong's Early Cinema," in *The Shaw Screen*, 19–35; and Sek Kei, "Shaw Movie Town's 'China Dream' and 'Hong Kong Sentiments,'" in *The Shaw Screen*, 39–40.

7. The founding of the People's Republic of China in 1949 led to a nationalization of the Chinese cinema industry under the control of the Communist Party. As a result, the distribution of Chinese films in and out of mainland China was tightly controlled. See Fu, "Introduction: The Shaw Brothers Diasporic Cinema," 4–5.

8. Ibid., 2–3.

9. The official Shaw Brothers webpage notes that "By 1965, Shaw Brothers Limited had 35 companies under its umbrella. The company owned outright 130 cinemas throughout South East Asia including Singapore and Malaysia, 9 amusement parks, 3 production studios—in Hong Kong, Singapore, and Kuala Lumpur." See "About Shaw: Marketing and Publicity," Shaw Theatres website, accessed April 7, 2012, http://www.shaw.sg/sw_abouthistory.aspx ?id=114%2053%20111%2051%2023%2018%2011%2018%2051%20222%20 226%20149%2089%20129%20239%20198.

10. It has also been noted that during its height in the 1960s, Shaw Brothers was receiving offers from Penang, Manila, San Francisco, and London Chinatown theater owners for distribution rights. See Fu, "Introduction: The Shaw Brothers Diasporic Cinema," 15.

11. Ibid., 1. For more on the Shaw Brothers Studio's expansion from a local film industry to a global enterprise, see Fu, "Introduction: The Shaw Brothers Diasporic Cinema," 6–15; and Kong, "Shaw Cinema Enterprise and Understanding Cultural Industries."

12. Kong, "Shaw Cinema Enterprise and Understanding Cultural Industries," 42.

13. Ibid.

14. See Fu, "Introduction: The Shaw Brothers Diasporic Cinema," 12–15; Kei, "Shaw Movie Town's 'China Dream' and 'Hong Kong Sentiments,'" 37–47; and Siu Leung Li, "Embracing Glocalization and Hong Kong-Made Musical Film," in *China Forever: The Shaw Brothers and Diasporic Cinema*, ed. Poshek Fu (Urbana: University of Illinois Press, 2008), 77–78.

15. Fu, "Introduction: The Shaw Brothers Diasporic Cinema," 12–13; Kei, "Shaw Movie Town's 'China Dream' and 'Hong Kong Sentiments,'" 37–38; and Li, "Embracing Globalization and Hong Kong-Made Musical Film," 77–78.

16. Before Run Run Shaw's reorganization of the company in the 1960s, the Shaw Brothers also produced, and even promoted, Cantonese-language cinema. It wasn't until the 1960s that the studio made the move to emphasizing

Mandarin productions. For more, see Fu, "Introduction: The Shaw Brothers Diasporic Cinema," 6–7; Law Kar, "Shaws' Cantonese Productions and Their Interactions with Contemporary Local and Hollywood Cinema," in *China Forever: The Shaw Brothers and Diasporic Cinema*, ed. Poshek Fu (Urbana: University of Illinois Press, 2008), 57–73; and Yung Sai-shing, "The Joy of Youth, Made in Hong Kong: Patricia Lam Fung and Shaws' Cantonese Films," in *The Shaw Screen: A Preliminary Study* (Hong Kong: Hong Kong Film Archive, 2003), 221–35.

17. I say this not to disregard the Shaw Brothers' Shanghai roots or to gloss over many of their audiences' China connections. Rather, my aim is to resituate their industry within conversations that go beyond a diasporic sentiment versus a Hong Kong–style framework.

18. Li, "Embracing Glocalization and Hong Kong-Made Musical Film," 77–78.

19. The Shaw Brothers argued that "Because the origin of Eastern civilization was in China . . . Chinese cinema should reach out to the audience as the purest and most authentic representation of 'Oriental flavor.'" Fu, "Introduction: The Shaw Brothers Diasporic Cinema," 9. For more on the Shaw Brothers' promotion of their films as displaying "oriental flavor," see Yuan Tang, "Yang Guifei" 楊貴妃 [Empress Yang], *Yinhe huabao* 銀河畫報 53, August 1962, 21. For more on the Shaw Brothers' relationship with the Japanese film industry, see Kinnia Shuk-ting Yau, "Shaws' Japanese Collaboration and Competition as Seen Through the Asian Film Festival Evolution," in *The Shaw Screen: A Preliminary Study* (Hong Kong: Hong Kong Film Archive, 2003), 279–91.

20. "Shao Yifu Zai Wanguo bolanhui" 邵逸夫在萬國博覽會 [Run Run Shaw in the World Expo], *Nanguo dianying*, January 1963, 62.

21. For a detailed analysis of Cold War Orientalism, especially in the United States, see Klein, *Cold War Orientalism*.

22. Li, "Embracing Glocalization and Hong Kong-Made Musical Film," 77.

23. Here, I adopt Shu-mei Shih's notion of "Sinophone," which she defines as "a network of places of cultural production outside China and on the margins of China and Chineseness, where a historical process of heterogenizing and localizing of continental Chinese culture has been taking place for several centuries." Shu-mei Shih, *Visuality and Identity: Sinophone Articulations Across the Pacific* (Berkeley: University of California Press, 2007), 4.

24. Shih, *Visuality and Identity*, 25.

25. Ibid., 30.

26. Ching Yau, "A Sensuous Misunderstanding: Women and Sexualities in Li Han-hsiang's Fengyue Films," in *Li Han-hsiang, Storyteller*, ed. Wong Ain-ling (Hong Kong: Hong Kong Film Archive, 2007), 100–13. For more on how *yanqing pian* was one of the Shaw Brothers' more lucrative genres, see Hao Wu 吳昊,

Di san leixing dianying 第三類型電影 [Shaw films: The alternative cult films] (Hong Kong: Celestial Pictures Limited, 2004), 73–74. For more on the genre of soft-core pornography, see David Andrews, *Soft in the Middle: The Contemporary Softcore Feature in Its Context* (Columbus: Ohio State University Press, 2006).

27. While Li Han-hsiang was one of the Shaw Brothers' most noted "soft-core" directors, he was also known for his award-winning historical classics such as *Liang Shanbo yu Zhu Yingtai* 梁山伯與祝英台 [*The Love Eterne*] (1963) and *Yang Guifei* 楊貴妃 [*Empress Yang*] (1962). As Yau Ching notes, Li was shooting the soft-core production *Jinping shuangyan* 金瓶雙艷 [*Golden Lotus*] (1974) while making plans for the historic epics *Qingguo qingcheng* 傾國傾城 [*The Empress Dowager*] (1975) and *Yingtai qixue* 瀛台泣血 [*The Last Tempest*] (1976). During the little hiatus between *Empress* and *Tempest* he put out a few other soft-core productions such as *Zhuojian qushi* 捉姦趣史 [*That's Adultery*] (1975) and *Piancai pianse* 騙財騙色 [*Love Swindlers*] (1976). See Yau, "A Sensuous Misunderstanding," 102.

 Known for sensationalized depictions of violence and sex, Kuei Chihung directed such critically acclaimed action movies as *Chengji chalou* 成記茶樓 [*The Tea House*] (1974) and *Wan ren zhan* 萬人斬 [*Killer Constable*] (1980), as well as more sexploitative *yanqing* productions such as *Nü jizhongying* 女集中營 [*Bamboo House of Dolls*] (1973).

 Aside from directing *yanqing* productions such as *Ainu* 愛奴 [*Intimate Confessions of a Chinese Courtesan*] (1972) and *Ainu xinzhuan* 愛奴新傳 [*Lust for Love of a Chinese Courtesan*] (1984), Chu Yuan was known for his adaptations of Gu Long's 古龍 works, such as *Duoqing jianke wuqing jian* 多情劍客無情劍 [*The Sentimental Swordsman*] (1977) and *Chu Liuxiang* 楚留香 [*Clans of Intrigue*] (1977).

28. Marketed as one of the Shaw Brothers' "Delectable Dozen," Lily Ho starred in a wide variety of genres, from musicals such as *Xiangjiang hua yue ye* 香江花月夜 [*Hong Kong Nocturne*] (1967), to martial art dramas such as *Shuihuzhuan* 水滸傳 [*The Water Margin*] (1972), to *yanqing* productions including *Ainu*. Stars known for their *yanqing* productions, or *yanxing* 艷星, such as Shao Yinyin and Chen Ping, were also cast in martial art films like *Juebu ditou* 決不低頭 [*To Kill a Jaguar*] (1977) and *Luding ji* 鹿鼎記 [*Tales of a Eunuch*] (1983).

29. In order to bypass various regions' differing censorship standards and market their *yanqing* productions to mainstream theaters, the Shaw Brothers distributed three versions of films: a "hot" version for the United States, Japan, and Europe; a "cold" version for Singapore, Malaysia, and Taiwan; and a "medium" version for Hong Kong. See Kong, "Shaw Cinema Enterprise and Understanding Cultural Industries," 47.

 Jasper Sharp notes that the Japanese Pink industry—a genre of low-budget soft-core sex movies in Japan that originated in the early 1960s, also called

pink eiga ピンク映画—was and remains an independently produced industry distributed to its own pink theaters separate from mainstream studio productions. See Jasper Sharp, *Behind the Pink Curtain: The Complete History of Japanese Sex Cinema* (Surrey: FAB Press, 2008).

30. See Zhang Tingxing 張廷興, *Zhongguo gudai yanqing xiaoshuo shi* 中國古代艷情小說史 [History of Chinese *Yanqing* literature] (Beijing: Zhongyang bian yi chubanshe, 2008).

31. For example, *Pan Jinlian* 潘金蓮 [*The Amorous Lotus Pan*] (1964), *Fengliu yunshi* 風流韻事 [*Illicit Desires*] (1973), *Jinping shuangyan* 金瓶雙艷 [*The Golden Lotus*] (1974), and *Wu Song* 武松 [*Tiger Killer*] (1982).

32. For example, Li Han-hsiang's *That's Adultery*.

33. For example, Shaw's Directors Committee's *Honglou chunmeng* 紅樓春夢 [*Dreams of Eroticism*].

34. For more on the mirrored relationship between the Confucian family structure and the imperial state in premodern *yanqing* literature, see Song Geng, *The Fragile Scholar: Power and Masculinity in Chinese Culture* (Hong Kong: Hong Kong University Press, 2004); and Paola Zamperini, *Lost Bodies: Prostitution and Masculinity in Chinese Fiction* (Leiden: Brill, 2010).

35. Yau, "A Sensuous Misunderstanding," 111.

36. Here, Yau refers specifically to director Li Han-hsiang's *yanqing* productions. See Yau, "A Sensuous Misunderstanding."

37. For more on the frequent depictions of courtesan/prostitute figures as devoted companions in premodern vernacular literature since the Tang dynasty, in addition to the dissolution of this idealized depiction of courtesan-client relations around the late nineteenth century, see Chloe Starr, *Red-Light Novels of the Late Qing* (Leiden: Brill, 2007); Catherine Yeh, *Shanghai Love: Courtesans, Intellectuals, and Entertainment Culture, 1850-1911* (Seattle: University of Washington Press, 2006); and Zamperini, *Lost Bodies*.

38. Here, the pronunciation of the characters' names are played with: Chen Yinbao 陳銀寶, meaning "silver" (*yinbao* 銀寶) but also sounding like "sexual treasure" (*yinbao* 淫寶); Mei Youli 梅有利, sounding like "no strength" or "no potency" (*meiyouli* 沒有力); Mei Youxin 梅有新, sounding like "no heart" (*meiyouxin* 沒有心).

39. This contingent relationality between Sinophone and Queer studies is addressed in Ari Larissa Heinrich's introduction to his co-edited anthology, *Queer Sinophone Cultures*. Heinrich notes, "Sinophone as a critical framework may not have set out specifically to address questions of gender and sexuality, but as part of larger movements in postcoloniality, and as something that has been essentially coeval with the emergence of queer studies, it certainly has a critical affinity for (or even debt to) these questions; Sinophone studies, lacking a 'queer' focus, is an inherently queer project." Heinrich, "'A Volatile

Alliance': Queer Sinophone Synergies Across Literature, Film, and Culture," in *Queer Sinophone Cultures*, ed. Howard Chiang and Ari Larissa Heinrich (New York: Routledge, 2014), 3.

40. Andrea Bachner, "Queer Affiliations: Mak Yan Yan's *Butterfly* as Sinophone Romance," in *Queer Sinophone Cultures*, ed. Howard Chiang and Ari Larissa Heinrich (New York: Routledge, 2014), 201.

41. Howard Chiang, "(De)Provincializing China: Queer Historicism and Sinophone Postcolonial Critique," in *Queer Sinophone Cultures*, ed. Howard Chiang and Ari Larissa Heinrich (New York: Routledge, 2014), 20.

42. Bachner, "Queer Affiliations," 204.

43. Heinrich, "'A Volatile Alliance,'" 6.

44. Elizabeth Freeman, "Time Binds, or, Erotohistoriography," *Social Text* 84–85, no. 23 (2005): 59.

45. Ibid., 57–68.

46. Carla Freccero, "Theorizing Queer Temporalities: A Roundtable Discussion," *GLQ: A Journal of Lesbian and Gay Studies* 13, nos. 2–3 (2007): 187.

47. Wu, *Di san leixing dianying*, 88–89.

48. Female same-sex desires were, however, underrepresented in this *yanqing* tradition since, as a homosocially circulated and produced genre, these desires were seen as trivial affairs. For more discussion, see Tze-lan D. Sang, *The Emerging Lesbian: Female Same-Sex Desire in Modern China* (Chicago: University of Chicago Press, 2003).

49. Charlotte Furth, "Androgynous Males and Deficient Females: Biology and Gender Boundaries in Sixteenth and Seventeenth Century China," *Late Imperial China* 9, no. 2 (1988): 7.

50. *Nanguo dianying*, January 1972, 116–17.

51. *Xianggang yinghua*, June 1972, 30–35.

52. For more on the rise of pornographic films in Euro-America, see Debbie Nathan, *Pornography* (Toronto: Groundwood Books/House of Anansi Press, 2007). The commercial value of this sensual wave from the West is noted, for instance, in *Xianggang yinghua*: "these 'bedchamber action movies' will most likely continue to be highly marketable for a while. . . . these films will continue to impact the viewers . . . due to the mass amount of such films produced in Europe." *Xianggang yinghua*, January 1979, 26–27.

53. Nguyen Tan Hoang, "Theorizing Queer Temporalities: A Roundtable Discussion," *GLQ: A Journal of Lesbian and Gay Studies* 13, nos. 2–3 (2007): 191.

54. For a detailed discussion of this double-meaning of "performative" that connotes both drama and deconstruction, see Judith Butler, "Performative Acts and Gender Constitution: An Essay in Phenomenology and Feminist Theory," in *Performing Feminisms: Feminist Critical Theory and Theatre*, ed. Sue-Ellen Case (Baltimore, Md.: Johns Hopkins University Press), 270–82; and Eve

Kosofsky Sedgwick, *Touching Feeling: Affect, Pedagogy, Performativity* (Durham, N.C.: Duke University Press, 2003), 6–8.

55. Paul de Man, *Allegories of Reading: Figural Language in Rousseau, Nietzsche, Rilke, and Proust* (New Haven, Conn.: Yale University Press, 1979), 301; Sedgwick, *Touching Feeling*, 7.

56. See Kam Tan and Annette Aw use the term "almost heterosexual" to discuss the Shaw Brothers' film *Love Eterne* in particular. See See Kam Tan and Annette Aw, "Love Eterne: Almost a (Heterosexual) Love Story," in *Chinese Films in Focus: 25 New Takes*, ed. Chris Berry (London: British Film Institute, 2003), 137–43.

57. Esther C. M. Yau, "Introduction: Hong Kong Cinema in a Borderless World," in *At Full Speed: Hong Kong Cinema in a Borderless World*, ed. Esther C. M. Yau (Minneapolis: University of Minnesota Press, 2001), 7.

58. Fu, "Introduction: The Shaw Brothers Diasporic Cinema," 15–22.

59. Ibid.

60. Ibid.

61. Freccero, "Theorizing Queer Temporalities," 187.

4. OFFENSE TO THE EAR: HEARING THE SINOPHONIC IN WANG ZHENHE'S *ROSE, ROSE, I LOVE YOU*

1. For more on the centrality of language, particularly the tensions between sound and script, in understanding the relationship between the concepts of "Sinophone" and "Chinese," see Jing Tsu, *Sound and Script in Chinese Diaspora* (Cambridge, Mass.: Harvard University Press, 2010), and "Sinophonics and the Nationalization of Chinese," in *Global Chinese Literature*, ed. Jing Tsu and David Der-wei Wang (Leiden: Brill, 2010), 93–114.

2. Here, I put quotes around the word "native" in relation to *benshengren*, many of whom were of the Han ethnic majority, to differentiate them from Taiwan's native aborigines, who were not of Han ethnicity.

3. In regard to Taiwan's complex sociolinguistic landscape at the time of the KMT's occupation in 1945, Tsu states that "Japan's colonial presence in the first half of the twentieth century left a foreign linguistic imprint on the island along with smaller, earlier traces of Portuguese and Dutch. Among the current population of twenty-two million in Taiwan, 73 percent are native speakers of the Southern Min topolect. They also speak Mandarin, a language they share with 12 percent of the population from the mainland. Hakka, a separate topolect with origins in northern China, accounts for another 15 percent, while less than 2 percent are the twenty or so aboriginal languages, about half of which are now extinct. Given this

ethnic makeup, whether one can or should write in a script that appropriately reflects the linguistic identity of Taiwan's literature is for some a politically fraught question and for others a question of technical feasibility." Tsu, *Sound and Script*, 144.

4. Tsu, *Sound and Script*, 6.

5. For a detailed discussion of the institutionalization process of making the Mandarin language the national language, see Tsu, *Sound and Script*, 1–17, 144–73, and "Sinophonics and the Nationalization of Chinese."

6. For more on the centrality of literature in defining Taiwanese identity at this time, see Angelina C. Yee, "Constructing a Native Consciousness: Taiwan Literature in the 20th Century," in *China Quarterly*, 165 (2001): 83–101; Kuei-fen Chiu, "Treacherous Translation: Taiwanese Tactics of Intervention in Transnational Cultural Flows," in *Concentric: Literary and Cultural Studies* 31, no. 1 (January 2005): 47–69; and David Der-wei Wang and Carlos Rojas, eds., *Writing Taiwan: A New Literary History* (Durham, N.C.: Duke University Press, 2007).

7. Modernist fiction in Taiwan has been seen as starting with the publication of *Xiandai wenxue*, yet modernist poetry arguably emerged as early as in the mid-1950s. Many have argued that this poetry paved the way for the rise of the modernist fiction in Taiwan. See Chiu, "Treacherous Translation," 51; and David Der-wei Wang, "Preface," in *Writing Taiwan*, viii.

8. See Bai Xianyong, "Liulang de zhongguoren: Taiwan xiaoshuo de fangzhu zhuti" 流浪的中國人:台灣小說的放逐主題 [The diasporic Chinese: The exile motif in Taiwan fiction], in *Diliuzhi shouzhi* 第六隻手指 [The sixth finger] (Taipei: Er-ya, 1995), 107–21; Chiu, "Treacherous Translation," 56–65; Sung-sheng Yvonne Chang, *Modernism and the Nativist Resistance: Contemporary Chinese Fiction from Taiwan* (Durham, N.C.: Duke University Press, 1993): 23–147; and Sung-sheng Yvonne Chang, *Literary Culture in Taiwan: Martial Law to Market Law* (New York: Columbia University Press, 2004), 90–121.

9. Chang, *Modernism and the Nativist Resistance*, 3.

10. Bai Xianyong, "Jindaban de zuihou yi ye" 金大班的最後一夜 [*The Last Night of Taipan Chin*], in *Taipei People* (Chinese-English Bilingual Edition) (Hong Kong: Chinese University Press, 2000), 120.

11. Chunming Huang, *Kanhai de rizi* 看海的日子 [Days of gazing at the sea] (Taipei: Lianhe wenxue, 2009), 11.

12. Wang started out his writing career by publishing in *Xiandai wenxue* and was well known for his aesthetic and formal experimentation with language. Yet, since his subject matter often touched on local and rural issues, his works were later often claimed by editors of the nativist journal *Wenji* 文季 [Literary quarterly] as weapons to fight against what they saw as modernist hegemony on the Taiwanese literary scene. See Chang, *Modernism and the Nativist Resistance*, 151.

13. Tsu, "Sinophonics and the Nationalization of Chinese."

14. Wang Zhenhe, *Rose, Rose, I Love You*, trans. Howard Goldblatt (New York: Columbia University Press, 1998), 1.

15. For more on Taiwan's precarious international positioning during the Cold War, especially its relation to China and the United States, see Jean-Marie Henckaerts, *International Status of Taiwan in the New World Order: Legal and Political Considerations* (Leiden: Brill, 1996); and Dennis Van Vranken Hickey, *United States-Taiwan Security Ties: From Cold War to Beyond Containment* (Westport, Conn.: Praeger, 1993): 17–29. For more on the Taiwanese government's tacit promotion of sex tourism, directed specifically at U.S. GIs during the Cold War era, see Hans Tao-Ming Huang, "State Power, Prostitution and Sexual Order in Taiwan: Towards a Genealogical Critique of 'Virtuous Custom,'" in *Inter-Asia Cultural Studies Reader*, ed. Kuan-Hsing Chen and Chua Beng Huat (New York: Routledge, 2007): 364–94; and Peizhou Chen 陳佩周, "Cong meidu, linbing dao aizi: zouguo taiwan xingbingshi" 從梅毒,淋病到愛滋:走過台灣性病史 [From syphilis and gonorrhea to AIDS: The history of venereal diseases in Taiwan], *Lianhebao*, December 13, 1992.

16. Wang, *Rose, Rose, I Love You*, 114.

17. Ibid., 132–33, my italics.

18. Ibid., 138.

19. Lydia He Liu, *Translingual Practice: Literature, National Culture, and Translated Modernity—China, 1900-1937* (Stanford, Calif.: Stanford University Press, 1995), 20.

20. See Chiu's analysis of the nativist accusations that Taiwan's modernist literature is a "double betrayal" in "Treacherous Translation," 51–69.

21. Song Zelai, *Song Zelai tan wenxue* 宋澤萊談文學 [Song Zelai on literature] (Taipei: Qianwei, 2004), 72.

22. Tsu, *Sound and Script*, 3.

23. Bachner goes on to detail the stakes of persistent subscription to the "mother tongue mystique," both in terms of national politics and within academia. She states, "The mystique of the mother tongue works on two levels. As an essentialist concept of identity, the idea of a given, natural language cements national ideology. It also acts as a screen to cover the fact that a national language is nothing but a highly constructed product, incessantly policed, standardized, and cleansed. On a second level, the mystique of linguistic nativity still constitutes a valuable currency in the humanities, in the figure of the native informant—or her more postmodern avatar, the hybrid, bilingual subject. As such it is a mechanism that restricts rather than allows access, by validating the expertise of certain native speakers only in a tightly controlled and limited field of knowledge." Andrea Bachner, "Book Review: Jing Tsu's *Sound and Script in Chinese Diaspora*," *MCLC Resource Center Publication*,

July 2011, accessed February 27, 2016, https://u.osu.edu/mclc/book-reviews/sound-and-script/.

24. Tsu, *Sound and Script*, 13.

25. By "translational histories," Chakrabarty refers to forms of historical writing through which hegemonic narratives—such as global modernity, capital, and national solidarity—are allowed to be continually affected by different local discourses and imaginations. The task of historicizing these competing narratives, according to Chakrabarty, is a task of translation, or rather at times nontranslation. More specifically, it is a task to highlight and to retain the moments of incommensurability by affective discourses, so that they can work to puncture, and even mediate, dominant discourses' totalizing enterprise of knowledge production. For more, see Dipesh Chakrabarty, *Provincializing Europe: Postcolonial Thought and Historical Difference* (Princeton, N.J.: Princeton University Press, 2000), 72–96.

26. Wang, *Rose, Rose, I Love You*, 155–56.

27. Ibid., 166.

28. Ibid., 161, 165.

29. Ibid., 167–68.

30. Ibid., 168, 169.

31. Ibid., 170.

32. Ibid.

33. Ibid., 177–78.

34. Ibid., 175.

35. Ibid., 180.

36. This can be seen in the premodern Chinese literary tradition in works such as *Haishang hua* 海上花 [The sing-song girls of Shanghai], or *Niehaihua* 孽海花 [Flower in the sea of evil]; examples in the Taiwanese literary canon include *Gulian hua* 孤戀花 [*Love's Lone Flower*].

37. Howard Goldblatt, "Translator's Preface," in *Rose, Rose, I Love You*, by Zhenhe Wang (New York: Columbia University Press, 1998), vii; Tsu, *Sound and Script*, 146.

38. Tsu, *Sound and Script*, 146.

39. Jacques Attali, *Noise: The Political Economy of Music*, trans. Brian Massumi (Minneapolis: University of Minnesota Press, 1985), 7.

40. Josh Kun, *Audiotopia: Music, Race, and America* (Berkeley: University of California Press, 2005), 22.

41. Ibid., 17.

42. Howard Goldblatt, "Afterword," in *Rose, Rose, I Love You*, by Zhenhe Wang (New York: Columbia University Press, 1998), 181.

43. "Yellow" here, Andrew Jones argues, signifies a double meaning of both pornography and racial identity. He states: "This doubleness . . . is embedded

within the signifier for the music itself. On the surface, the yellowness of the music is a reference to the fleshy, supposedly decadent appeal for which Li's music has so often been condemned. But in its very yellowness, the music is also color-coded, identified as Chinese, and thus subsumed under the racialized hierarchies of colonial modernity." Andrew F. Jones, *Yellow Music: Media Culture and Colonial Modernity in the Chinese Jazz Age* (Durham, N.C.: Duke University Press, 2001), 78. For more on the politics surrounding "yellow music" and Li Jinhui's music in particular, see Jones, *Yellow Music*, 73–104.

44. As a part of the New Life Movement (1934), the Nationalist government began banning popular music and, as Andrew Jones notes, "sponsor[ed] mass rallies in which citizens might learn 'a habit and an instinct for unified behavior' by way of singing patriotic anthems." Jones, *Yellow Music*, 112.

45. This disregard for popular music (to the extent of banning it) should be understood in the context of the intellectual currents of the time. In the eyes of many left-wing revolutionaries, who were largely influenced by the May Fourth Movement and its call for literary realism, music should serve the function of "documenting" "real" and "grass-roots" nationalistic fervor. As seen in literary critic Guo Moruo's 郭沫若 1928 essay, "The Echo of the Phonograph," aurality can be used as a metaphor to herald the function of the left-wing writer. Guo emphasizes that writers must "serve as phonographs, 'recording' the struggles and aspirations of the proletariat and subsequently playing them back to the society at large as a means of political mobilization." Quoted in Jones, *Yellow Music*, 107.

46. The song was released by Columbia Records as catalog number 39367.

47. Goldblatt, "Afterword," 181.

48. Jones, *Yellow Music*, 78.

49. Goldblatt, "Afterword," 181.

50. For a detailed discussion of the film within the context of Sinophonic musicals, see Lily Wong, "Moving Serenades: Hearing the Sinophonic in MP & GI's *Longxiang Fengwu*," *Journal of Chinese Cinemas* 7, no. 3 (November 2013): 225–40.

51. Taiwan's own local mass-production of Mandarin popular music began in the early 1960s along with the popularization of TV broadcasting and LP production. Shin Hyunjoon and Ho Tung-hung explain that, starting in the mid-1960s, Taiwan became one of the major export bases of Mandarin popular music. See Shin and Ho, "Translation of 'America' During the Early Cold War Period: A Comparative Study on the History of Popular Music in South Korea and Taiwan," *Inter-Asia Cultural Studies* 10, no. 1 (2009): 89.

52. Shin and Ho state that, during the Cold War, Taiwan's popular music scene was mainly composed of these categories: (1) "patriotic songs" propagated through official education and information agencies, (2) popular music

originating in Shanghai and (re)made in Hong Kong, (3) film music and theme songs that were also produced in Hong Kong, and (4) Taiwanese-language songs surviving in the form of "hybridized songs," pairing Japanese melodies with Taiwanese lyrics. For more on Taiwanese popular music during the Cold War, see Shin and Ho, "Translation of 'America,'" 89–90.

53. Although the state regulation of popular music was targeted primarily at Taiwanese popular music sung in Southern Min topolect, Mandarin popular music was not completely free from censorship either. As Shin and Ho mention, the classic Mandarin popular song "Maomao yu" 毛毛雨 [Drizzling rain] was banned because the title was reminiscent of "Chairman Mao." Shin and Ho, "Translation of 'America,'" 87–88.

54. Hans Tao-ming Huang asserts, "The biggest impact of American pressure on the leisure/pleasure businesses in Taiwan occurred at the height of the Vietnam War when the 'Rest and Relaxation Centre' was founded by the US government in Taipei in 1965: roughly 200,000 GIs took leave in Taiwan between 1965–1970 while yet another 200,000 were received by the Centre between 1970 and 1971. If every GI spent US $5,000 of his US $12,000 annual salary in Taiwan, it was once speculated, the influx of American GIs between 1970 and 1971 alone would have had brought into Taiwan the fortune of US $1000 million." Huang, "State Power, Prostitution and Sexual Order in Taiwan," 370–71.

55. Shin and Ho, "Translation of 'America,'" 94. Shin and Ho show that musicians who played in these GI clubs could earn from three to six times the monthly salary paid for normal jobs of the time.

5. DWELLING: AFFECTIVE LABOR AND REORDERED KINSHIPS IN *THE FOURTH PORTRAIT* AND *SEEKING ASIAN FEMALE*

1. Many have approached this reordering of global capital through logics of the free market, flexible accumulation, and post-Fordist international division of labor. See David Harvey, *A Brief History of Neoliberalism* (Oxford: Oxford University Press, 2007); Michael Hardt and Antonio Negri, *Empire* (Cambridge, Mass.: Harvard University Press, 2000), and *Multitude: War and Democracy in the Age of Empire* (New York: Penguin, 2004); Mark Blyth, *Great Transformations: Economic Ideas and Institutional Change in the Twentieth Century* (Cambridge: Cambridge University Press, 2002); Kenneth R. Hoover, *Economics as Ideology: Keynes, Laski, Hayek and the Creation of Contemporary Politics* (Lanham, Md.: Rowman & Littlefield, 2003); and Aihwa Ong, *Neoliberalism as Exception: Mutations in Citizenship and Sovereignty* (Durham, N.C.: Duke University Press, 2007).

2. See Milton Friedman, *Capitalism and Freedom* (Chicago: University of Chicago Press, 2002); Peter A. Hall, *The Political Power of Economic Ideas: Keynesianism across Nations* (Princeton, N.J.: Princeton University Press, 1989); Blyth, *Great Transformations*; and Hoover, *Economics as Ideology*.

3. Jodi Melamed, "The Spirit of Neoliberalism: From Racial Liberalism to Neoliberal Multiculturalism," *Social Text* 89, no. 4 (2006): 1.

4. See Harvey, *Brief History of Neoliberalism*; Alfredo Saad-Filho and Deborah Johnston, *Neoliberalism: A Critical Reader* (London: Pluto Press, 2005); and Melamed, " Spirit of Neoliberalism," 1–24.

5. See Hardt and Negri, *Empire* and *Multitude*; Michael Hardt, "Affective Labor," *Boundary 2* 26, no. 2 (1999): 89–100; and "Foreword: What Affects Are Good For," in *The Affective Turn: Theorizing the Social*, ed. Patricia Ticineto Clough and Jean Halley (Durham, N.C.: Duke University Press, 2007), ix–xiii.

6. Hardt, "Affective Labor," 96.

7. Ibid.

8. Hardt, "Affective Labor," 98.

9. Françoise Lionnet and Shu-mei Shih, "Introduction: Thinking Through the Minor, Transnationally," in *Minor Transnationalism*, ed. Françoise Lionnet and Shu-mei Shih (Durham, N.C.: Duke University Press, 2005), 7.

10. My formulation of "dwelling" branches away from Heidegger's theorization of the term in "Building Dwelling Thinking," in *Basic Writings: Ten Key Essays, Plus the Introduction to Being and Time* by Martin Heidegger, ed. David Farrell Krell (New York: HarperCollins, 1993), 343–63. With dwelling, Heidegger conveys a rooted sense of selfhood that underlies the assumption that there exists an authentic, or fundamental, way humans belong on earth. He articulates dwelling as a full and content mode of being that is different from the alienated "homelessness," which Heidegger sees as characterizing the era of technological modernity (363). My approach does not conceive a smooth relation between one's sense of place and understanding of identity. I offer a rerouted understanding of dwelling that is situated yet persistently volatile.

11. In this sense, my use of dwelling is similar to Sianne Ngai's study of "ugly feelings"—envy, irritation, paranoia, anxiety—through which she traces noncathartic states of feelings that signify suspended agency within late modernity. See Ngai, *Ugly Feelings* (Cambridge, Mass.: Harvard University Press, 2005). Lauren Berlant, in *Cruel Optimism* (Durham, N.C.: Duke University Press, 2011), theorizes a similar affective structure in a neoliberal age, one that is also precariously suspended. Yet, unlike Berlant's reading of affective suspension via optimistic yet dubious attachments to socioeconomic mobility, the affective structure of "dwelling" that I trace in this chapter is characterized by ambivalence and disinterest.

12. My reading of Chineseness as a dwelling neoliberal desire is in a way a minor transnational reworking of Lisa Rofel's *Desiring China: Experiments in*

Neoliberalism, Sexuality, and Public Culture (Durham, N.C.: Duke University Press, 2007). To Rofel, postsocialist China operates on the site of neoliberal desire: having newly earned freedom to desire for and be desired by a global, cosmopolitan, public. Rofel's argument centers on the making of desiring Chinese citizen-subjects. However, I pivot my focus away from China-as-nation and toward Chineseness-as-affective structure and discuss subject and community formation beyond that which falls neatly within national or cultural borders. Additionally, I investigate how identities and communities are formed through a persistently volatile affective structure of "dwelling" rather than the actively directional emotion of "desire." Desire, Rofel argues, is championed within the affirmative culture of a neoliberal market economy, stressing active and continuous consumption.

13. Gilles Deleuze and Félix Guattari explain their concept of "rhizome" as a decentered, dispersed, and emergent process that "pertains to a map . . . that is always detachable, connectable, reversible, modifiable, and has multiple entryways and exits and its own lines of flight." Gilles Deleuze and Félix Guattari, *A Thousand Plateaus: Capitalism and Schizophrenia* (Minneapolis: University of Minnesota Press, 1987), 21.

14. June Yip writes, "Emerging in the 1980s, Taiwanese New Cinema put Taiwanese filmmaking on the international map and is thought by many to be the heir to the nativist cultural traditions of hsiang-t'u literature." Yip, *Envisioning Taiwan: Fiction, Cinema, and the Nation in the Cultural Imaginary* (Durham, N.C.: Duke University Press, 2004), 9. For more on Taiwanese Cinema's relation to the "native soil" movements in Taiwan in the early 1980s, see Ruxiu Chen, *Taiwanese New Cinema's History, Culture and Experience*, 2nd ed. (Taipei: Wanxing, 1997); June Yip, "Constructing a Nation: Taiwanese History and the Films of Hou Hsiao-hsien," in *Transnational Chinese Cinemas: Identity, Nationhood, Gender*, ed. Sheldon Hsiao-peng Lu (Honolulu: University of Hawai'i Press, 1997), 139–68; and Chris Berry and Feii Lu, "Introduction," in *Island on the Edge: Taiwan New Cinema and After*, ed. Chris Berry and Feii Lu (Hong Kong: Hong Kong University Press, 2005), 1–12.

15. Amy Kaplan, *The Anarchy of Empire in the Making of U.S. Culture* (Cambridge, Mass.: Harvard University Press, 2002), 1.

16. Since the director, Debbie Lum, becomes a character within her own documentary, I refer to her as "Debbie," as she is referred to by the other characters in the film.

17. Drawing from Eduardo Bonilla-Silva's work on color-blind politics in post–civil rights era United States, Nakamura and Peter A. Chow-White remind us that "the neoliberal ideology that defines our current political, economic, and socio-cultural moment moves race, like all other forms of personal identity, into the realm of the personal rather than the collective responsibility." Lisa Nakamura and Peter A. Chow-White, *Race After the Internet*

(New York: Routledge, 2011), 4–5. See Eduardo Bonilla-Silva, *Racism Without Racists: Color-Blind Racism and the Persistence of Racial Inequality in the United States* (Lanham, Md.: Rowman & Littlefield, 2013). Privatization of identity politics can lead to the subsequent assumption that the cyberworld is a post-identity utopia. It masks how the Internet and other computer-based technologies are "complex topographies of power and privilege, made up of walled communities, new (plat)forms of economic and technological exclusion, and both new and old styles of race as code, interaction, and image." Nakamura and Chow-White, *Race After the Internet*, 17.

18. Such repackaging of Orientalized identity markers in an age, and through a medium, that presumes to be post-identity is noted in Lisa Nakamura's conception of "Cybertypes." Nakamura, "Cybertyping and the Work of Race in the Age of Digital Reproduction," in *New Media, Old Media: A History and Theory Reader*, ed. Wendy Hui Kyong Chun and Thomas Keenan (New York: Routledge, 2006), 318.

19. This Orientalized fantasy that is played out through Steven's search for Chinese females is not unique in the world of digital technology. Wendy Hui Kyong Chun argues that "new media" extend "old" racial and sexual structures, such markers of exotic/erotic others are in fact what drive digital technologies' sense of "newness." What the cyberworld promises is a present and future that is expansively global (comprehensive, all-inclusive, and networked), an exciting new frontier that resembles an exotic urban landscape and offers the "pleasure of exploring, the pleasure of 'learning,' and the pleasure of being somewhat overwhelmed, but ultimately jacked in." Chun, *Control and Freedom: Power and Paranoia in the Age of Fiber Optics* (Cambridge, Mass.: MIT Press, 2008), 177.

20. Chun defines "high-tech Orientalism" as the exoticizing of the digital landscape that "promises intimate knowledge, sexual concourse with the other, which it reduces to data or local details." *Control and Freedom*, 177.

21. Chun, *Freedom and Control*, 29.

22. Thomas Keenan, "Windows: Of Vulnerability," in *The Phantom Public Sphere*, ed. Bruce Robbins (Minneapolis: University of Minnesota Press, 1997), 121–41.

23. Chun, *Freedom and Control*, 15–16.

24. Nakamura, "Cybertyping and the Work of Race in the Age of Digital Reproduction," 323.

25. Ibid., 323.

26. Ibid., 322.

27. Helen Grace, "Monuments and the Face of Time: Distortions of Scale and Asynchrony in Postcolonial Hong Kong," *Postcolonial Studies* 10, no. 4 (2007): 473.

28. Ibid., 470.

CODA: WHAT DWELLS

1. 詞: 日日春關懷互助協會; 黑手那卡西曲: 陳柏偉 [Lyric: Collective of Sex Workers and Supporters, Black Hand Nakasi; Song: Chen Bo-wei].

2. Heishou nakasi黑手那卡西 [Black hand nakasi], "Xingfu" 幸福 [Happiness], StreetVoice, accessed January 3, 2016, https://tw.streetvoice.com/twbhn /songs/119260/.

3. Ibid.

4. Ibid.

5. Aihwa Ong, *Flexible Citizenship: The Cultural Logics of Transnationality* (Durham, N.C.: Duke University Press, 1999).

6. Sara Ahmed, *The Promise of Happiness* (Durham, N.C.: Duke University Press, 2010), 216.

7. For more on the privatization of identity politics under neoliberal logics, see Lisa Nakamura and Peter A. Chow-White, *Race After the Internet* (New York: Routledge, 2011); and Eduardo Bonilla-Silva, *Racism Without Racists: Color-Blind Racism and the Persistence of Racial Inequality in the United States* (Lanham, Md.: Rowman & Littlefield, 2013).

8. See Brian Massumi, *Parables for the Virtual: Movement, Affect, Sensation* (Durham, N.C.: Duke University Press, 2002); Michael Hardt, "Affective Labor," *Boundary 2* 26, no. 2 (1999): 89–100; and Hardt, "Foreword: What Affects Are Good For," in *The Affective Turn: Theorizing the Social*, ed. Patricia Ticineto Clough and Jean Halley (Durham, N.C.: Duke University Press, 2007), ix–xiii.

BIBLIOGRAPHY

BOOKS AND ARTICLES

Ahmed, Sara. "Collective Feelings: Or, the Impressions Left by Others." *Theory, Culture & Society* 21, no. 2 (April 2004): 25–42.

——. *The Cultural Politics of Emotion*. 2nd ed. New York: Routledge, 2015.

——. "Embodying Strangers." In *Body Matters: Feminism, Textuality, Corporeality*, edited by Avril Horner and Angela Keane, 85–96. Manchester: Manchester University Press, 2000.

——. *The Promise of Happiness*. Durham, N.C.: Duke University Press, 2010.

Andrews, David. *Soft in the Middle: The Contemporary Softcore Feature in Its Contexts*. Columbus: Ohio State University Press, 2006.

Anker, Elisabeth R. *Orgies of Feeling: Melodrama and the Politics of Freedom*. Durham, N.C.: Duke University Press, 2014.

Attali, Jacques. *Noise: The Political Economy of Music*. Translated by Brian Massumi. Minneapolis: University of Minnesota Press, 1985.

Bachner, Andrea. *Beyond Sinology: Chinese Writing and the Scripts of Culture*. New York: Columbia University Press, 2014.

——. "Book Review: Jing Tsu's *Sound and Script in Chinese Diaspora*." *MCLC Resource Center Publication*, July 2011. Accessed February 27, 2016. https://u.osu.edu/mclc/book-reviews/sound-and-script/.

——. "Queer Affiliations: Mak Yan Yan's *Butterfly* as Sinophone Romance." In *Queer Sinophone Cultures*, edited by Howard Chiang and Ari Larissa Heinrich, 201–20. New York: Routledge, 2014.

Bai Xianyong 白先勇. "Gulian hua" 孤戀花 [*Love's Lone Flower*]. In *Taipei People* (Chinese-English Bilingual Edition), 229–58. Hong Kong: Chinese University Press, 2000.

——. "Jindaban de zuihou yi ye" 金大班的最後一夜 [*The Last Night of Taipan Chin*]. In *Taipei People* (Chinese-English Bilingual Edition), 113–45. Hong Kong: Chinese University Press, 2000.

——. "Liulang de zhongguoren: Taiwan xiaoshuo de fangzhu zhuti" 流浪的中國人:台灣小說的放逐主題 [The diasporic Chinese: The exile motif in Taiwan fiction]. In *Diliuzhi shouzhi* 第六隻手指 [The sixth finger], 107–21. Taipei: Er-ya, 1995.

Barrett, Eileen, and Mary Cullinan, eds. *American Women Writers: Diverse Voices in Prose Since 1845.* New York: St. Martin's Press, 1992.

Beale, Howard. *Theodore Roosevelt and the Rise of America to World Power.* Baltimore, Md.: Johns Hopkins University Press, 1956.

Bean, Jennifer M., Anupama Kapse, and Laura Horak, eds. *Silent Cinema and the Politics of Space.* Bloomington: Indiana University Press, 2014.

Berlant, Lauren. *Cruel Optimism.* Durham, N.C.: Duke University Press, 2011.

Berry, Chris, and Feii Lu. "Introduction." In *Island on the Edge: Taiwan New Cinema and After,* edited by Chris Berry and Feii Lu, 1–12. Hong Kong: Hong Kong University Press, 2005.

Bhabha, Homi. "DissemiNation: Time, Narrative, and the Margins of the Modern Nation." In *The Location of Culture,* 199–244. New York: Routledge, 1994.

Blyth, Mark. *Great Transformations: Economic Ideas and Institutional Change in the Twentieth Century.* Cambridge: Cambridge University Press, 2002.

Bonilla-Silva, Eduardo. *Racism Without Racists: Color-Blind Racism and the Persistence of Racial Inequality in the United States.* Lanham, Md.: Rowman & Littlefield, 2013.

Brown, Wesley, and Amy Ling, eds. *Imagining America: Stories from the Promised Land.* New York: Persea Books, 1991.

Bush, Christopher. *Ideographic Modernism: China, Writing, Media.* Oxford: Oxford University Press, 2012.

Butler, Judith. "Performative Acts and Gender Constitution: An Essay in Phenomenology and Feminist Theory." In *Performing Feminisms: Feminist Critical Theory and Theatre,* edited by Sue-Ellen Case, 270–82. Baltimore, Md.: Johns Hopkins University Press.

Chakrabarty, Dipesh. *Provincializing Europe: Postcolonial Thought and Historical Difference.* Princeton, N.J.: Princeton University Press, 2000.

Chan, Anthony B. *Perpetually Cool: The Many Lives of Anna May Wong (1905-1961).* Lanham, Md.: Scarecrow Press, 2007.

Chan, Jeffery Paul, Frank Chin, Lawson Fusao Inada, and Shawn Wong, eds. *Aiiieeeee! An Anthology of Asian-American Writers.* Washington, D.C.: Howard University Press, 1983.

Chan, Sucheng. "The Exclusion of Chinese Women, 1870–1943." In *Entry Denied: Exclusion and the Chinese Community in America, 1882-1943,* edited by Sucheng Chan, 94–146. Philadelphia: Temple University Press, 1991.

Chang, Michael G. "The Good, the Bad, and the Beautiful: Movie Actresses and Public Discourse in Shanghai, 1920s–1930s." In *Cinema and Urban Culture in Shanghai, 1922-1943*, edited by Yingjin Zhang, 128–59. Stanford, Calif.: Stanford University Press, 1999.

Chang, Sung-sheng Yvonne. *Literary Culture in Taiwan: Martial Law to Market Law*. New York: Columbia University Press, 2004.

——. *Modernism and the Nativist Resistance: Contemporary Chinese Fiction from Taiwan*. Durham, N.C.: Duke University Press, 1993.

Chatterjee, Partha. *Nationalist Thought and the Colonial World: A Derivative Discourse*. Minneapolis: University of Minnesota Press, 1986.

Cheah, Pheng. "Mattering." *Diacritics* 26, no. 1 (Spring 1996): 108–39.

Chen, Kuan-Hsing. *Asia as Method: Toward Deimperialization*. Durham, N.C.: Duke University Press, 2010.

——. "Why Is 'Great Reconciliation' Impossible? De-Cold War/Decolonization, or Modernity and Its Tears (Part I)." *Inter-Asia Cultural Studies* 3, no. 1 (2002): 77–99.

——. "Why Is 'Great Reconciliation' Impossible? De-Cold War/Decolonization, or Modernity and Its Tears (Part II)." *Inter-Asia Cultural Studies* 3, no. 2 (2002): 235–51.

Chen Peizhou 陳佩周. "Cong meidu, linbing dao aizi: Zouguo taiwan xingbingshi" 從梅毒,淋病到愛滋:走過台灣性病史 [From syphilis and gonorrhea to AIDS: The history of venereal diseases in Taiwan]. *Lianhebao* 聯合報, December 13, 1992.

Chen, Ruxiu. *Taiwanese New Cinema's History, Culture and Experience*. 2nd ed. Taipei: Wanxing, 1997.

Cheng, Anne Anlin. "Shine: On Race, Glamour, and the Modern." *Publications of the Modern Language Association* 126, no. 4 (2011): 1022–41.

Cheng Jihua 程季華, ed. *Ruan Lingyu*. Beijing: Zhongguo dianying, 1985.

Cheng Jihua 程季華, Li Shaobai 李少白, and Xing Zuwen 邢祖文, eds. *Zhongguo dianying fazhan shi* 中國電影發展史 [The historical development of Chinese cinema]. 2 vols. Beijing: Zhongguo dianying chubanshe, 1963.

Chiang, Howard. "(De)Provincializing China: Queer Historicism and Sinophone Postcolonial Critique." In *Queer Sinophone Cultures*, edited by Howard Chiang and Ari Larissa Heinrich, 19–51. New York: Routledge, 2014.

Chiu, Kuei-fen. "Treacherous Translation: Taiwanese Tactics of Intervention in Transnational Cultural Flows." *Concentric: Literary and Cultural Studies* 31, no. 1 (January 2005): 47–69.

Cho, Yu-fang. *Uncoupling American Empire: Cultural Politics of Deviance and Unequal Difference, 1890-1910*. Albany: State University of New York Press, 2013.

Chow, Rey. *Sentimental Fabulations, Contemporary Chinese Films: Attachment in the Age of Global Visibility*. New York: Columbia University Press, 2007.

Chun, Allen 陳奕麟. "From Nationalism to Nationalizing: Cultural Imagination and State Formation in Post-war Taiwan." *Australia Journal of Chinese Affairs* 31 (1994): 49–69.

——. "Jiegou Zhongguoxing: lun zuqun yishi zuowei wenhua zuowei rentong zhi aimei buming" 解構中國性:論族群意識作為文化作為認同之曖昧不明 [Fuck Chineseness: On the ambiguities of ethnicity as culture as identity]. *Taiwan shehui yanjiu jikan* 台灣社會研究季刊 [*Taiwan: A Radical Quarterly in Social Sciences*] 33 (1999): 103–31.

Chun, Wendy Hui Kyong. *Control and Freedom: Power and Paranoia in the Age of Fiber Optics*. Cambridge, Mass.: MIT Press, 2008.

Chung, Stephanie Po-yin. "The Industrial Evolution of a Fraternal Enterprise: The Shaw Brothers and the Shaw Organization." In *The Shaw Screen: A Preliminary Study*, 1–17. Hong Kong: Hong Kong Film Archive, 2003.

Clifford, James. *Routes: Travel and Translation in the Late Twentieth Century*. Cambridge, Mass.: Harvard University Press, 1997.

Collective of Sex Workers and Supporters. *Jinü lianheguo* 妓女聯合國 [Sex worker united nations]. Taipei: Collective of Sex Workers and Supporters Press, 2007.

Cui, Shuqin. *Women Through the Lens: Gender and Nation in a Century of Chinese Cinema*. Honolulu: University of Hawai'i Press, 2003.

Cutter, Martha J. "Sui Sin Far's Letters to Charles Lummis: Contextualizing Publication Practices for the Asian American Subject at the Turn of the Century." *American Literary Realism* 38, no. 3 (2006): 259–75.

de Man, Paul. *Allegories of Reading: Figural Language in Rousseau, Nietzsche, Rilke, and Proust*. New Haven, Conn.: Yale University Press, 1979.

Deleuze, Gilles, and Félix Guattari. *A Thousand Plateaus: Capitalism and Schizophrenia*. Minneapolis: University of Minnesota, 1987.

Ding, Naifei. "Prostitutes, Parasites, and the House of State Feminism." *Inter-Asia Cultural Studies* 3, no. 3 (2000): 305–18.

Ding, Naifei, and Liu Renpeng. "Reticent Poetics, Queer Politics." *Inter-Asia Cultural Studies* 6, no. 1 (2005): 30–55.

Ferens, Dominika. *Edith and Winnifred Eaton: Chinatown Missions and Japanese Romances*. Urbana: University of Illinois Press, 2002.

Fetterley, Judith, and Marjorie Pryse, eds. *American Women Regionalists, 1850–1910*. New York: Norton, 1992.

Freccero, Carla. "Theorizing Queer Temporalities: A Roundtable Discussion." *GLQ: A Journal of Lesbian and Gay Studies* 13, nos. 2–3 (2007): 177–95.

Freeman, Elizabeth. "Time Binds, or, Erotohistoriography." *Social Text* 84–85, no. 23 (2005): 57–68.

——. *Time Binds: Queer Temporalities, Queer Histories*. Durham, N.C.: Duke University Press, 2010.

Friedman, Milton. *Capitalism and Freedom*. Chicago: University of Chicago Press, 2002.

Fu, Poshek, ed. *China Forever: The Shaw Brothers and Diasporic Cinema*. Urbana: University of Illinois Press, 2008.

——. "Introduction: The Shaw Brothers Diasporic Cinema." In *China Forever: The Shaw Brothers and Diasporic Cinema*, edited by Poshek Fu, 1–25. Urbana: University of Illinois Press, 2008.

Furth, Charlotte. "Androgynous Males and Deficient Females: Biology and Gender Boundaries in Sixteenth and Seventeenth Century China." *Late Imperial China* 9, no. 2 (1988): 1–31.

Ghosh, Bishnupriya. *Global Icons: Apertures to the Popular*. Durham, N.C.: Duke University Press, 2011.

Gilroy, Paul. *The Black Atlantic: Modernity and Double Consciousness*. Cambridge, Mass.: Harvard University Press, 1993.

Goldblatt, Howard. "Afterword." In *Rose, Rose, I Love You*, by Wang Zhenhe, 181–83. New York: Columbia University Press, 1998.

——. "Translator's Preface." In *Rose, Rose, I Love You*, by Wang Zhenhe, vii–x. New York: Columbia University Press, 1998.

Grace, Helen. "Monuments and the Face of Time: Distortions of Scale and Asynchrony in Postcolonial Hong Kong." *Postcolonial Studies* 10, no. 4 (2007): 467–83.

Gronewold, Sue. *Beautiful Merchandise: Prostitution in China, 1860–1936*. New York: Harrington Park Press, 1982.

Grosz, Elizabeth. *Volatile Bodies: Toward a Corporeal Feminism*. Bloomington: Indiana University Press, 1994.

Guan Zhongxiang 管中祥, ed. *Gongmin bu lengxue: Xinshiji taiwan gongmin xingdong shijian bu* 公民不冷血:新世紀台灣公民行動事件簿 [The people are not cold hearted: Notes on Taiwanese citizen activism in the new century]. Taipei: Under Table Press, 2015.

Hall, Peter A. *The Political Power of Economic Ideas: Keynesianism Across Nations*. Princeton, N.J.: Princeton University Press, 1989.

Hammond, Andrew. "From Rhetoric to Rollback: Introductory Thoughts on Cold War Writing." In *Cold War Literature: Writing the Global Conflict*, edited by Andrew Hammond, 1–14. New York: Routledge, 2003.

Hansen, Miriam. "Early Silent Cinema: Whose Public Sphere?" *New German Critique* 29 (Spring–Summer 1983): 147–84.

——. "Fallen Women, Rising Stars, New Horizons: Shanghai Silent Film as Vernacular Modernism." *Film Quarterly* 54, no. 1 (Autumn 2000): 10–22.

Hardt, Michael. "Affective Labor." *Boundary 2* 26, no. 2 (1999): 89–100.

——. "Foreword: What Affects Are Good For." In *The Affective Turn: Theorizing the Social*, edited by Patricia Ticineto Clough and Jean Halley, ix–xiii. Durham, N.C.: Duke University Press, 2007.

Hardt, Michael, and Antonio Negri. *Empire*. Cambridge, Mass.: Harvard University Press, 2000.

——. *Multitude: War and Democracy in the Age of Empire*. New York: Penguin, 2004.

Harris, Kristine. "The New Woman Incident: Cinema, Scandal, and Spectacle in 1935 Shanghai." In *Transnational Chinese Cinemas: Identity, Nationhood, Gender*, edited by Sheldon Hsiao-peng Lu, 277–302. Honolulu: University of Hawai'i Press, 1997.

Harvey, David. *A Brief History of Neoliberalism*. Oxford: Oxford University Press, 2007.

Hayot, Eric. *Chinese Dreams: Pound, Brecht, Tel Quel*. Ann Arbor: University of Michigan Press, 2012.

——. *The Hypothetical Mandarin: Sympathy, Modernity, and Chinese Pain*. Oxford: Oxford University Press, 2009.

Heidegger, Martin. "Building Dwelling Thinking." In *Basic Writings: Ten Key Essays, Plus the Introduction to Being and Time*, by Martin Heidegger, edited by David Farrell Krell, 343–63. New York: HarperCollins, 1993.

Heinrich, Ari Larissa. "'A Volatile Alliance': Queer Sinophone Synergies Across Literature, Film, and Culture." In *Queer Sinophone Cultures*, edited by Howard Chiang and Ari Larissa Heinrich, 3–16. New York: Routledge, 2014.

Hemmings, Clare. "Invoking Affect: Cultural Theory and the Ontological Turn." *Cultural Studies* 19, no. 5 (2005): 548–67.

Henckaerts, Jean-Marie. *International Status of Taiwan in the New World Order: Legal and Political Considerations*. Leiden: Brill, 1996.

Henriot, Christian. *Prostitution and Sexuality in Shanghai: A Social History, 1849–1949*. Cambridge: Cambridge University Press, 2001.

Herring, George C. *From Colony to Superpower: U.S. Foreign Relations Since 1776*. Oxford: Oxford University Press, 2008.

Hershatter, Gail. *Dangerous Pleasures: Prostitution and Modernity in Twentieth-Century Shanghai*. Berkeley: University of California Press, 1999.

——. "Modernizing Sex, Sexing Modernity: Prostitution in Early-Twentieth-Century Shanghai." In *Chinese Femininities/Chinese Masculinities: A Reader*, edited by Susan Brownell and Jeffrey N. Wasserstrom, 199–225. Berkeley: University of California Press, 2002.

Hickey, Dennis Van Vranken. *United States–Taiwan Security Ties: From Cold War to Beyond Containment*. Westport, Conn.: Praeger, 1993.

Ho, Josephine 何春蕤. "Cong fandui renkoufanmai dao quanmian shehui guixun: Taiwan ershao NGO de mushi daye" 從反對人口販賣到全面社會規訊:台灣兒少 NGO 的牧世大業 [From anti-trafficking to social discipline: The pastoral project of Taiwan's child-protection NGOs]. *Taiwan shehui yanjiu jikan* 台灣社會研究季刊 [*Taiwan: A Radical Quarterly in Social Sciences*] 59 (2005): 1–42.

——. "From Anti-Trafficking to Social Discipline, or the Changing Role of Women's NGOs in Taiwan." In *Trafficking and Prostitution Reconsidered: New Perspectives on Migration, Sex Work and Human Rights*, edited by Kamala Kempadoo, Jyoti Sanghera, and Bandana Pattanaik, 83–105. Boulder, Colo.: Paradigm, 2005.

——. "Sex Revolution and Sex Rights Movement in Taiwan." In *Taiwanese Identity from Domestic, Regional and Global Perspectives*, edited by Jens Damm and Gunter Schubert, 123–39. Münster: LIT, 2007.

Hoang, Nguyen Tan. "Theorizing Queer Temporalities: A Roundtable Discussion." *GLQ: A Journal of Lesbian and Gay Studies* 13, nos. 2–3 (2007): 177–95.

Hodges, Graham Russell Gao. *From Laundryman's Daughter to Hollywood Legend: Anna May Wong*. New York: Palgrave Macmillan, 2005.

Hom, Marlon K. *Songs of Gold Mountain: Cantonese Rhymes from San Francisco Chinatown*. Berkeley: University of California Press, 1987.

Hong Kong Film Archive. *The Shaw Screen: A Preliminary Study*. Hong Kong: Hong Kong Film Archive, 2003.

Hoover, Kenneth R. *Economics as Ideology: Keynes, Laski, Hayek and the Creation of Contemporary Politics*. Lanham, Md.: Rowman & Littlefield, 2003.

Hoskins, Janet, and Viet Thanh Nguyen. *Transpacific Studies: Framing an Emerging Field*. Honolulu: University of Hawai'i Press, 2014.

Hsieh, Lili. "Interpellated by Affect: The Move to the Political in Brian Massumi's Parables for the Virtual and Eve Sedgwick's Touching Feeling." *Subjectivity* 23 (2008): 219–35.

Hsu, L. Hsuan. *Mrs. Spring Fragrance: Edith Maude Eaton/Sui Sin Far*. Ontario: Broadview Press, 2011.

Huang Chunming 黃春明. *Kanhai de rizi* 看海的日子 [Days of gazing at the sea]. Taipei: Lianhe wenxue, 2009.

——. *Sayonara! Zaijian* 莎喲娜啦. 再見 [Sayonara! Goodbye]. Taipei: Lianhe wenxue, 2009.

Huang, Hans Tao-Ming. *Queer Politics and Sexual Modernity in Taiwan*. Hong Kong: Hong Kong University Press, 2011.

——. "State Power, Prostitution and Sexual Order in Taiwan: Towards a Genealogical Critique of 'Virtuous Custom.'" In *Inter-Asia Cultural Studies Reader*, edited by Kuan-Hsing Chen and Chua Beng Huat, 364–94. New York: Routledge, 2007.

Huang, Yunte. *Transpacific Displacement: Ethnography, Translation, and Intertextual Travel in Twentieth-Century American Literature*. Berkeley: University of California Press, 2002.

——. *Transpacific Imaginations: History, Literature, Counterpoetics*. Cambridge, Mass.: Harvard University Press, 2008.

Jacobs, Lea. *The Wages of Sin: Censorship and the Fallen Woman Film, 1928–1942*. Berkeley: University of California Press, 1995.

Jones, Andrew F. *Yellow Music: Media Culture and Colonial Modernity in the Chinese Jazz Age*. Durham, N.C.: Duke University Press, 2001.

Jun, Helen H. *Race for Citizenship: Black Orientalism and Asian Uplift from Pre-Emancipation to Neoliberal America*. New York: New York University Press, 2011.

Jung, Moon-Ho. "Outlawing 'Coolie': Race, Nation, and Empire in the Age of Emancipation." *American Quarterly* 57, no. 3 (2005): 677–701.

Kaplan, Amy. *The Anarchy of Empire in the Making of U.S. Culture*. Cambridge, Mass.: Harvard University Press, 2002.

Keenan, Thomas. "Windows: Of Vulnerability." In *The Phantom Public Sphere*, edited by Bruce Robbins, 121–41. Minneapolis: University of Minnesota Press, 1997.

Kei, Sek. "Shaw Movie Town's 'China Dream' and 'Hong Kong Sentiments.'" In *The Shaw Screen: A Preliminary Study*, 37–47. Hong Kong: Hong Kong Film Archive, 2003.

Kempadoo, Kamala, Jyoti Sanghera, and Bandana Pattanaik, eds. *Trafficking and Prostitution Reconsidered: New Perspectives on Migration, Sex Work and Human Rights*. Boulder, Colo.: Paradigm, 2005.

Kim, Jodi. *Ends of Empire: Asian American Critique and the Cold War*. Minneapolis: University of Minnesota Press, 2010.

Kipnis, Laura. *Bound and Gagged: Pornography and the Politics of Fantasy in America*. New York: Grove Press, 1996.

Klein, Christina. *Cold War Orientalism: Asia in the Middlebrow Imagination, 1945-1961*. Berkeley: University of California Press, 2003.

Kong, Lily. "Shaw Cinema Enterprise and Understanding Cultural Industries." In *China Forever: The Shaw Brothers and Diasporic Cinema*, edited by Poshek Fu, 27–56. Urbana: University of Illinois Press, 2008.

Koppelman, Susan. *Women's Friendships: A Collection of Short Stories*. Norman: University of Oklahoma Press, 1991.

Kun, Josh. *Audiotopia: Music, Race, and America*. Berkeley: University of California Press, 2005.

Kvidera, Peter. "Resonant Presence: Legal Narratives and Literary Space in the Poetry of Early Chinese Immigrants." *American Literature* 77, no. 3 (2005): 511–39.

Lauter, Paul, and Richard Yarborough, eds. *The Heath Anthology of American Literature*. Vol. 2. New York: Cengage Learning, 2013.

Law, Kar. "Shaw's Cantonese Productions and Their Interactions with Contemporary Local and Hollywood Cinema." In *China Forever: The Shaw Brothers and Diasporic Cinema*, edited by Poshek Fu, 57–73. Urbana: University of Illinois Press, 2008.

Lawrance, Alan. *China Since 1919: Revolution and Reform: A Sourcebook*. New York: Routledge, 2004.

Lee, Erika. *At America's Gates: Chinese Immigration During the Exclusion Era, 1882-1943*. Chapel Hill: University of North Carolina Press, 2003.

Lee, Haiyan. *Revolution of the Heart: A Genealogy of Love in China, 1900-1950*. Stanford, Calif.: Stanford University Press, 2007.

Lee, Julia H. *Interracial Encounters: Reciprocal Representations in African and Asian American Literatures, 1896-1937*. New York: New York University Press, 2011.

Leong, Karen J. "Anna May Wong and the British Film Industry." *Quarterly Review of Film and Video* 23, no. 1 (2006): 13–22.

——. *The China Mystique: Pearl S. Buck, Anna May Wong, Mayling Soong, and the Transformation of American Orientalism*. Berkeley: University of California Press, 2005.

Leung, Louise. "East Meets West: Anna May Wong Back on Screen After an Absence of Several Years, Discusses Her Native Land." *Hollywood Magazine*, January 1939.

Leyda, Jay. *Dianying Electric Shadows: An Account of Films and Film Audience in China.* Cambridge, Mass.: MIT Press, 1972.

Li, Siu Leung. "Embracing Glocalization and Hong Kong-Made Musical Film." In *China Forever: The Shaw Brothers and Diasporic Cinema*, edited by Poshek Fu, 74–95. Urbana: University of Illinois Press, 2008.

Lim, Shirley Geok-lin. "Sibling Hybridity: The Case of Edith Eaton/Sui Sin Far and Winnifred Eaton (Onoto Watanna)." *Life Writing* 4, no. 1 (2007): 81–99.

Lim, Shirley Jennifer. "'I Protest': Anna May Wong and the Performance of Modernity." In *A Feeling of Belonging: Asian American Women's Public Culture, 1930–1960*, 47–86. New York: New York University Press, 2005.

Lionnet, Françoise, and Shu-mei Shih. "Introduction: Thinking Through the Minor, Transnationally." In *Minor Transnationalism*, edited by Françoise Lionnet and Shu-mei Shih, 1–23. Durham, N.C.: Duke University Press, 2005.

Liu, Cynthia W. "When Dragon Ladies Die, Do They Come Back as Butterflies? Re-imagining Anna May Wong." In *Countervisions: Asian American Film Criticism*, edited by Darrell Hamamoto and Sandra Liu, 23–39. Philadelphia: Temple University Press, 2000.

Liu, Lydia He. *Translingual Practice: Literature, National Culture, and Translated Modernity—China, 1900–1937.* Stanford, Calif.: Stanford University Press, 1995.

Lorde, Audre. "Eye to Eye: Black Women, Hatred, and Anger." In *Sister Outsider: Essays and Speeches by Audre Lorde*, 145–75. Freedom, Calif.: Crossing Press, 1984.

Lowe, Lisa. *Immigrant Acts: On Asian American Cultural Politics.* Durham, N.C.: Duke University Press, 1996.

Lu, Sheldon Hsiao-peng. "Historical Introduction: Chinese Cinemas (1896–1996) and Transnational Film Studies." In *Transnational Chinese Cinemas: Identity, Nationhood, Gender*, edited by Sheldon Hsiao-peng Lu, 1–31. Honolulu: University of Hawai'i Press, 1997.

——, ed. *Transnational Chinese Cinemas: Identity, Nationhood, Gender.* Honolulu: University of Hawai'i Press, 1997.

Lu Xun 鲁迅. "Gossip Is a Fearful Thing." In *Selected Works of Lu Xun*, Vol. 4, translated by Yang Hsien-yi and Gladys Yang, 186–88. Beijing: Foreign Language Press, 1960.

Lye, Colleen. *America's Asia: Racial Form and American Literature, 1893–1945.* Princeton, N.J.: Princeton University Press, 2005.

Massumi, Brian. *Parables for the Virtual: Movement, Affect, Sensation.* Durham, N.C.: Duke University Press, 2002.

Melamed, Jodi. "The Spirit of Neoliberalism: From Racial Liberalism to Neoliberal Multiculturalism." *Social Text* 24, no. 4 (2006): 1–24.

Mengel, Laurie, and Paul Spickard. "Deconstructing Race: The Multiethnicity of Sui Sin Far." *Books and Culture* 3, no. 4 (1997): 4–5.

Meyer, Richard J. *Ruan Ling-yu: The Goddess of Shanghai*. Hong Kong: Hong Kong University Press, 2005.

Nakamura, Lisa. "Cybertyping and the Work of Race in the Age of Digital Reproduction." In *New Media, Old Media: A History and Theory Reader*, edited by Wendy Hui Kyong Chun and Thomas Keenan, 317–33. New York: Routledge, 2006.

Nakamura, Lisa, and Peter A. Chow-White. *Race After the Internet*. New York: Routledge, 2011.

Nathan, Debbie. *Pornography*. Toronto: Groundwood Books/House of Anansi Press, 2007.

Ngai, Mae M. *Impossible Subjects: Illegal Aliens and the Making of Modern America*. Princeton, N.J.: Princeton University Press, 2004.

Ngai, Sianne. *Ugly Feelings*. Cambridge, Mass.: Harvard University Press, 2005.

Nguyen, Viet Thanh. "On the Origins of Asian American Literature: The Eaton Sisters and the Hybrid Body." In *Race and Resistance: Literature and Politics in Asian America*, 33–59. Oxford: Oxford University Press, 2002.

Ong, Aihwa. *Flexible Citizenship: The Cultural Logics of Transnationality*. Durham, N.C.: Duke University Press, 1999.

——. *Neoliberalism as Exception: Mutations in Citizenship and Sovereignty*. Durham, N.C.: Duke University Press, 2007.

Ono, Kent A., and Vincent N. Pham. *Asian Americans and the Media*. Cambridge: Polity, 2009.

Palumbo-Liu, David. *Asian/American: Historical Crossings of a Racial Frontier*. Stanford, Calif.: Stanford University Press, 1999.

Pang, Laikwan. *Building a New China in Cinema: The Chinese Left-Wing Cinema Movement, 1932–1937*. Lanham, Md.: Rowman & Littlefield, 2002.

Peffer, George. *If They Don't Bring Their Women Here: Chinese Female Immigration Before Exclusion*. Champaign: University of Illinois Press, 1999.

Rofel, Lisa. *Desiring China: Experiments in Neoliberalism, Sexuality, and Public Culture*. Durham, N.C.: Duke University Press, 2007.

Saad-Filho, Alfredo, and Deborah Johnston. *Neoliberalism: A Critical Reader*. London: Pluto Press, 2005.

Sandmeyer, Elmer. *The Anti-Chinese Movement in California*. Champaign: University of Illinois Press, 1991.

Sang, Tze-lan D. *The Emerging Lesbian: Female Same-Sex Desire in Modern China*. Chicago: University of Chicago Press, 2003.

Sarkar, Bhaskar. "The Melodrama of Globalization." *Cultural Dynamics* 20 (2008): 31–51.

——. *Mourning the Nation: Indian Cinema in the Wake of Partition*. Durham, N.C.: Duke University Press, 2009.

Sedgwick, Eve Kosofsky. *Touching Feeling: Affect, Pedagogy, Performativity*. Durham, N.C.: Duke University Press, 2003.

Seigworth, Gregory, and Melissa Gregg. "An Inventory of Shimmers." In *The Affect Theory Reader*, edited by Gregory Seigworth and Melissa Gregg, 1–25. Durham, N.C.: Duke University Press, 2010.

Sergeant, Harriet. *Shanghai*. London: Jonathan Cape, 1991.

Shah, Nayan. *Contagious Divides: Epidemics and Race in San Francisco's Chinatown*. Berkeley: University of California Press, 2001.

Sharp, Jasper. *Behind the Pink Curtain: The Complete History of Japanese Sex Cinema*. Surrey: FAB Press, 2008.

Shelley, Louise. *Human Trafficking: A Global Perspective*. Cambridge: Cambridge University Press, 2010.

Shen Ji 沈寂. *Ruan Ling-yu: Yidai yingxing* 阮玲玉：一代影星 [Ruan Lingyu: Movie star of a generation]. Shanghai: Shanxi Renmin Chubanshe, 1985.

Shih, Shu-mei. "Against Diaspora: The Sinophone as Places of Cultural Production." In *Global Chinese Literature: Critical Essays*, edited by Jing Tsu and David Der-wei Wang, 29–48. Leiden: Brill, 2010.

——. *Visuality and Identity: Sinophone Articulations Across the Pacific*. Berkeley: University of California Press, 2007.

Shimizu, Celine Parreñas. *The Hypersexuality of Race: Performing Asian/American Women on Screen and Scene*. Durham, N.C.: Duke University Press, 2007.

——."The Sexual Bonds of Racial Stardom: Asian American Femme Fatales in Hollywood." In *The Hypersexuality of Race: Performing Asian/American Women on Screen and Scene*, 58–101. Durham, N.C.: Duke University Press, 2007.

Shin, Hyunjoon, and Tung-hung Ho. "Translation of 'America' During the Early Cold War Period: A Comparative Study on the History of Popular Music in South Korea and Taiwan." *Inter-Asia Cultural Studies* 10, no. 1 (2009): 83–102.

Singer, Ben. *Melodrama and Modernity: Early Sensational Cinema and Its Contexts*. New York: Columbia University Press, 2001.

Song Geng. *The Fragile Scholar: Power and Masculinity in Chinese Culture*. Hong Kong: Hong Kong University Press, 2004.

Song, Min Hyoung. "Sentimentalism and Sui Sin Far." *Legacy* 20, nos. 1–2 (2003): 134–53.

Song Zelai 宋澤萊. *Song Zelai tan wenxue* 宋澤萊談文學 [Song Zelai on literature]. Taipei: Qianwei, 2004.

Spence, Jonathan D. *The Search for Modern China*. New York: Norton, 1999.

Starr, Chloe. *Red-Light Novels of the Late Qing*. Leiden: Brill, 2007.

Stevens, Sarah. "Figuring Modernity: The New Women and the Modern Girl in Republican China." *NWSA Journal* 15, no. 3 (Autumn 2003): 82–103.

Stoler, Ann Laura. "Intimidations of Empire: Predicaments of the Tactile and Unseen." In *Haunted by Empire: Geographies of Intimacy in North American History*, edited by Ann Laura Stoler, 1–22. Durham, N.C.: Duke University Press, 2006.

——. "Tense and Tender Ties: The Politics of Comparison in North American History and (Post) Colonial Studies." In *Haunted by Empire: Geographies of Intimacy*

in North American History, edited by Ann Laura Stoler, 23–67. Durham, N.C.: Duke University Press, 2006.

Tan, See Kam, and Annette Aw. "Love Eterne: Almost a (Heterosexual) Love Story." In *Chinese Films in Focus: 25 New Takes*, edited by Chris Berry, 137–43. London: British Film Institute, 2003.

Teng, Emma Jinhua. *Eurasian: Mixed Identities in the United States, China, and Hong Kong, 1842–1943*. Berkeley: University of California Press, 2013.

Tsing, Anna Lowenhaupt. *Friction: An Ethnography of Global Connection*. Princeton, N.J.: Princeton University Press, 2005.

Tsu, Jing. "Sinophonics and the Nationalization of Chinese." In *Global Chinese Literature*, edited by Jing Tsu and David Der-wei Wang, 93–114. Leiden: Brill, 2010.

——. *Sound and Script in Chinese Diaspora*. Cambridge, Mass.: Harvard University Press, 2010.

Tsu, Jing, and David Der-wei Wang. "Introduction: Global Chinese Literature." In *Global Chinese Literature: Critical Essays*, edited by Jing Tsu and David Der-wei Wang, 1–14. Leiden: Brill, 2010.

Tu, Thuy Linh Nguyen. "Forgetting Anna May Wong." *Wasafiri* 19, no. 43 (2004): 14–18.

Unger, J. Marshall. *Ideogram: Chinese Characters and the Myth of Disembodied Meaning*. Honolulu: University of Hawai'i Press, 2003.

Vasey, Ruth. *The World According to Hollywood*. Madison: University of Wisconsin Press, 1997.

Verdery, Katherine. *The Political Lives of Dead Bodies: Reburial and Postsocialist Change*. New York: Columbia University Press, 1999.

Wang, Chih-ming. *Transpacific Articulations: Student Migration and the Remaking of Asian America*. Honolulu: University of Hawai'i Press, 2013.

Wang, David Der-wei. "Preface." In *Writing Taiwan: A New Literary History*, edited by David Der-wei Wang and Carlos Rojas, vii–x. Durham, N.C.: Duke University Press, 2007.

Wang, David Der-wei, and Carlos Rojas, eds. *Writing Taiwan: A New Literary History*. Durham, N.C.: Duke University Press, 2007.

Wang Fangping 王芳萍 et al., eds. *Yu chang tongxing, fanqiang yuejie* 與娼同行, 翻牆越界 [In solidarity with sex workers, we cross borders]. Taipei: Juliu tushu, 2002.

Wang, Gungwu. "A Single Chinese Diaspora?" In *Diasporic Chinese Ventures: The Life and Work of Wang Gungwu*, edited by Gregor Benton and Hong Liu, 157–77. New York: Routledge, 2004.

Wang, Yiman. "Anna May Wong: A Border-Crossing 'Minor' Star Mediating Performance." *Journal of Chinese Cinema* 2, no. 2 (2008): 91–102.

——. "The Art of Screen Passing: Anna May Wong's Yellow Yellowface Performance in the Art Deco Era." *Camera Obscura* 60, no. 3 (2005): 159–91.

——. "The Crisscrossed Stare: Protest and Propaganda in China's Not-So-Silent Era." In *Silent Cinema and the Politics of Space*, edited by Jennifer M. Bean, Anupama Kapse, and Laura Horak, 186–209. Bloomington: Indiana University Press, 2014.

Wang Zhenhe 王禎和. *Jiazhuang yi niuche* 嫁妝一牛車 [An oxcart for dowry]. Taipei: Yuanjing chuban shiyegongsi, 1975.

——. *Kuaile de ren* 快樂的人 [The happy person]. Taipei: Haixia wenyi chubanshe, 1989.

——. *Meigui meigui wo ai ni* 玫瑰玫瑰我愛你 [Rose, rose, I love you]. Taipei: Yuanjing chuban shiyegong si, 1984.

——. *Rose, Rose, I Love You*. Translated by Howard Goldblatt. New York: Columbia University Press, 1998.

Westdad, Odd Arne. *The Global Cold War: Third World Interventions and the Making of Our Times*. Cambridge: Cambridge University Press, 2007.

White-Parks, Annette. *Sui Sin Far/Edith Maude Eaton: A Literary Biography*. Champaign: University of Illinois Press, 1995.

Williams, Linda. "Film Bodies: Gender, Genre and Excess." In *Film Genre Reader II*, edited by Barry Keith Grant, 140–58. Austin: University of Texas Press, 2012.

Williams, Raymond. *Politics and Letters: Interviews with New Left Review*. London: Verso, 2015.

Wilson, Rob, and Arif Dirlik, eds. *Asian/Pacific as Space of Cultural Production*. Durham, N.C.: Duke University Press, 1995.

Wong, Anna May. "The Chinese Are Misunderstood." *Huazi ribao*, February 22, 1936.

Wong, Lily. "Moving Serenades: Hearing the Sinophonic in MP & GI's *Longxiang Fengwu*." *Journal of Chinese Cinemas* 7, no. 3 (November 2013): 225–40.

Wong, Sau-ling. "Global Vision and Locatedness: World Literature in Chinese/By Chinese from a Chinese-Americanist Perspective." In *Global Chinese Literature: Critical Essays*, edited by Jing Tsu and David Der-wei Wang, 49–76. Leiden: Brill, 2010.

——. "The Politics and Poetics of Folksong Reading: Literary Portrayals of Life under Exclusion." In *Entry Denied: Exclusion and the Chinese Community in America, 1882–1943*, edited by Sucheng Chan, 246–67. Philadelphia: Temple University Press, 1991.

Wu Hao 吳昊. *Di san leixing dianying* 第三類型電影 [Shaw films: The alternative cult films]. Hong Kong: Celestial Pictures Limited, 2004.

Xia Linqing 夏林清, ed. *Gongchang yu jiquan yundong* 公娼與妓權運動 [1998 world action forum for sex work rights]. Taipei: Collective of Sex Workers and Supporters Press, 2000.

Xiao, Zhiwei. "Anti-Imperialism and Film Censorship During the Nanjing Decade, 1927–1937." In *Transnational Chinese Cinemas: Identity, Nationhood, Gender*, edited by Sheldon Hsiao-peng Lu, 35–58. Honolulu: University of Hawai'i Press, 1997.

Yao, Stephen. *Foreign Accents: Chinese American Verse from Exclusion to Postethnicity.* Oxford: Oxford University Press, 2010.

Yau, Ching. "A Sensuous Misunderstanding: Women and Sexualities in Li Han-hsiang's Fengyue Films." In *Li Han-hsiang, Storyteller,* edited by Wong Ain-ling, 100–13. Hong Kong: Hong Kong Film Archive, 2007.

Yau, Esther C. M. "Introduction: Hong Kong Cinema in a Borderless World." In *At Full Speed: Hong Kong Cinema in a Borderless World,* edited by Esther C. M. Yau, 1–30. Minneapolis: University of Minnesota Press, 2001.

Yau, Kinnia Shuk-ting. "Shaws' Japanese Collaboration and Competition as Seen Through the Asian Film Festival Evolution." In *The Shaw Screen: A Preliminary Study,* 279–91. Hong Kong: Hong Kong Film Archive, 2003.

Yee, Angelina C. "Constructing a Native Consciousness: Taiwan Literature in the 20th Century." *China Quarterly* 165 (2001): 83–101.

Yeh, Catherine. *Shanghai Love: Courtesans, Intellectuals, and Entertainment Culture, 1850-1911.* Seattle: University of Washington Press, 2006.

Yip, June. "Constructing a Nation: Taiwanese History and the Films of Hou Hsiao-hsien." In *Transnational Chinese Cinemas: Identity, Nationhood, Gender,* edited by Sheldon Hsiao-peng Lu, 139–68. Honolulu: University of Hawai'i Press, 1997.

——. *Envisioning Taiwan: Fiction, Cinema, and the Nation in the Cultural Imaginary.* Durham, N.C.: Duke University Press, 2004.

Yuan Tang. "Yang Guifei" 楊貴妃 [Empress Yang]. *Yinhe huabao* 銀河畫報 53, August 1962, 21.

Yun, Lisa. *The Coolie Speaks: Chinese Indentured Laborers and African Slaves in Cuba.* Philadelphia: Temple University Press, 2008.

Yung, Sai-shing. "The Joy of Youth, Made in Hong Kong: Patricia Lam Fung and Shaws' Cantonese Films." In *The Shaw Screen: A Preliminary Study,* 221–35. Hong Kong: Hong Kong Film Archive, 2003.

Zamperini, Paola. *Lost Bodies: Prostitution and Masculinity in Chinese Fiction.* Leiden: Brill, 2010.

Zhang Tingxing 張廷興. *Zhongguo gudai yanqing xiaoshuo shi* 中國古典艷情小說史 [History of Chinese *Yanqing* literature]. Beijing: Zhongyang bian yi chubanshe, 2008.

Zhang, Yingjin. *Chinese National Cinema.* New York: Routledge, 2004.

——. "Prostitution and Urban Imagination: Negotiating the Public and Private in Chinese Films of the 1930s." In *Cinema and Urban Culture in Shanghai, 1922-1943,* edited by Yingjin Zhang, 160–80. Stanford, Calif.: Stanford University Press, 1999.

Zhang, Zhen. *An Amorous History of the Silver Screen: Shanghai Cinema, 1896-1937.* Chicago: University of Chicago Press, 2005.

Zhou, Chengren. "Shanghai's Unique Film Productions and Hong Kong's Early Cinema." In *The Shaw Screen: A Preliminary Study,* 19–35. Hong Kong: Hong Kong Film Archive, 2003.

JOURNALS AND NEWSPAPERS

Apple Daily
Beiyang huabao
Central China Daily News
Dagongbao
Da zhong dianying
Dianying huabao
Dianying zazhi
Diansheng
Dongsen xinwenbao
Film Favourites
Huazi ribao
Lianhe wanbao
Lianhua huabao
Mien Film
Mon Ciné
Nanguo dianying
New York Times
North-China Daily News
North-China Herald
Peiping Morning Post
Photoplay
Picturegoer
Radio Movie Daily News
Rob Wagner's Script
SETN News
Shenbao
Shidai dianying
Variety
Xianggang yinghua
Yisheng dianying

SONGS AND FILMS

Black Hand Nakasi 黑手那卡西. "Xingfu" 幸福 [Happiness]. Accessed January 3, 2016. https://tw.streetvoice.com/twbhn/songs/119260/.
Brenon, Herbert. *Peter Pan*. Famous Players-Lasky for Paramount Pictures, 1924.
Bruckman, Clyde. *Welcome Danger*. The Harold Lloyd Corporation, 1929.
Bu Wancang 卜萬蒼. *Lian'ai yu yiwu* 戀愛與義務 [Love and duty]. Lianhua Film Company, 1931.

——. *Sange modeng nüxing* 三個摩登女性 [Three modern women]. Lianhua Film Company, 1933.

Cai Chusheng 蔡楚生. *Xin nüxing* 新女性 [New woman]. Lianhua Film Company, 1935.

Chu Yuan 楚原. *Ainu* 愛奴 [*Intimate Confessions of a Chinese Courtesan*]. Shaw Brothers, 1972.

——. *Ainu xinzhuan* 愛奴新傳 [*Lust for Love of a Chinese Courtesan*]. Shaw Brothers, 1984.

——. *Chu Liuxiang* 楚留香 [*Clans of Intrigue*]. Shaw Brothers, 1977.

——. *Duoqing jianke wuqing jian* 多情劍客無情劍 [*The Sentimental Swordsman*]. Shaw Brothers, 1977.

Chung Mong-hong 鍾孟宏. *Di si zhang hua* 第四張畫 [*The Fourth Portrait*]. Cream Film Production, 2010.

Corrigan, Lloyd. *Daughter of the Dragon*. Paramount Pictures, 1932.

Dupont, E. A. *Piccadilly*. BIP Wardour, 1929.

Fei Mu 費穆. *Chengshi zhi ye* 城市之夜 [Night in the city]. Lianhua Film Company, 1932.

——. *Langshan diexueji* 狼山喋血記 [Blood on Wolf Mountain]. Lianhua Film Company, 1936.

Franklin, Chester M. *Toll of the Sea*. Technicolor Motion Picture Company for Metro Pictures, 1922.

Grinde, Nick. *King of Chinatown*. Paramount Pictures, 1939.

Guan Wenqing 關文清. *Modeng xinniang* 摩登新娘 [Modern bride]. Daguan Film Company, 1935.

Hua Shan 華山. *Juebu ditou* 決不低頭 [*To Kill a Jaguar*]. Shaw Brothers, 1977.

——. *Luding ji* 鹿鼎記 [*Tales of a Eunuch*]. Shaw Brothers, 1983.

Kuei Chihung 桂治洪. *Chengji chalou* 成記茶樓 [*The Tea House*]. Shaw Brothers, 1974.

——. *Nü jizhongying* 女集中營 [*Bamboo House of Dolls*]. Shaw Brothers, 1973.

——. *Wan ren zhan* 萬人斬 [*Killer Constable*]. Shaw Brothers, 1980.

Laine, Frankie. "Rose, Rose, I Love You." By Wilfred Thomas. Columbia Records, 1951.

Li Han-hsiang 李翰祥. *Fengliu yunshi* 風流韻事 [*Illicit Desires*]. Shaw Brothers, 1973.

——. *Jinping shuangyan* 金瓶雙艷 [*The Golden Lotus*]. Shaw Brothers, 1974.

——. *Junfa qushi* 軍閥趣史 [*The Scandalous Warlord*]. Shaw Brothers, 1979.

——. *Liang Shanbo yu Zhu Yingtai* 梁山伯與祝英台 [*Love Eterne*]. Shaw Brothers, 1963.

——. *Piancai pianse* 騙財騙色 [*Love Swindlers*]. Shaw Brothers, 1976.

——. *Qingguo qingcheng* 傾國傾城 [*The Empress Dowager*]. Shaw Brothers, 1975.

——. *Wu Song* 武松 [*Tiger Killer*]. Shaw Brothers, 1982.

——. *Yang Guifei* 楊貴妃 [*Empress Yang*]. Shaw Brothers, 1962.

——. *Yingtai qixue* 瀛台泣血 [*The Last Tempest*]. Shaw Brothers, 1976.

——. *Zhuojian qushi* 捉姦趣史 [*That's Adultery*]. Shaw Brothers, 1975.

Li Pingqian 李萍倩. *Xiandai yi nüxing* 現代一女性 [A modern woman]. Lianhua Film Company, 1933.

Lum, Debbie. *Seeking Asian Female: A Documentary*. Chicken and Egg Pictures, 2012.

Shaw's Directors Committee 邵氏全體導演. *Honglou chunmeng* 紅樓春夢 [*Dreams of Eroticism*]. Shaw Brothers, 1977.

Sternberg, Josef von. *Shanghai Express*. Süddeutsche Zeitung, 2008.

Sun Yu 孫瑜. *Dalu* 大路 [The big road]. Lianhua Film Company, 1935.

Tao Qin 陶秦. *Longxiang fengwu* 龍翔鳳舞 [*Calendar Girls*]. Motion Picture and General Investment Co., 1959.

Umetsugu, Inoue 井上梅次. *Xiangjiang hua yue ye* 香江花月夜 [*Hong Kong Nocturne*]. Shaw Brothers, 1967.

Walsh, Raoul. *Thief of Bagdad*. Douglas Fairbanks Pictures for United Artists, 1924.

Wang Yin 王引. *Hong meigui* 紅玫瑰 [*Red Rose*]. Shaw Brothers, 1952.

Wu Cun 吳村. *Tianya genü* 天涯歌女 [Wandering songstress]. Guotai yingpain gongsi 國泰影片公司, 1940.

Wu Younggang 吳永剛. *Shennü* 神女 [The goddess]. Guangzhou: Beauty Culture Communication, 2006.

Zhou Shilu 周詩祿. *Pan Jinlian* 潘金蓮 [*The Amorous Lotus Pan*]. Shaw Brothers, 1964.

INDEX